T0346922

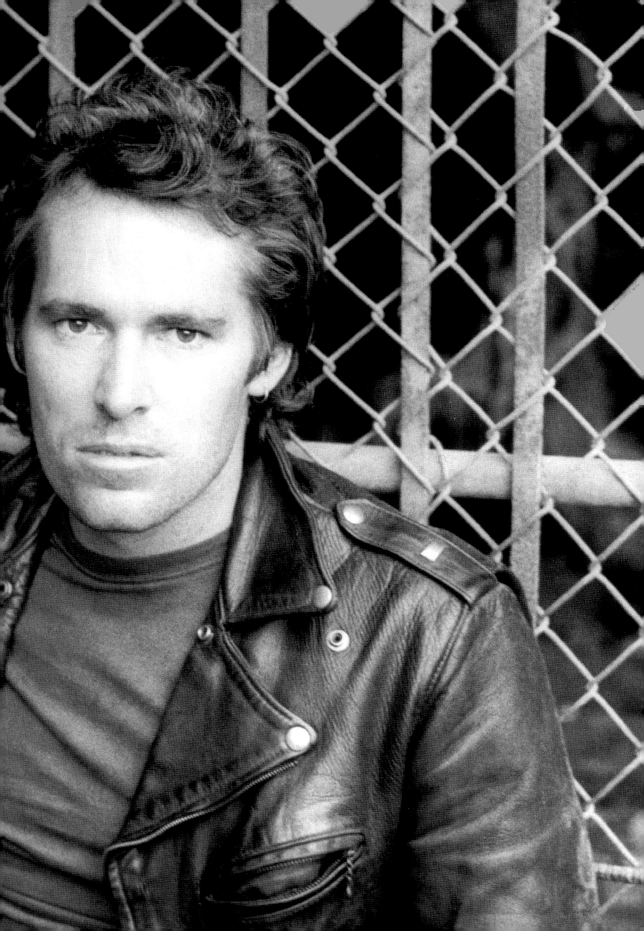

SEMIOTEXT(E) NATIVE AGENTS SERIES

Published by Semiotext(e)
2007 Wilshire Blvd., Suite 427, Los Angeles, CA 90057
www.semiotexte.com

Special thanks to John Ebert and Marc Lowenthal.

This book was made possible in part by David Kordansky Gallery, Los Angeles.

Author photograph: Bernard Yenelouis

Pages 2–3: Production still from *Sextool* (1975) Photo by Curtis Taylor
Pages 6–7: Fred Halsted shooting *Sextool*
Pages 8–9: From a contact sheet of *Sextool* production stills

Image credits:

Archives Canada: page 62
Cahiers du cinéma: page 28
Frank Carrillo: page 92
Tom Harvey: pages 22 (top), 80
Hustler Video: front cover, back cover, pages 2–3, 6–10, 41, 43–52, 54, 66–67, 69, 72, 75–76, 79, 84, 89, 100, 102, 129–144
Provincial Archives of Alberta: page 61
Joel Shepard: page 29
Michael Yanoska: pages 70–71, 73
Elizabeth Purchell: pages 212, 214–215, 220, 223, 226, 227

Design: Hedi El Kholti

ISBN: 978-1-63590-176-4
Distributed by The MIT Press, Cambridge, Mass. and London, England
Printed in Korea

HALSTED
PLAYS HIMSELF

William E. Jones

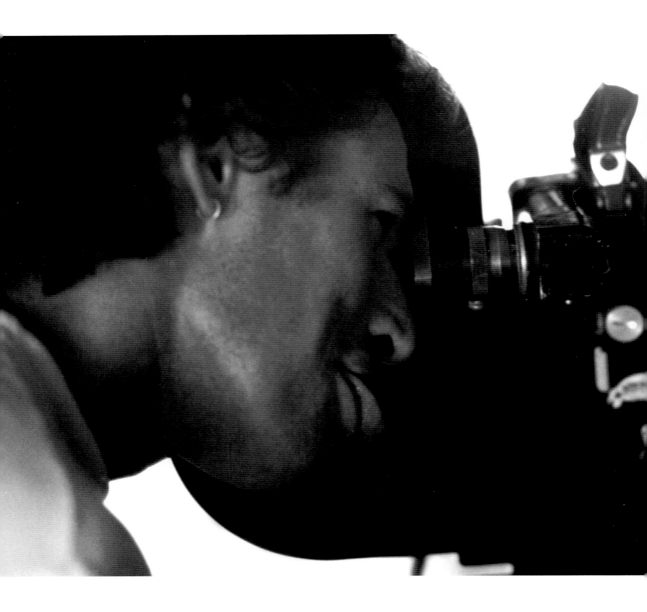

CONTENTS

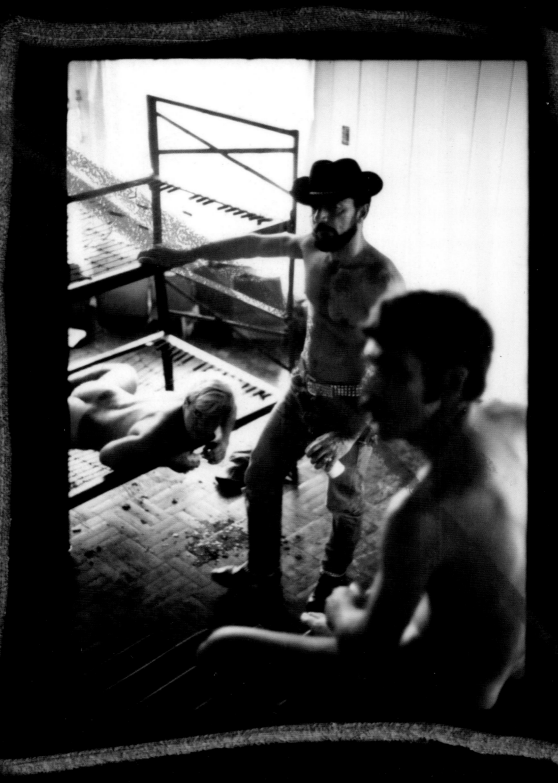

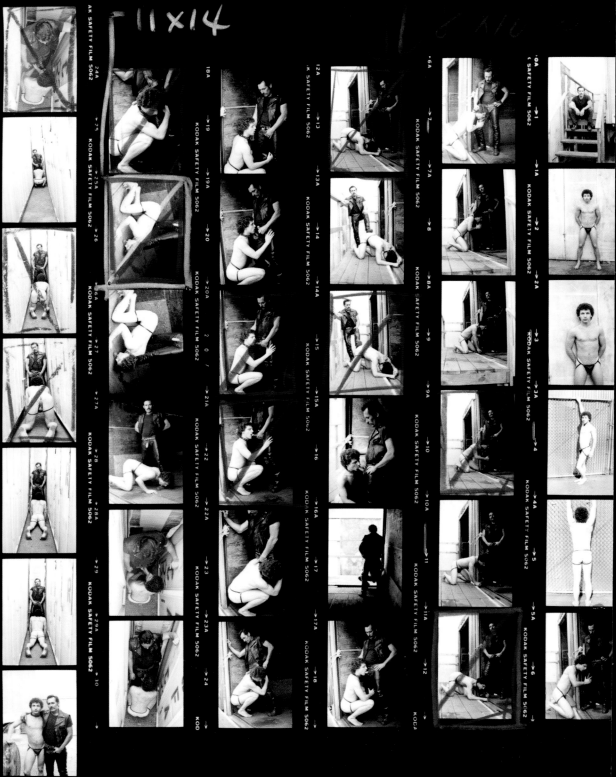

A Griffith Park "love in," shot circa 1970, in *L. A. Plays Itself* (1972)

Boy watching in Griffith Park in *L. A. Plays Itself* (1972)

Older Man: Yeah, I guess so.

Young Man: You know where I can get maybe a little bit of work, make a little bread? I don't care too much about… as long as it ain't too hard a work, I don't mind.

Older Man: Yeah, I know a few friends. We can maybe get you a job.

Young Man: Oh, yeah?

Older Man: It'd be kind of easy work. I've got these friends that… you know, just a little bit of stuff here and there…

Young Man: How soon?

Older Man: … make some easy money and get yourself a souped-up car.

Young Man: Hey, that sounds fine. I wanna do that as soon as I can, because I ain't even got no bread, except two dollars, and I'm gonna finish that off when I buy my beans tonight.

Older Man: Well, listen, um, let me think, 'cause we want to get you into a nice little spot. You know, you've got some attributes.

Young Man: Yeah? (Laughs)

Older Man: We can work with this kind of stuff. You know, you want to put yourself in with the right people. Otherwise, they'll fuck you over… got to get out of that.

Young Man: You don't seem like them people what's fucks other guys over.

Older Man: No, I don't do that. I learned what's going on around here, and I don't want to see any good guys make mistakes.

Young Man: Yeah, well, listen…

Older Man: I'll show you what you do, 'cause there's ropes…

Young Man: Yeah?

Older Man: Just learn 'em, and…

Young Man: Well, if you're gonna be hangin' around sometimes, maybe I'll see you. Or we can go fuck around, or do some stuff.

Older Man: We'll go run around. You can see my car. (Laughs)

Young Man: You got one?

Older Man: We'll go drive around, and I'll show you spots. There's lots of spots in L. A. They're each different, and there's all different kinds of people.

Young Man: Yeah.

Older Man: And you, like, sort of specialize a little bit, and make a little bread. Fuck it.

Young Man: All right.

Older Man: You don't give stuff away free.

Young Man: No, no. That sounds all right to me.

Older Man: Like those guys across the street. They're just losers. They'll just drain all your blood. They're like vultures. Like on the prairies, you know, something comes along and stumbles out, and then these vultures just come around and get it, picking meat right off the bones.

Young Man: Yeah, they don't look like they do nothin', they're just hangin' around. They're the ones like I've seen that the cops is always talkin' to 'em, on account of they ain't worth nothin' no how. I'll tell you what, why don't, maybe, you know, sometime, after you get some time today, maybe we'll go fuck…

Older Man: A little later, we'll just go out and get a little beer and go over to my place, and we'll just rap, and I'll show you my car, and just fill you in a little bit on what's happenin', and you just follow me, and do what I tell you to do, and you know…

Young Man: All right.

Older Man: We'll get you set up a bit. You got to get set up, and you got to have someone to show you the ropes.

Young Man: That sounds cool to me, and uh…

Older Man: … get you a car, you know, man.

Young Man: Yeah, you got a fast one?

Older Man: Yeah.

Young Man: How 'bout we take a ride in your fast one?

Older Man: We can do that, and then I'll show you around, and relax a little bit, and I'll give you a place you can just crash, and have a real good time, and I'll show you the ropes a little bit.

Young Man: All right, that sounds fine, 'cause I just got a little tiny sleeping bag, you know, and that gets kinda cold by myself.

Older Man: Yeah, you just do what I tell you to do, and… Listen, I'm parked around the corner. You'll see me drive up. It's a red Ranchero, and I'll be back in a few minutes.

Young Man: All right. I'll go fix me up something, and I'll be waitin' around for you.

Older Man: That's good. Just go get your stuff, and…

Young Man: Are you sure you're gonna come back around?

Older Man: I'll be right back. I'm just parked right around the corner.

Young Man: All right. I'll wait for you, 'cause I think you're kinda okay.

FRED ... He's a legend

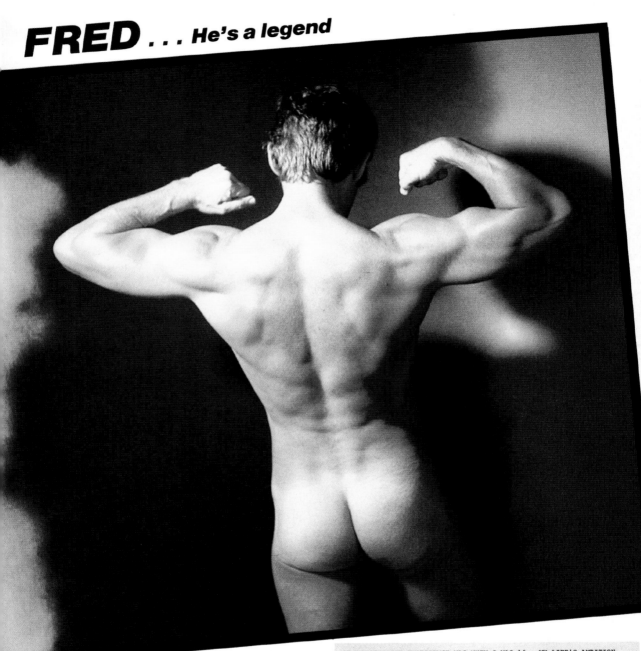

*Fred Halsted
by Fred Halsted*

Photos by COSCO

MY FIRST DADDY EXPERIENCE WAS WHEN I WAS 16. MY LIFE'S AMBITION HAD BEEN TO BE PRESIDENT OF MY HIGH SCHOOL. AND HERE I WAS -- NEW IN SAN JOSE -- IN MY JUNIOR YEAR -- FRESH FROM BAKERSFIELD HIGH SCHOOL. THE SCHOOL WAS ELITIST AND EVERYONE HAD BEEN FRIENDS SINCE THEY WERE BORN. MY GOAL -- TAKE OVER THE SCHOOL IN 18 MONTHS. MY STRATEGY -- MEDIA.

I TOOK OVER THE DRAMA AND SPEECH DEPTS -- THAT GOT ME KNOWN FAST. THE DRAWBACK -- ONLY SISSIES WERE IN THE DRAMA DEPT. TO SUCCEED I HAD TO NEUTRALIZE THE SPORTS DEPT. I THREW DOWN MY CHALLENGE AT THE ANNUAL PHYSICAL FITNESS TESTS. THERE EVERY STUDENT WAS TESTED FOR STRENGTH. I LOUDLY CHALLENGED THE FOOTBALL, BASKETBALL AND TRACK TEAMS TO BEAT ME. WHEN I CAME IN #2 IN THE SCHOOL I WON THE RESPECT OF THE SPORTS DEPT -- PLUS VALUABLE SUPPORT FROM THE CHEERLEADERS. I WON THE ELECTION AND MY DREAM. LATER, I WAS IMPEACHED 3 TIMES -- FOR ADVOCATING BEER IN DRINKING FOUNTAINS INSTEAD OF WATER -- FOR FAILING ALL MY CLASSES (TOO BUSY POLITICKING) AND THROWING OUT THE SCHOOL'S HONOR CODE (DO RIGHT!). THAT WAS MY FIRST DADDY TRIP.

THE NEW ONE IS HALSTED'S. JOEY AND I HAVE STARTED A STAND-UP FUCK CLUB. IF YOU LIKE THE NEW YORK TRUCK SCENE, YOU WILL LIKE OUR CLUB. 4 HUGE TRUCKS AND LOTS OF INSANITY. THE ATMOSPHERE IS LIKE THE CLUBHOUSE YOU HAD WHEN YOU WERE 7. ONLY NOW AN ADULT VERSION. DAVID WEBB, JOEY AND I PUT IS TOGETHER. OPENING NIGHT WAS PACKED -- IN THE HEAT OF THE PARTY, OUR MANAGER, MARK VAN ELLS,

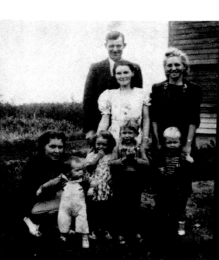

me in the white pants, Age 2, in Kamsack, Saskatchewan

At age 11, in Oildale, Ca.

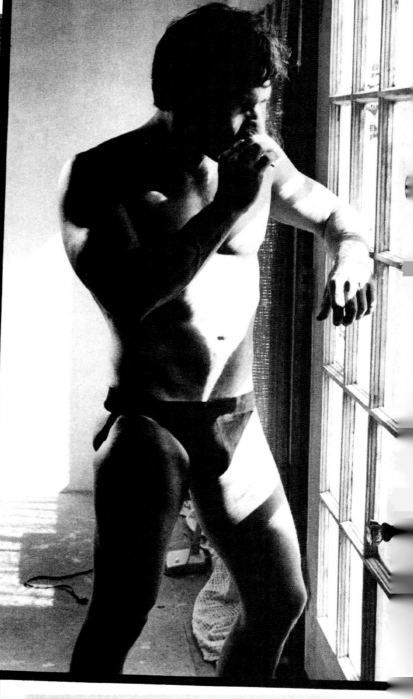

CALLED ME ASIDE. THERE WAS A LOT OF LOUD POUNDING COMING FROM THE TRUCKS. I WENT OUTSIDE AND IT WAS LOUD. BUT NO MOANS OR SCREAMS. SO I LISTENED. IT GOT LOUDER. I WONDERED IF SOMEONE WAS FLIPPING OUT. IT IS EASY FOR ME TO RELATE TO ALCOHOLICS AND INSANITY SO I STEPPED INSIDE.

AN EMPTY TRUCK IN MANY WAYS IS LIKE A PADDED CELL. INSIDE WERE TWO HOT PUNKS. ONE BLOND, SMOOTH SKINNED AND CHEWY TITS. THE OTHER DARK AND ITALIAN. THEY WERE PICKING EACH OTHER UP AND THROWING EACH OTHER INTO THE SIDE OF THE TRUCK -- PLUS A LOT OF KICKING OF THE SIDES OF THE TRUCK. LOOKED LIKE A NEW PUNK DANCE TO ME.

NEXT I WENT INTO THE CARGO CONTAINERS. THERE THE LOUD MOANS AND RED LIGHTS LEFT NO DOUBT AS TO THE HOT SEX THAT WAS GOING ON. I STOOD LISTENING TO THE SULTRY GROANS. AFTER A LOT OF WORK AND MONEY, IT WAS TERRIFIC TO SEE AND HEAR THE PLACE COME ALIVE!

NOW I'M PRESIDENT AGAIN -- OF A CLUB!

Just out of high school, Age 18, in San Jose, Ca

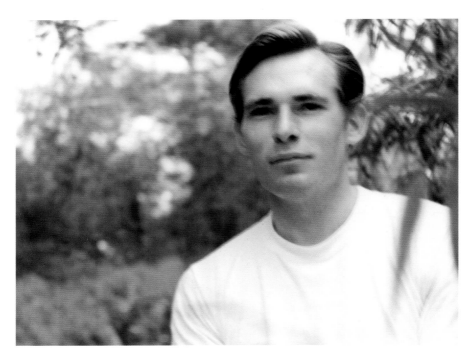

Fred as a young man, before the production of *L. A. Plays Itself*. Photo by Tom Harvey.

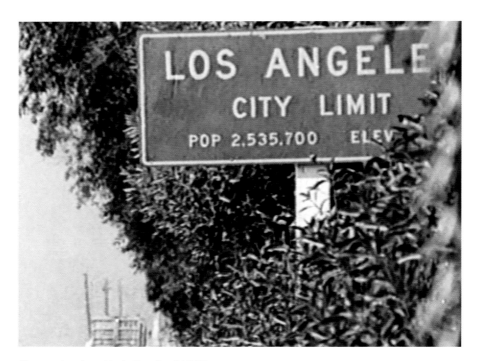

The opening shot of *L. A. Plays Itself* (1972)

BETWEEN SCANDAL AND OBLIVION

City Limits

Born in Long Beach in 1941 and raised all over the state of California, Fred Halsted rarely left his adopted city of Los Angeles. Capturing the city as few other films could, *L. A. Plays Itself* (1972), Halsted's first film, has come to be regarded as a classic within the genre of gay porn. It looks more like an experimental film than a porno, and in its time, it earned Halsted the kind of celebrity that simply isn't possible today. He never held a regular job; he didn't teach; he had no gallery representation; he had no agent; he didn't shoot commercials or advertising campaigns; he never had a social security number. He directed films and performed in them, published a magazine, ran a sex club, and for a while at least, he kept all of these ventures afloat.

Fred Halsted invented himself as an artist and as a persona. He was the son of a mother who did agricultural work and a father who worked in construction. Halsted studied botany in college, not filmmaking, and worked as a gardener for clients such as Joey Heatherton and Vincent Price. In 1969, when a rainy spring obliged him to take a break from gardening, and the same year that filmed sex scenes, or "loops," were first shown publicly in East Los Angeles, Fred decided to make his own "autobiographical homosexual story," the work that became *L. A. Plays Itself.*

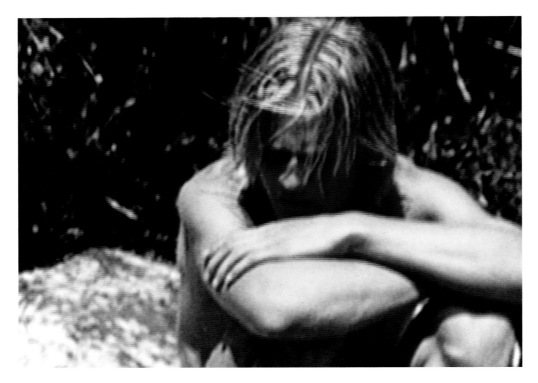

Rick Coates in *L. A. Plays Itself* (1972)

L. A. Plays Itself begins with a shot of a sign that appears at the city limits of Los Angeles. The population figure listed (2,535,700) recalls a distant era of the city's growth. The scene changes to the mists of the canyons beyond Malibu, unlikely oases at the edge of the metropolitan area. In voice over, we hear a fragment of conversation between Halsted and a man with an accent that identifies him as a former resident of an East Coast city. This man utters the words "Los Angeles stinks," and Fred, coming to the city's defense in his own languid way, makes the stock complaint that the place is filling up with New Yorkers. As the dialogue fades, replaced by Japanese koto music, resplendent nature shots take over the visuals. A lone hiker (Jim Frost) pauses when he sees a naked blond (Rick Coates)—identified as "Elf in Stream" in the film's press release—who offers to give him head. Their sexual encounter is interrupted by shots of approaching bulldozers, reminders of the real estate development that makes the local economy grow and ruins sylvan sexual retreats.

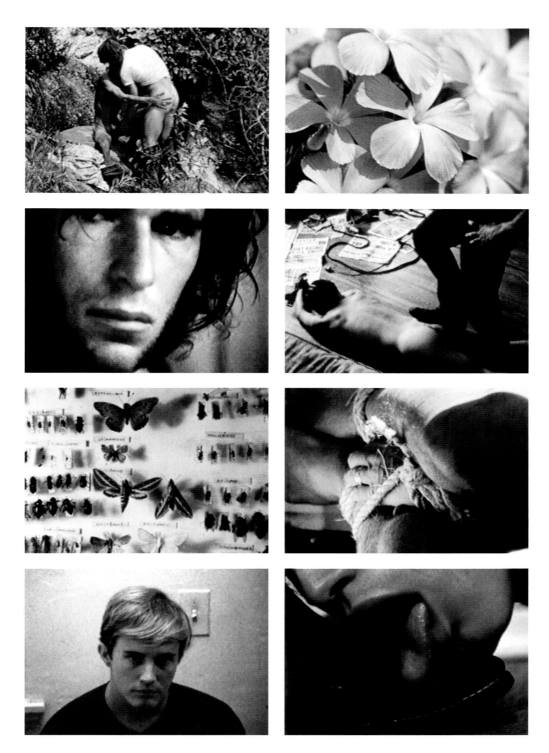

Stills from *L. A. Plays Itself* (1972)

The second half of *L. A. Plays Itself* shows something much darker: an older man torturing and violating a young innocent. The sequence is most commonly understood as a dramatization of how Fred Halsted's affair with lover and co-star Joseph Yale began, though it is not as straightforward as it would seem. Voice over dialogue introduces the youth as a cowboy hustler newly arrived from Texas. He is eager to "fuck around" with the soft-spoken Halsted, whom we hear and see in the picture. Halsted offers to show him the ropes, and these turn out to be quite literal. The youth gets bound, beaten and kicked, and at the climax of the movie, fist fucked. In the scene it is clear that Halsted shot additional material with a stand-in for Joseph Yale. Likewise, the voice on the soundtrack was not Yale's either, but belonged to a tongue-tied young hick, or else a brilliantly convincing but uncredited actor.

The echoing conversation between Halsted and the cowboy comes from no place in particular. It does not appear to emanate from the space of the visuals; rather it comments upon them. The action between Halsted and Yale does not play out as one continuous scene. It is punctuated by other sequences: Fred cruising Hollywood in his red Ranchero and hippies gathering at Griffith Park "love-ins." Unidentified men make appearances as surreptitiously filmed baskets and asses, and many wear dirty pants with worn denim at the crotches accentuating what aficionados would call their meat. The diverse images and non-synchronous soundtrack suggest that we are seeing not only a scene between two men whom some spectators know were lovers in real life, but also an archetypal story played out against the background of early 1970s Hollywood. *L. A. Plays Itself* does not provide the expected stereotype of film glamour and movie stars, but rather a glimpse of life on the street, Hollywood as slum. The effect is riveting and disturbing, and only becomes more so with passing years.

At the time of *L. A. Plays Itself*'s release, Halsted expressed concern about real estate development destroying the wild areas of the Santa Monica Mountains. It is ironic that there is still a significant wilderness in the canyons that Halsted thought would be destroyed; what vanished utterly was the Hollywood street life that Halsted extensively filmed and may have thought would last forever. Hustlers no longer ply their trade near the YMCA along Selma Avenue, but in the 1960s, the street's name conjured up images of young

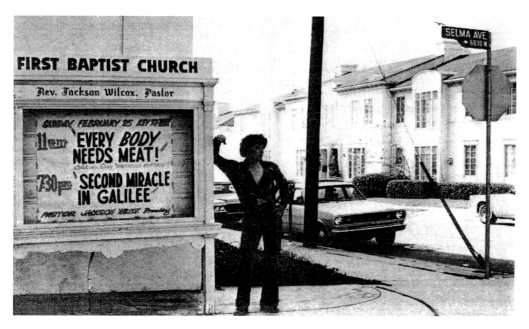

A working boy leaning against Pastor Wilcox's church on Selma Avenue. Photo by Robert Opel.

men turning tricks. The neighborhood had long been associated with vice. In the early 20th Century, Hollywood's developers attempted to improve the tone of the area by giving free land to churches. Congregations became resigned to the presence of "undesirables" who did not leave until the hustler strip moved to Santa Monica Boulevard in the late 1970s. Halsted acknowledged the coexistence of these elements in *L. A. Plays Itself*, which shows the white front steps of the First Baptist Church of Hollywood as a resting place for working boys.

Jacques Demy's only Hollywood film, *Model Shop*, is a predecessor of *L. A. Plays Itself* in that it also represented Selma Avenue. It was released in April 1969, around the time Halsted made the decision to begin his film. *Model Shop* follows the rather vacant, muscle-bound George Matthews (Gary Lockwood) across Los Angeles in his search for $100 to make a payment on his green MG. George gets distracted by a beautiful woman in a convertible (Anouk Aimée) who drives to her home above the Sunset Strip and then to the place where she works. There George pays $12 for the privilege of taking pictures of this woman called "Lola" for fifteen minutes. It is as though George enters another world when he crosses the threshold of the model shop; what transpires has a logic all

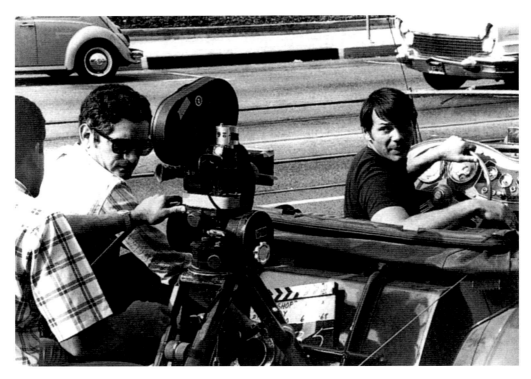

Jacques Demy directing Gary Lockwood in *Model Shop* (1969)

its own. A receptionist returns George's (and the spectator's) attention to the outside world by mentioning Selma Avenue as the place where customers must take their exposed film for processing. At the laboratory, George hands his film to a man in a frilly shirt who says he likes it when they're pretty, though it's not certain whether he means the girls from the model shop or his customer, who wears jeans so tight that he can barely find room for his money. The $12 George has spent on his pictures prevents him from making the car payment in full. The film's dialogue does not explicitly acknowledge it, but with his looks, George could easily have made up the difference with fifteen minutes of illicit work. Three years later, *L. A. Plays Itself* provided a glimpse of what *Model Shop* could not show, what Gary Lockwood's character would have encountered had he gotten out of his car and taken a stroll along the meat rack on Selma Avenue.

Fred Halsted knew that he had made an unprecedented film, and he wanted *L. A. Plays Itself* to have the maximum impact. He asked publicist Stuart Byron to arrange the film's New York premiere. Byron held preview screenings in

Fred Halsted cruising Hollywood in *L. A. Plays Itself* (1972)

March 1972. The first audience's reaction was volcanic. In an interview with the San Francisco publication *Kalendar*, Halsted described the scene.

> Nothing could throw me after my first screenings of these films. In New York City, I invited all the gay liberationists, writers and other artists. I thought, "Jesus, here I've made this great gay liberation film, *L. A. Plays Itself*. They can't help but love it." I was there and I was happy and then the curtain went down and they started to boo and hiss and stomp their feet. I thought, "My god, is this a gay, liberated audience?" I had to go up and talk to them, to the *crème de la crème* of New York gay lib writers and poets and jack offs, had to explain what I had just done on screen.
>
> They said, "What are you doing all this shit for?"
>
> "What do you mean?" I said. "That's the way I ball. I'm just another faggot and that's just another sex scene. Why make such a big deal out of it? You know all about it." It was a hostile audience, which surprised me, but I

disarmed them in ten minutes. "Where are all the fist fucking faggots around town?" I asked. "I know this stuff goes on and we all go to it and we all go to these places, so why are you acting as if your virginity has been lost or something?" I guess they expected love and kisses and beautiful flowers, which they got, too, but I think they expected me to give them a poem to sexual virginity.

A more sedate second preview screening was attended by cultural figures from whom Byron collected quotes for publicity purposes. The audience included curator Henry Geldzahler, art critic Gregory Battcock, and Salvador Dalí. Dalí had some years earlier assaulted Joseph Cornell after a screening. Dalí maintained that Cornell had stolen the idea for *Rose Hobart* from him, though there is no evidence that this idea ever manifested itself outside Dalí's imagination. He apparently found no reason to mount a similar attack on Fred Halsted; the septuagenarian *enfant terrible* was heard at the screening repeatedly muttering "new information for me." Two weeks later this phrase featured prominently in print advertisements for *L. A. Plays Itself*, as did the word "homosexual"—instead of the customary and euphemistic description "all male"—a first for *The New York Times*. Stuart Byron worked for Halsted with a sense of mission, garnering the film widespread attention and helping to usher in the mainstream media's brief embrace of "porno chic."

The success of *L. A. Plays Itself* also had consequences that Halsted likely never knew. Chantal Akerman once worked in the ticket booth of New York's 55th Street Playhouse, which during the early 1970s devoted itself to gay porn. Akerman's coworker, a statuesque drag queen who called everyone regardless of sex or station in life "Miss Thing," taught her the useful skill of stealing from the box office. During her tenure as ticket girl, Akerman managed to skim $4000 from the receipts. At that time, the sum was enough to fund the short *La Chambre* and *Hotel Monterey*, her first long film. *L. A. Plays Itself* was the movie playing during the entire period of her lucrative job. Fred Halsted thus helped Akerman at a formative stage of her career, and if Halsted's account of his relationship with the film's distributor is true, Akerman made more money from the premiere engagement of *L. A. Plays Itself* than he did. This story appears in

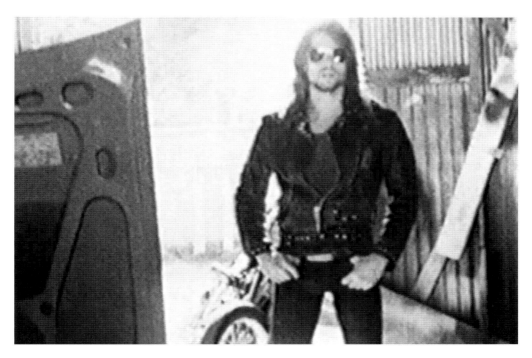

Clarence Tweed in *Sex Garage* (1972)

Chantal Akerman: Autoportrait en cinéaste, though in the published version, she doesn't mention her absent and unwitting benefactor's name.

Before the theatrical release of *L. A. Plays Itself*, Halsted made a short film to accompany it, *Sex Garage*. As in *L. A. Plays Itself*, there is a seriousness of intent in *Sex Garage*, which is as direct and erotic as its title suggests. Most of the film was indeed shot in a garage in the Hollywood Hills in a mere six hours. *Sex Garage* defied genre conventions—as embryonic as they were in the gay porn of 1972—but did so in ways different from *L. A. Plays Itself*. *Sex Garage*, at a running time of 35 minutes and in black and white, begins with an image of a bespectacled woman (Sonia Boyd) as she drives her Mazda to the garage of the title. There she performs fellatio on her longhaired boyfriend (Bob Madison) who is the garage's mechanic, and who later finds another kind of action. The press release for *Sex Garage* refers to it as "the first trisexual porno film." The straight sex between hippie kids, often shown in macroscopic detail, casually introduces bisexuality into a gay porn film long before the bisexual genre became fashionable in the late 1980s.

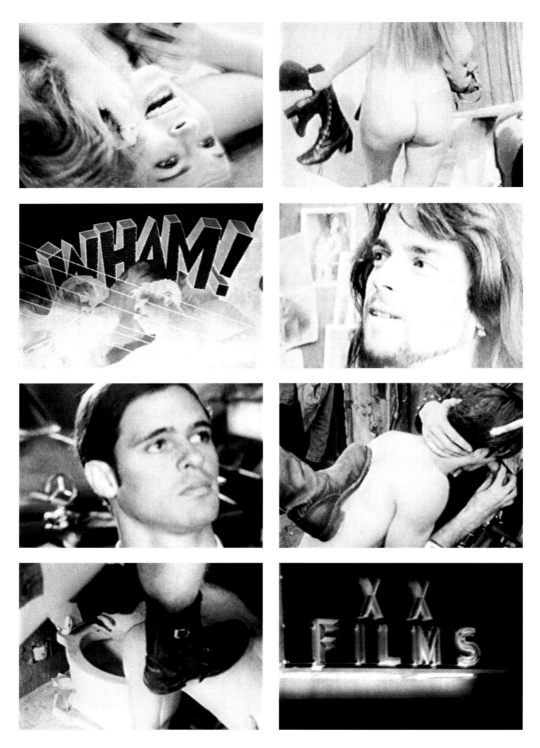

Stills from *Sex Garage* (1972)

The first part of *Sex Garage*, like the complex sequences of *L. A. Plays Itself*, alternates between distinct spaces with different musical themes: a garage with the soul song "When Tomorrow Comes" by The Emotions, and a marble shower with "Jesu, Joy of a Man's Desiring" as transcribed for piano by Dame Myra Hess. The camera lingers over a hundred-dollar bill, a note from a stockbroker to his boyfriend asking him to "take the car in and grease it up," and the body of the broker's kept boy (Gus Harvey) in the shower. This young man masturbates, dresses, and drives to the garage in his Mercedes. He arrives just as the mechanic's girlfriend reaches her climax. The arrival of a customer frightens the woman. She flees, carrying her calf-length boots with her, and leaves the men to their own devices. The kept boy quickly begins worshipping the blonde hippie mechanic to the sound of Bach, and as he gives him head, a biker (Clarence Tweed) rides his motorcycle to the garage. Vertiginous views of pavement rushing under the biker's boots and details of the motorcycle's body, accompanied by the shrieks of an analog synthesizer, create an unsettling dramatic tension. Upon the arrival of the biker, who wears long hair, a beard, a leather jacket, and under his jeans, a jockstrap that looks as though it has never been washed, the sex becomes much more intense. The kept boy, who has been forced to wear the woman's cast off panties, gets fucked by the biker and gets his head thrust into a toilet by the mechanic. The action is represented in a disjunctive montage with frequent superimpositions of engines and equipment. A barrage of synthesized noises overtakes the soundtrack. The camera work (by Halsted himself) is frenetic and shaky. Women in antique cheesecake photos seem to bear witness to the scene, which culminates in the biker penetrating an exhaust pipe. The biker ejaculates on his motorcycle seat, "Jesu, Joy of a Man's Desiring" returns to the soundtrack, and the men leave the garage. The last shot, a distant view of traffic on the Hollywood Freeway, suggests a city of frustrated drivers all looking for their own sex garages.

With its images of billboards along the Sunset Strip and characters revealed through (and on top of) their vehicles, *Sex Garage* was a Los Angeles car culture film that could not be shown in the city where it was made. Police Chief Edward Davis threatened to prosecute producers and exhibitors of early gay movies in Los Angeles as part of his constant, unpopular, and ultimately risible campaign of

persecution aimed at gay men. Davis' regime did not exert power beyond the city limits, so Halsted exhibited his films in the unincorporated area of Los Angeles County that would later become the independent city of West Hollywood.

Edward Davis' famous last gesture of contempt towards Los Angeles' gay community was the raid on the Mark IV Baths. A slave auction sponsored by the leather magazine *Drummer* became the focus of Operation Emancipation, which involved the surveillance and subsequent arrest of 40 people—including Halsted and Yale, performer Val Martin, *Drummer* publisher John Embry and editor Jeanne Barney—who were charged with violating California's 19th Century anti-slavery law. Davis' LAPD spent hundreds of thousands of dollars and deployed over 100 officers for the operation. By the time the cases came to trial, the district attorney was at a loss as to how to proceed, and the city council demanded to know why the police had gone to such lengths to deal with the "threat" of Los Angeles' leather community congregating for a charity benefit at a bathhouse. Operation Emancipation attracted so much negative publicity that it effectively ended Davis' hopes for a Republican gubernatorial nomination, though he continued to enjoy support in the "cop land" of the Santa Clarita Valley, an area he later represented as State Senator. Halsted, like many gay men of the time, had been arrested for lewd conduct on more than one occasion, but he was badly shaken by this experience of police harassment, and was especially disturbed that Joey Yale was the very last of the suspects to be released from police custody.

Fred Halsted was in the public eye consistently for several years, first with *L. A. Plays Itself* and *Sex Garage*, and then with *Erotikus: A History of the Gay Movie* (1974). This compilation, directed by Tom De Simone, a. k. a. Lancer Brooks, was a showcase for Halsted and his films. As the *Erotikus* press release stated, "the naked narrator, Fred Halsted... guides the viewer through decades of all male erotica." Halsted speaks from a director's chair, at first fully clothed, then later in the nude. At the end of the film, he masturbates and reaches a climax during a montage of cum shots set to the theme of Ravel's *Bolero*. De Simone was not satisfied with Fred's performance in this capacity, so he used a double with a larger endowment and more impressive ejaculation. Presumably this was De Simone's excuse for paying Halsted less than his promised fee, to Halsted's enduring resentment. For its historical survey of gay porn, *Erotikus*

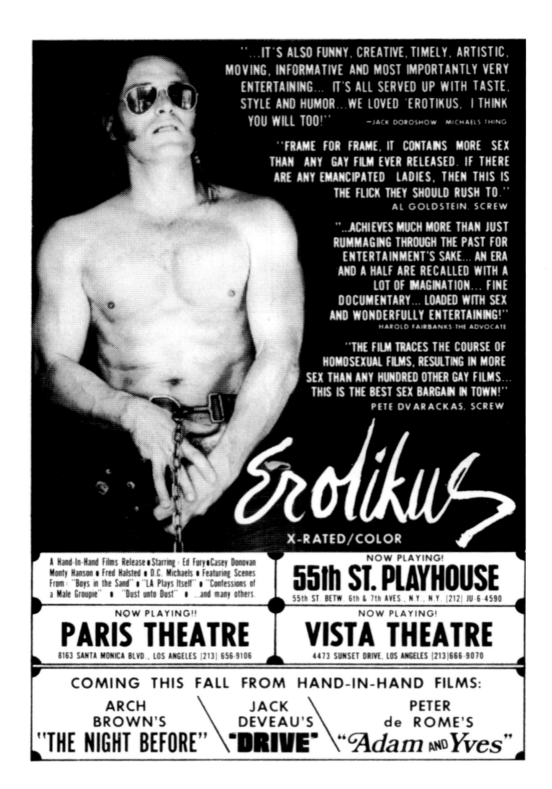

35

DRUMMER GOES TO A SLAVE AUCTION

The whole thing started out innocently enough, if a slave auction can be called innocent. The Leather Fraternity had promised its members such a function as its first get-together. It was to be an occasion to meet other members and to show the Bike Clubs and Leather Community that we really existed. Two things were important. First, it should be private, not open to the "tourists," the non-leather people. No gigglers, no voyeurs, no strangers and no tickets sold at the door. And net profits from the sale of tickets, after paying for the hall and expenses, were earmarked for such charities as the Gay Community Services Center, which was having trouble staying open.

February 14, being Valentine's Day, was chosen for obvious reasons. However, other than a few telephone conversations, nothing was done because it wasn't possible to be ready in time.

Actor Val Martin, our star auctioneer, planned to be out of town that month, so we decided on the second weekend in April. Having such an event without Val was unthinkable. The only other likely candidate was Fred Halsted, who was busy with his own *Package*. Finally, in March, a letter was sent to Fraternity members, inviting them to the "Slave Auction Benefit" on Saturday, April 10.

Volunteers came by to be auditioned for their "slavery" roles. There were eager young faces looking for someone to serve, even for a weekend. The rules were carefully explained: monies raised from their "sale" were to go to the charity of the buyer's choice. There was no stipulation as to which organization would benefit. In fact, if the slave had a favorite charity, he could discuss it with his new Master. The only stipulation was that it be a GAY charity—none of this "Toys for Tots" shit that the Uncle Toms of the Leather crowd seem to be so fond of. Should the slave feel that his buyer was not to his liking, the buyer would be told privately that it was no deal, his check would be returned if he wished but thank you, anyway. We weren't out to hurt anyone's feelings, on either side.

The way tickets were selling, it was beginning to look as though we should have chosen a place larger than the Mark IV Health Club. However, we decided that anything more than 200 people would make it less than private and more of a circus. So the Mark IV it was, a little more air-conditioned and

carpeted and muzaked than necessary, but they had a barred, mirrored "cell" to hold the "slaves." Overall it was a lot more plush and a lot less public than the settings of similar auctions in Long Beach and San Diego.

H.E.L.P., Inc., the oldest legal aid organization in Southern California, obtained a one-day beer license. The Emporium was strong-armed into lending props of leather and metal to drape around. The Mark IV had a newly constructed set of stocks in the background, which were never used, but proved themselves to be very photogenic.

By nine o'clock that Saturday night, the affair was underway. Although things got off to a slow start, there was excitement stirring in quarters that had spent a fortune in money and manpower and whose efforts would make this an auction to remember.

But let's go back in time, back to before the affair was even planned. A bug was placed on DRUMMER's telephone lines shortly after we ran an article entitled "The Triumph of the Black Pipe," a final rundown of a police attack on the Leather segment of the gay community three years earlier. The article was, to put it mildly, critical of the largest raid on gay people to that date. It told of the fruitless (oops) waste of money, the lack of convictions as well as the hang-ups and the incompetence of the LAPD. In Los Angeles, it is dangerous to run such an article. And this one was read in high places.

What has all this to do with a Slave Auction? We are merely setting the stage for the highly choreographed production that was to follow. After tapping DRUMMER's telephones, long before any printed notice of the auction/benefit, the police began surveillance of: (a) DRUMMER's offices, (b) the plant where DRUMMER and other gay religious and organization publications are printed, and (c) the homes of

(Continued on page 14)

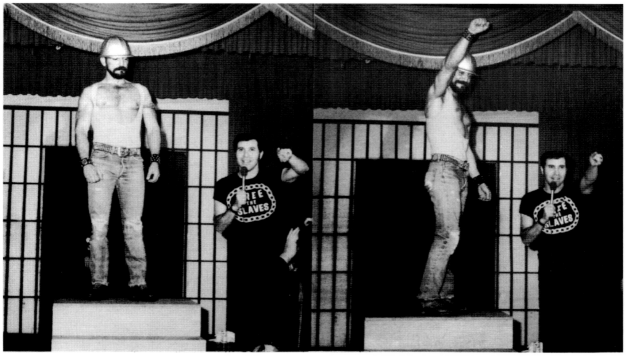

VAL MARTIN, auctioneer at the LEATHER FRATERNITY auction is himself auctioned off at the fund raiser FREE THE SLAVES auction by filmmaker PAT ROCCO. Someone needed a master since VAL was sold for $250. His defiant salute to the audience at the close of bidding is typically our VAL. He was one of the four defendants the L.A.D.A. chose to charge. The L.A. City Attorney refused to press charges.

Headline on a par with "Dewey Defeats Truman" was bannered on the ultra-conservative Orange County REGISTER. Its equally inaccurate news coverage was never followed up as the REGISTER lost interest when the case took another turn. Surprisingly, the Northern California ADVOCATE was even more inaccurate, loading its columns with attacks on Southern California Gay leaders and the Leather Community.

Los Angeles Police Chief EDWARD M. DAVIS has taken on the Mayor, City Council, State Legislature, Governor, Federal Government, L.A. Times, Women's Liberation, Blacks, Chicanos, Flaming Youth, but most of his vitriol is spent on the Gays, which he has termed "lepers". The Chief's use of something between $100,000 and $200,000 in city funds to launch his attack on the Slave Auction Benefit might have an effect on his upcoming usually sacrosanct Police Budget. However, in Los Angeles, EDWARD M. DAVIS is seldom challenged at all, by anybody.

Comic book image in *L. A. Plays Itself* (1972)

Manson family headline in *L. A. Plays Itself* (1972)

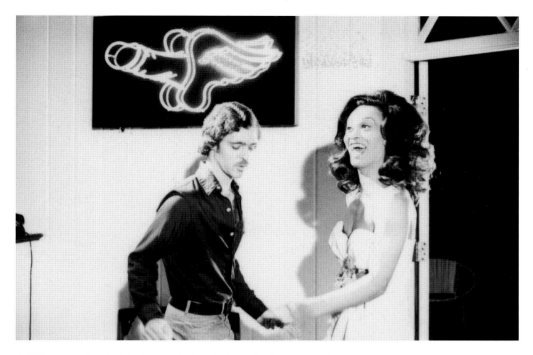

Jeff (Gus Harvey) and Gloria (Charmaine Lee Anderson) in *Sextool* (1975)

Anderson pranced and danced herself into celebrity—she was Empress of Hawaii in the Court of Many Rivers of Louis XIV, an American drag ball association—though only Halsted saw fit to put her in a movie.

Fred Halsted's interest in androgyny was an unlikely and rarely examined aspect of his work. In a number of his interviews, he expressed admiration for the gender benders of glam rock, whom he considered to be in the advance guard of a sexual revolution, and for those icons of pre-clone gay culture, bearded drag queens like Gloria Hole of the Cycle Sluts. Gloria Hole appears on the cover of the first Halloween issue of *Drummer*, edited by Jeanne Barney, one of Fred's best friends and surely the only woman who attended every leather event in Los Angeles in the mid-1970s. This issue, which met with some disapproval from the magazine's readership, was one of the last before Barney left her position at *Drummer*, and before the codes of masculinity to which urban leather men adhered became serious dogma. Unlike many later participants in that subculture, Barney and Halsted had a sense of humor about "butching it up."

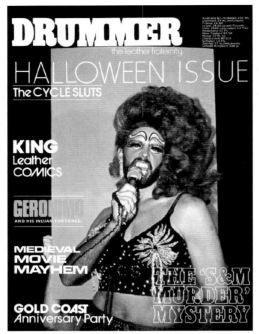

The Halloween issue of *Drummer* and its editor, Jeanne Barney, showing the magazine to Gloria Hole of the Cycle Sluts

Gus Harvey appeared (without dialogue) as the kept boy in *Sex Garage*; in *Sextool*, his character Jeff undergoes an abrupt transformation from a sexually ambivalent date for Gloria (whose gender he may or may not be willing to acknowledge) to a gay clone looking for love from a one-night stand. At *Sextool*'s party, one drag queen asks another about the curious couple of Jeff and Gloria: "Do you think he knows?" Her friend responds, "About her or himself? They're both ladies!"

The bitchy drag queen repartee provides some comic relief in what may be the most relentless and explicit sex film ever made for general release. Unlike Pasolini's more symbolic *Salò* (released posthumously during the same year) there are no chocolate turds or foam rubber penises in *Sextool*. All manner of scenes of domination and submission take place without simulation. Early in the film, a sailor (Tim Rhodes) has his uniform ripped off and receives the brutal attentions of several partners. The soundtrack of dirty talk mixed with a crescendo of synthesized noise seems to anticipate the industrial music of Nurse With Wound. Through the wire mesh of a steel bunk bed frame, the

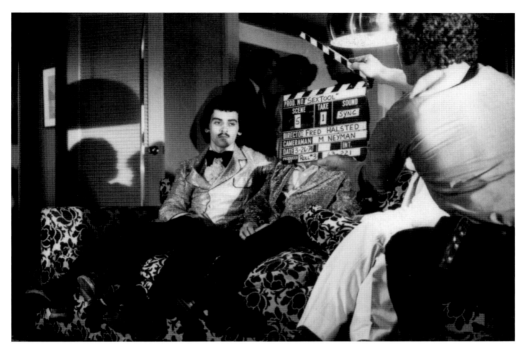

On the set of *Sextool* (1975)

Fred Halsted and Joey Yale during the production of *Sextool* (1975)

Page 44–47: The sailor rape scene from *Sextool* (1975)

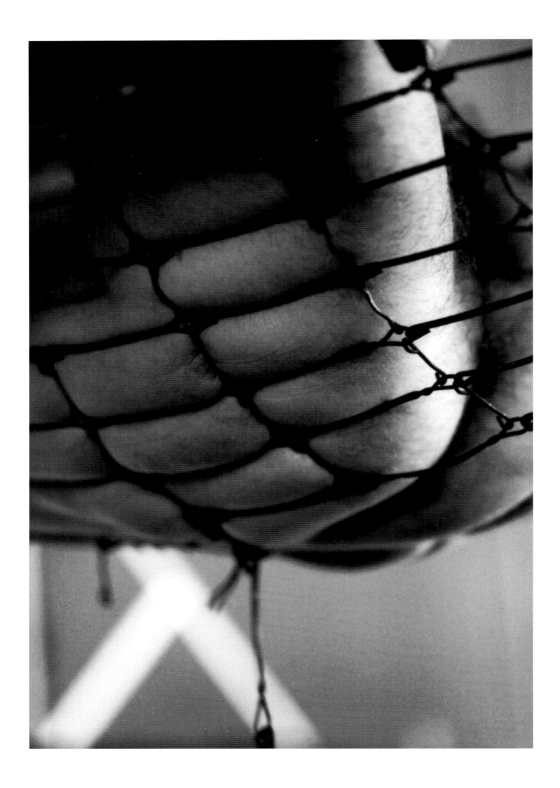

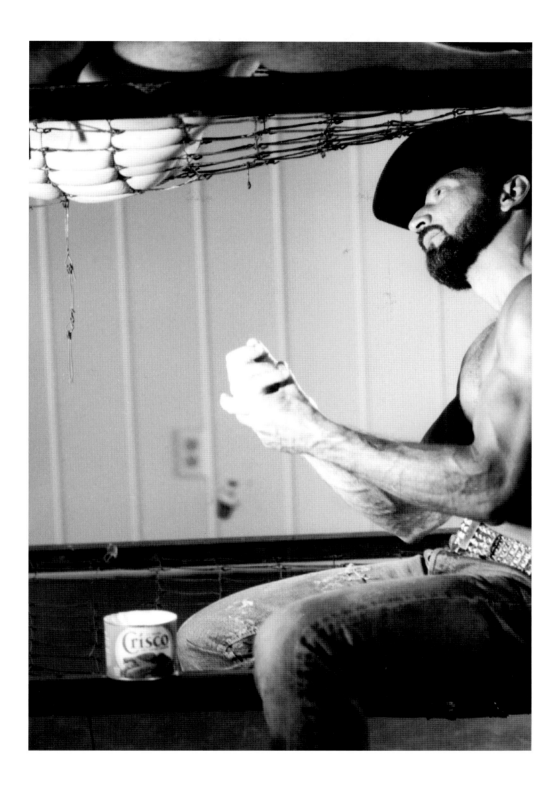

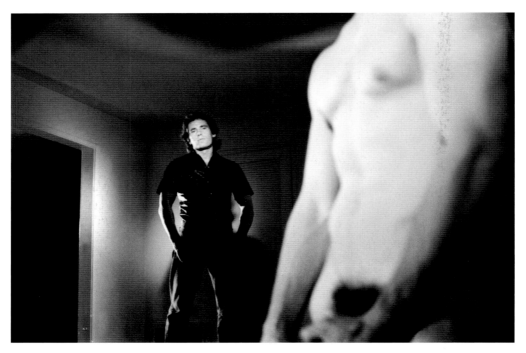

Fred Halsted on the set of *Sextool* (1975)

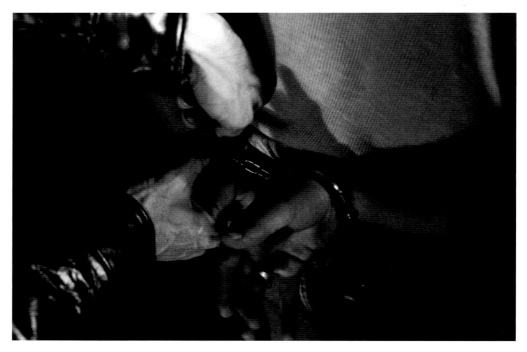

Handcuffing a suspect in *Sextool* (1975)

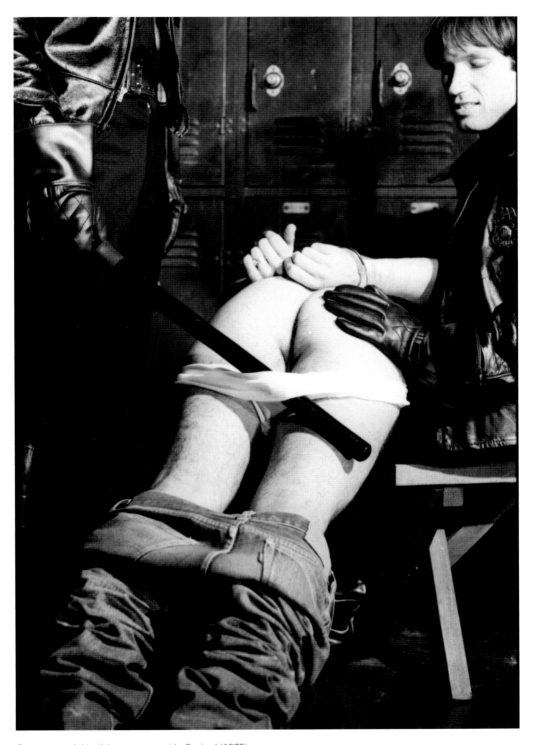

Cops use a night stick on a suspect in *Sextool* (1975)

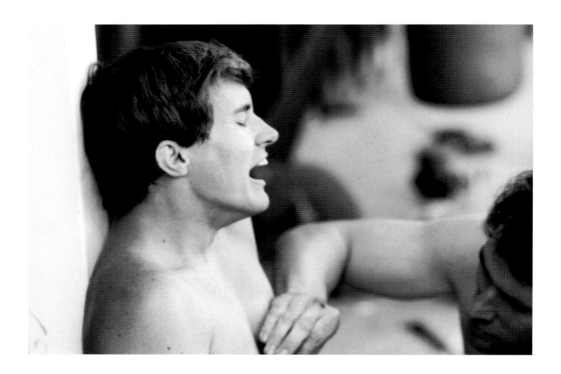

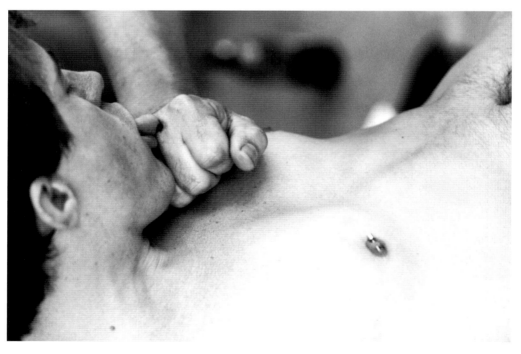

Pages 50-52: Joey Yale and Fred Halsted in the boxer scene from *Sextool* (1975)

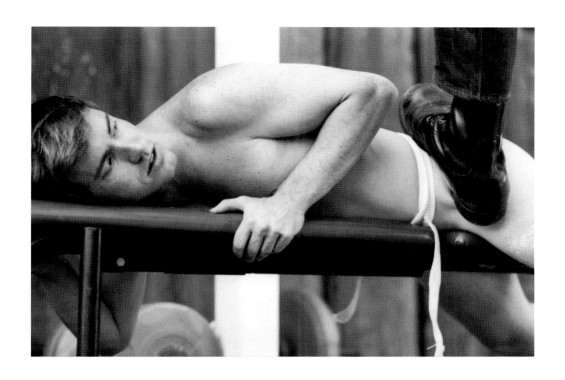

51

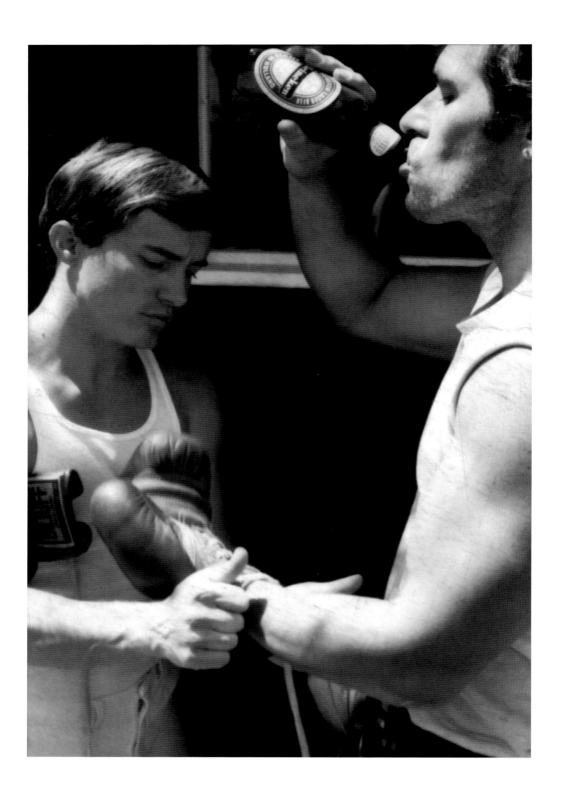

sailor takes a fist from leather man Val Martin. Later, two uniformed cops rough up a young man to the accompaniment of a police radio, and then penetrate him with a night stick. Fred Halsted and Joey Yale appear as a boxer and his trainer/slave in a scene that is undermined before it begins. Gloria remarks about Fred, "He thinks he's a boxer, but his idea of a workout is a bottle of beer in one hand and wearing a pair of gloves." During the sex, Fred is impatient and unpredictable in his violence. Joey willingly licks Fred's blood and drinks his piss, but Fred's performance has a carelessness and anger that the film cannot quite explain away.

Sextool, more fragmentary than its predecessors, has a wealth of interesting passages that do not quite form a coherent whole. Their links are mainly in the dialogue, often as not delivered in voice over by Charmaine Lee Anderson. Some sequences of *Sextool* look as though George Kuchar shot them, while others look like a documentary about rough sex between men. The latter sequences are characterized by long takes and constant camera movement, in a style that served Christopher Rage well when he directed videos in the early 1980s. Halsted shot as though he was using video, yet he made *Sextool* in 35mm. The choice was disastrous for him. The expense of 35mm film caused Halsted to avoid shooting much transitional material, and in the editing, he constructed a film that was by necessity schematic. Halsted hoped that the format change would allow the film to be shown at art houses, few of which had 16mm projectors. Mainstream theater managers balked at *Sextool*, which was even more aggressive in its sexuality and aesthetics than *L. A. Plays Itself*. An alternative strategy would normally have been to show the film on the porno circuit, but since only a handful of gay porn theaters were equipped with 35mm projectors, *Sextool* was left with minimal theatrical distribution.

In light of subsequent developments in cinema and changes in the political climate, it is difficult to understand how Fred Halsted could have considered *Sextool* a commercial art house attraction. Halsted maintained that he was simply representing the milieu to which he belonged; he did not understand the resistance of supposedly sophisticated audiences. He had no time for squares and barely acknowledged their existence. As far as he was

The drunken sailor in *Sextool* (1975)

concerned, everyone was a pervert. It was a hypothesis difficult to disprove. In one of his characteristic flights of fancy, Halsted went as far as predicting that U.S. government grants would soon be given to sex films. (How many *Sextools* would the federal expenditures on the Iraq War have funded?) His cockeyed optimism made him an easy target for his detractors, but no one could accuse Halsted of being a coward.

Whereas the fisting scene of *L. A. Plays Itself* occurs only at the film's end, scenes of extreme sexual activity occur throughout *Sextool*. This posed problems for Halsted not only with puzzled or offended theater managers, but also with video distributors. When VCA prepared *L. A. Plays Itself* for its release on VHS in the mid-1980s, the company simply removed the ending, since by that time, its content was too risky to include in an adult video for wide distribution. No such bowdlerized version was possible for *Sextool*. Acts now considered likely to attract the attention of law enforcement authorities (e. g., water sports, fisting, and anal penetration by objects, like an LAPD nightstick, that are not expressly manufactured as sex toys) occur in almost

every scene in the film. Though Fred and Joey's own company sold a limited number of super-8 and video copies of *Sextool* by mail order, the film never received a general release in either of these formats, and consequently it languishes in an undeserved obscurity.

In 1974, the Museum of Modern Art invited Halsted to present his work in a screening series with the wonderfully appropriate name of Cineprobe. The event, attended by a capacity audience (reputedly including Groucho Marx), allowed Halsted to display his considerable charm. Dressed for the occasion in an uncharacteristically formal suit, he took questions from the audience, and though it was rather animated, the discussion was civil. Outside the venue, a political group passed out a flyer that characterized *L. A. Plays Itself* in negative terms.

> It is an exploitation film, made by a self-described petty criminal and hustler, for audiences unfamiliar with sadomasochistic sex. It is designed to reinforce fears about S&M prevailing amongst straights and gays alike. Its contempt for homosexuals appeals to straight-identified gays and serves to expiate their self-loathing. The Museum of Modern Art, never known for its love for either gays or sadomasochists, has applied the pretentious label of "Art" to those expressions of anti-homosexuality which coincide with the self-contempt of its closeted gays.

The main objection raised by the protesters was a variation on the warning, "don't try this at home": *L. A. Plays Itself*'s fisting scene did not show the proper way to do it. Halsted had not faked the penetration shown in close up, but the wider shots in the scene were clearly simulations performed with more brutality than most recipients of a fist could bear. If Halsted intended to anger potential allies with his representations of gay sex, he certainly succeeded, and the protests gave rise only to mutual incomprehension. There was too great a difference of culture and education between Halsted and his opponents. Though Halsted supported gay liberation in his way, and by anyone's standards did more than engage in empty talk, he was unschooled in and indifferent to the proper vocabulary of gay politics. His casual use of the word "faggot" to

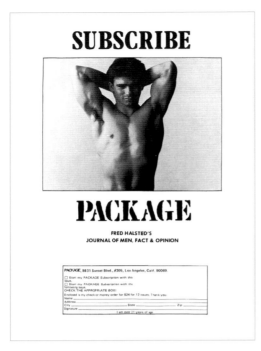
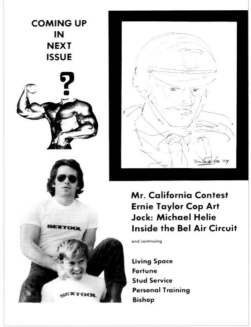

From Fred Halsted's magazine *Package* (1976–77)

describe himself and others appalled the faint of heart. Halsted also had no patience for liberationists' pious, humanistic notions of art. Again from the pamphlet: "There are many of us in the gay community who believe that Art should transcend bigotry and ignorance, and speak to our humanity, not our contempt."

Whatever the difficulties Halsted transcended during his public appearances in New York, they had one unambiguously important result. After the Cineprobe screening, the Museum of Modern Art acquired prints of *L. A. Plays Itself*, *Sex Garage* and *Sextool*. This lent a distinction to Halsted's work that neither he nor his distributors ever forgot. Unique among gay porn videos, the box cover of *L. A. Plays Itself* and *Sex Garage* bore the words "Part of the permanent film collection of the Museum of Modern Art." (Whether this tag line had a beneficial effect on sales remains unknown.) Other early gay films—considered pornography simply by virtue of their subject matter, therefore outside the purview of most institutions—have been lost, or at best survive as faded magenta shadows of their former selves; but Halsted's first

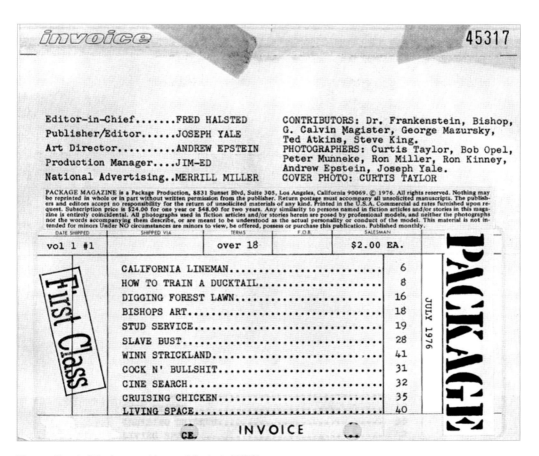

invoice 45317

Editor-in-Chief.......FRED HALSTED
Publisher/Editor......JOSEPH YALE
Art Director.........ANDREW EPSTEIN
Production Manager....JIM-ED
National Advertising..MERRILL MILLER

CONTRIBUTORS: Dr. Frankenstein, Bishop, G. Calvin Magister, George Mazursky, Ted Atkins, Steve King.
PHOTOGRAPHERS: Curtis Taylor, Bob Opel, Peter Munneke, Ron Miller, Ron Kinney, Andrew Epstein, Joseph Yale.
COVER PHOTO: CURTIS TAYLOR

PACKAGE MAGAZINE is a Package Production, 8831 Sunset Blvd, Suite 305, Los Angeles, California 90069. © 1976. All rights reserved. Nothing may be reprinted in whole or in part without written permission from the publisher. Return postage must accompany all unsolicited manuscripts. The publishers and editors accept no responsibility for the return of unsolicited materials of any kind. Printed in the U.S.A. Commercial ad rates furnished upon request. Subscription price is $24.00 for one year or $48.00 for two years. Any similarity to persons named in fiction articles and/or stories in this magazine is entirely coincidental. All photographs used in fiction articles and/or stories herein are posed by professional models, and neither the photographs nor the words accompanying them describe, or are meant to be understood as the actual personality or conduct of the model. This material is not intended for minors Under NO circumstances are minors to view, be offered, possess or purchase this publication. Published monthly.

DATE SHIPPED	SHIPPED VIA	TERMS	F.O.B.	SALESMAN
vol 1 #1		over 18		$2.00 EA.

CALIFORNIA LINEMAN............................ 6
HOW TO TRAIN A DUCKTAIL...................... 8
DIGGING FOREST LAWN.......................... 16
BISHOPS ART.................................. 18
STUD SERVICE................................. 19
SLAVE BUST................................... 28
WINN STRICKLAND.............................. 41
COCK N' BULLSHIT............................. 31
CINE SEARCH.................................. 32
CRUISING CHICKEN............................. 35
LIVING SPACE................................. 40

First Class

PACKAGE

JULY 1976

INVOICE

The masthead of the inaugural issue of *Package* (1976)

three films have been preserved and are potentially available for exhibition to a new generation of spectators.

Fred Halsted had become a celebrated film artist, but he still had to cope with the commercial failure of *Sextool*. He cast about for something to do and settled on writing and publishing. He contributed to *Drummer*, and founded his own magazine, *Package*, which lasted for six issues. *Drummer* and *Package* provided forums for Halsted's opinion pieces, and more importantly, for his interesting but overlooked body of erotic writing. Halsted's stories reveled in a great range of sexual expression, including several acts—an encounter with a partner who wished to be lit on fire during sex comes to mind—outrageous even for the S/M community. Halsted often exaggerated, but the substance of his writing was at times directly autobiographical. Fred wrote one story about

a trick who turned nasty and broke his leg; around the time it was published, Fred appeared in public wearing a cast.

Halsted in his writing, as in his films, fashioned a role for himself to play. His stories are narrated in the first person by the ultimate top, a man who can fuck and dominate anyone crossing his path. In the context of fiction such an invulnerable figure engenders expectations no character can satisfy. Skeptics object that this man too can be topped. Understanding the weakness or implausibility of his persona, Halsted introduced a foil for himself, a character named Dennis, a policeman of ambiguous sexuality, a handsome stud with a fast car. He was willing to follow Fred's lead in playing out wild exhibitionistic scenes, and he used Fred's body for his own pleasure. And he may even have existed. One evening, friends expected Fred to visit them at their home in the Hollywood Hills, but he never arrived. The next day Fred explained that he had gone to their street, Nichols Canyon, but had gotten no further than the middle of the road, where he had had sex with his companion as cars sped by on either side of them. Alas, no one but Fred got a glimpse of this man whose sex appeal literally stopped traffic, nor did his friends ever learn his name. Regardless of how factual they might have been, the Dennis and Fred stories occupy familiar imaginary territory. A manifest contempt for figures of authority often concealed a not-so-latent worship of them. As Edmund White noted in his book *States of Desire* (1980), the cop fantasy pervaded the sex lives of many gay men, and its influence was peculiarly strong in the city controlled by a paramilitary, fag-baiting LAPD.

Though unable to direct a project as ambitious as *Sextool* again, Halsted was still a star. He had a major role in *El Paso Wrecking Corp.* (1977) part of Joe Gage's great trilogy of narrative gay porn films about proletarian men. With Joseph Yale, Halsted starred in a play, *News for Tennessee*, which received good reviews during its 1979 run in Los Angeles. Halsted's magnetism was apparent when Rosa von Praunheim interviewed him for his documentary on the American gay rights movement, *Army of Lovers, or Revenge of the Perverts* (1979).

Fred Halsted projected a seductive personality in his many interviews. He was given to spontaneous utterances, and he preferred to embrace rather than repress contradictions. These traits made for good copy in an era of personal and

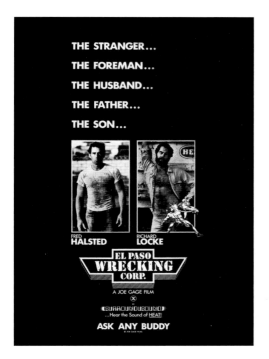
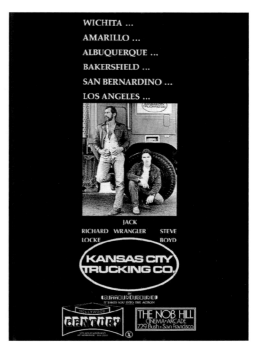

Ads for Joe Gage's *El Paso Wrecking Corp.* (1977) featuring Fred Halsted, and its predecessor, *Kansas City Trucking Co.* (1976)

sexual liberation, but they frustrated his more rigorously logical interlocutors. In an especially contentious give and take with activist Mikhail Itkin, the discussion devolved into a dispute over semantics after Halsted equated his belief in gay superiority with fascism. A friend of Fred's who read this interview offered the following opinion:

> Fred was a real con artist, feeding the innocent interviewers what they wanted to hear. Their questions fed his imagination, and, loaded with a joint or two before their arrival, he let go. I knew him as a silent, introspective person, until he had smoked pot, then he became excessively chatty, and authoritarian on just about every subject.
>
> Fred was ranting on about being a fascist, but at one point he said, "Well, okay, I'm an anarchist." He could never be just an ordinary person. It was all part of his self-made image of being controversial (not only in the films he made, but how he wanted to portray himself). I often heard him spout off about these sorts of things and simply laughed at him.

Curiously, Itkin later achieved a posthumous superiority of his own when he was canonized as Saint Mikhail of California by the Moorish Orthodox Church of America. Fred Halsted may prove to be the only gay pornographer to have been interviewed by a future saint.

Paul Alcuin Siebenand conducted an interview with Halsted for his 1975 Ph. D. dissertation, *The Beginnings of Gay Cinema in Los Angeles: The Industry and the Audience*, an oral history of gay porn in the place where it became most intensely industrialized at the moment when that process was getting underway. Fred was the most voluble of the directors interviewed, and the transcript contains one of his most bizarre "routines."

> You should have been here last weekend. My last friend was a Fundamentalist Christian. As we went through the night, I revealed his Christianity to him and as he was eating the shit out of my asshole, I told him that the words of the Lord are written right there…. And I told him, you don't say to me "yes, sir," but "yes, sir Lord." I put him through a revelation to himself.
>
> I am very religious. I am not a Christian. I told him that anytime he wants to see where the Lord is, he just has to watch my asshole…. I showed him that I feel the Lord is present at all times and everywhere. We just have to wake people up to the fact. They just don't understand. Slapping and beating them doesn't always work because that can be glamorous. I just make them eat my shit, that is my *modus operandi*…. I find such little satisfaction because I find such few people that I can break out of their egocentric shells and protectiveness, their Christianity and humanity and whatever else it is that they surround themselves with. The Lord is everywhere. It is all Him.

This episode can certainly be appreciated by anyone who has felt the urge to tell a religious fundamentalist to eat shit, but Fred's crude story also raises a question in theology. The boundary between the sacred and the profane has been contested for millennia, and the debate reached an especially fervent pitch when the Roman Catholic Church established the doctrine of the Eucharist. The Church demonized anyone who might promulgate the notion that the bread consumed during communion (then digested and excreted)

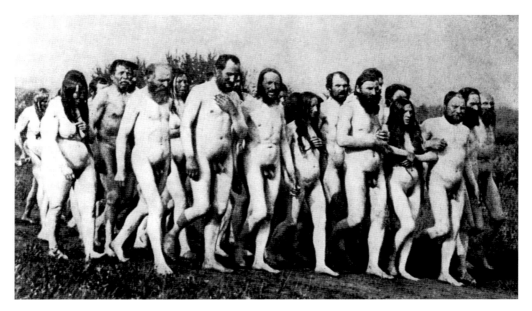

Sons of Freedom, the most radical Doukhobors, marching naked on the Canadian prairie, 1903

could be confused with the Body of Christ. Those suggesting that bits of the Son of God could somehow reside in one's bowels were called Stercoranists, or shit people. More a phantasm than an organized movement, these shit-believers were demolished with precise and extensive theological argument, rather than by the customary means of torture and execution. Thus the threat of filth was banished once and for all; that is, until the faithful began to ask questions about Jesus' body. During the Son of God's life on earth, He did possess a body, He did eat, and His words in the Gospels include references to the process of digestion. Did Jesus shit? A priest might respond, "It is best to incline one's mind towards other things." Fred Halsted, for whom the Judeo-Christian tradition was only so much background noise, got to the heart of the matter in the tactless way of an outsider.

Halsted mentioned religious beliefs in most of his interviews, but journalists rarely followed up on his comments. In all likelihood, they had no idea what he was talking about, since Halsted had a religious upbringing like few others. His mother, Lillian Halsted (née Samoyloff) belonged to the Doukhobors, or "spirit wrestlers," a sect with its origins in Russia hundreds of years ago. Though exact numbers are impossible to ascertain, there were probably no

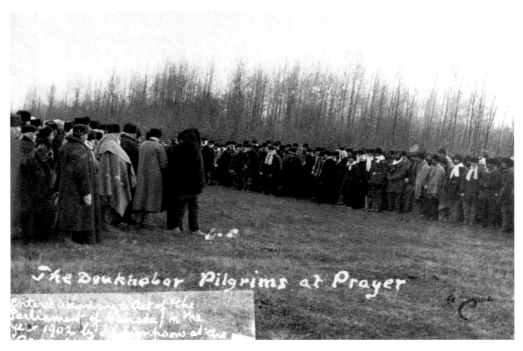

Doukhobor pilgrims at prayer, near Yorkton, Saskatchewan, 1902

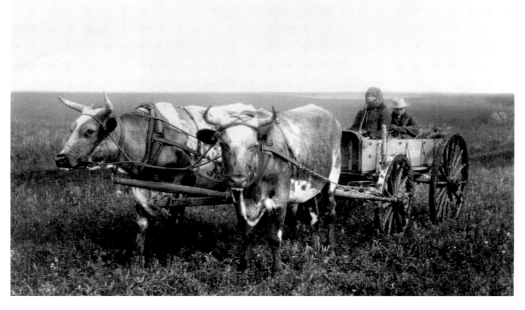

Doukhobor ox cart, Saskatchewan, early 20th Century

more than 50,000 Doukhobors in the world at any time. George Woodcock and Ivan Avakumovic, in their 1968 book *The Doukhobors*, provided the most complete account of this sect. Much of the following summary paraphrases their work.

It is easier to make a list of what the Doukhobors rejected—liturgy, icons, churches, clergy, sacraments, and written scripture—than to specify what they actually believed. They resisted putting anything into writing, including their own history, and relied entirely upon an oral tradition of psalms and hymns called the Living Book. The Doukhobors made no distinction between historical fact and mythology, and their common practice was to tell misleading lies to any (presumably hostile) outsider. The Doukhobors believed that all people had direct access to their god; therefore no mediation by priests was necessary. The Doukhobors were radical pacifists; they considered it a sin to kill any human being, even in war, since god dwelt within all. They denied the right of the state, or of any external authority, to dictate their actions. The Doukhobors saw special merit in irrational, spontaneous acts, since such acts were thought to be divinely inspired. These beliefs were anathema to a czarist government that would have had the Doukhobors exterminated for refusing to pay their taxes and declining to sacrifice their young men to the Russian army. The inefficiency of the imperial administration, as well as the intervention of prestigious figures, ensured the Doukhobors' survival. Leo Tolstoy and his friends, who mistakenly took the Doukhobors for religious anarchists, and the Quakers, who did not understand that intransigent Doukhobors would refuse formal education, funded the emigration of most of these religious dissidents to Canada at the end of the 19th Century.

Soon after their arrival in the Western Hemisphere, the Doukhobors suffered division and strife. The main body of the sect followed a prophet, whose dreams and visions determined their actions, up to and including the complete destruction of their communal farms and the pursuit of long religious pilgrimages without definite end. Independent Doukhobors refused to accept the prophet's authority, and when the command came to leave their homes on the Canadian prairies, they stayed put, established more permanent

communities, and eventually enrolled their children in public schools. For the faction called the Sons of Freedom, the prophet's commands were not radical enough. They not only destroyed their own communities and wandered westward to British Columbia, they also engaged in a campaign of subversion, involving activities as benign as marching nude through Canadian cities and as malicious as committing arson against other people's property.

Lillian Samoyloff, born 1913 in Kamsack, Saskatchewan, came from a family of Independent Doukhobors who left their community and moved to California. There they, like most Doukhobors, did the work they knew best, planting and harvesting crops. In 1936, Lillian married Milton William Halsted, the son of Jay Bruce Halsted and Franc Elizabeth Wealthy Queen Atkins. Milton came from Youngstown, Ohio and had no connection to the Doukhobors. Members of his family had done manual labor for the railroad and had worked as domestic servants. Milton and Lillian had two children, Milton Jay and Fred Charles Halsted. Milton William abandoned his wife and sons in 1944, when Milton Jay was seven and Fred was three years old. According to a Samoyloff family history, Milton William Halsted later married six more times before dying on a construction site in Palm Springs at age 53. It was a ruptured spleen, not a disgruntled spouse, that killed him.

Fred Halsted described his mother as a "hustler" who struggled to support her young children. A few years after the departure of Mr. Halsted, Lillian found her second husband, a Doukhobor from her native town in Saskatchewan and the brother-in-law of her first cousin. This man was born John Kazakoff, but changed his name to John Knight after he arrived in the United States in 1947.

John Knight might have made an acceptable husband for Lillian, but he was a terrible stepfather who abused his younger stepson. Fred revealed this in the context of an *Advocate* interview, one of the last journalistic pieces to take his artistic ambitions seriously. Fred's announcement only served to alienate him further from his family, especially since he had been using his real last name all along in his career. Brother Milton Halsted, prosperous and upright—or as one of Fred's lovers called him, "a rich asshole"—may have dismissed the story as histrionic and fraudulent, because Fred needed a lot of attention and was always

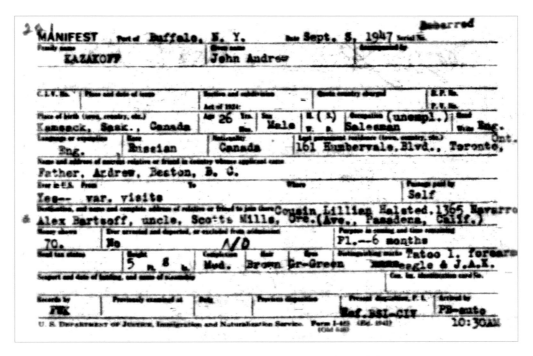

Immigration document of John Kazakoff, a. k. a. John Knight, Fred Halsted's stepfather

willing to break with family decorum to get it. According to his niece, Fred once appeared at a relative's wedding with bandaged wrists and a nurse in tow. He was flaunting that he had recently attempted suicide. It is unclear if anyone, including Fred, appreciated the gravity of his stunt.

Halsted seemed to dare people to dismiss him with absurd behavior and pronouncements, and yet, a careful reading of his interviews makes it clear that Fred Halsted had a rare kind of integrity. He stood for something entirely serious, even as he provided bathetic distractions for his audience. He had religious beliefs that, while unconventional, were grounded in history. In the midst of a society's obsession with self-realization, he wished to explore the limits of human sexual behavior. And during the brief period when it was possible, he sought to make truly independent films.

Fred Halsted continued to direct during the 1980s, but the terms of his involvement in the porn industry had changed, and most of his feature films and videos from that period have little to recommend them beyond the obvious attractions. The best of the lot is *A Night at Halsted's* (1981), shot at

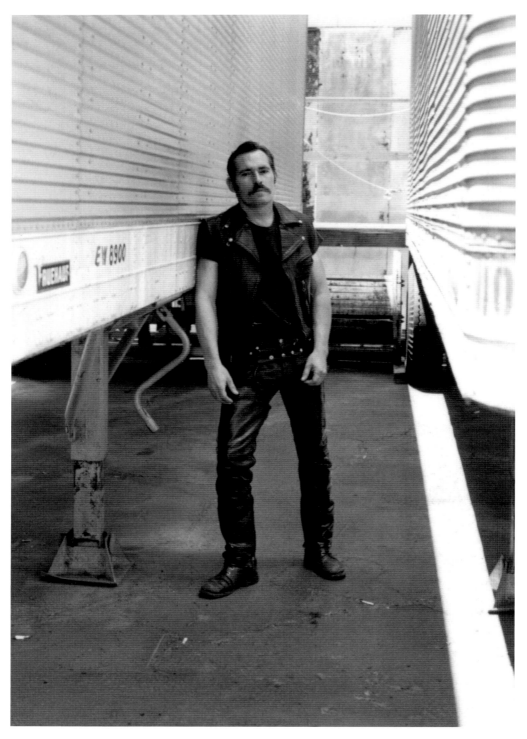

Fred outside the trucks at his sex club, Halsted's

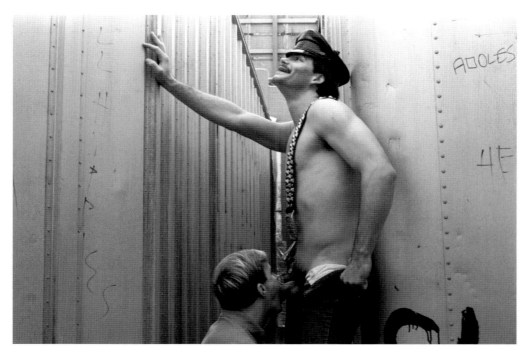

Joey Yale serving as fluffer for J. W. King on the set of *A Night at Halsted's* (1981)

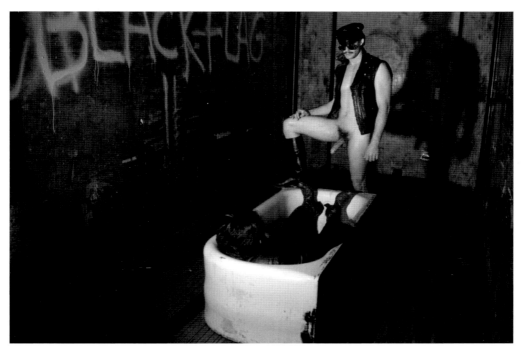

Inside Halsted's

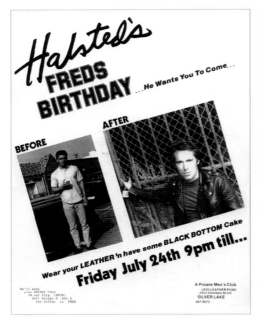
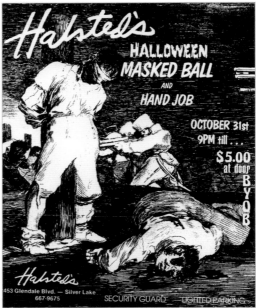

Invitations to parties at Halsted's, 1981

the sex club Fred owned near the intersection of Glendale Boulevard and Silverlake Boulevard. (Condominiums hastily constructed to cash in on the sub-prime interest real estate boom took the place of this building in 2007.) Halsted's was a raw industrial space transformed into what Fred called a "stand-up fuck club." Its amenities included the trailer of an eighteen-wheeler simulating the trucks of New York's Meatpacking District, a Plexiglas wall with a glory hole, and a set of bunk beds without mattresses. The club lasted only a year or so, and Fred himself admitted that Los Angeles did not have enough perverts to support the sort of business he envisioned. Before Halsted's closed its doors, Fred made his document of the place, and a soundtrack of punk and new wave music added an interesting dimension to what was essentially a conventional gay porn film. *A Night at Halsted's* begins to the chilling tune of Gary Numan's "I Die: You Die" and ends with X's "We're Desperate." In between, such hits as "Anarchy in the U. K." and "Oh, Bondage! Up Yours" accompany the action. The effect is by turns hilarious and electrifying.

Fred appears in *A Night at Halsted's* at the club's shoeshine stand, getting his boots licked, as he does in *L. A. Plays Itself*. The licker from that previous film,

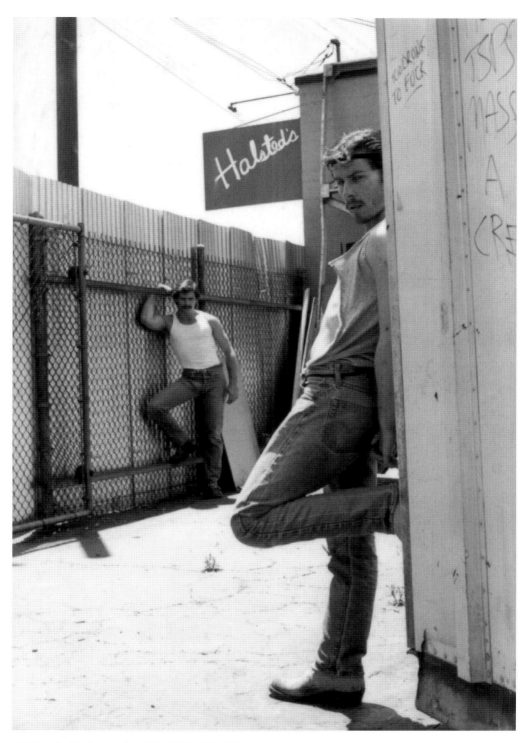

At Halsted's, Fred's "stand up fuck club" in Silverlake

Joyce Dewitt

Joyce, a senior, has been active in theatre and speech activities since her freshman year. She has been sen here in *The Crucible* and *The Man Who Came To Dinner*. She portrayed Lait in *South Pacific* in 1964 and last year was seen in the role of Tiger Lily in *Peter Pan* and as Mammy Yokum in *Lil' Abner*. Joyce won high honors last year in statewide competion in dramatic interpretation. Tonight, she distinquishes her high school career with the difficult role of Medea. I'm sure after viewing her performance this evening, you will agree that Miss Dewitt is one of the most promising talents to emerge from Student Theatre in the past five years.

Joe Yanoska

A newcomer to Speedway last year, Joe, a junior, is active in Student Theatre and Speaker' Bureau. Tonight he brings power to the role of Jason. You will be seeing much more of Joe in Coming productions.

A high school theatrical program featuring Joey Yale's classmate, Joyce De Witt

Joseph Yale, has a non-sexual role as the club's cashier in this one. Though the film is set at nighttime indoors, Yale wears mirrored sunglasses. He also wears a filthy jockstrap like a necktie, and he fidgets while he talks. The film reveals that Yale's days as a young stud or "twink" were behind him by that time. (A term that Halsted and Yale claimed to have invented, "twink" derives from Hostess Twinkies, snack pastries that are white, sickeningly sweet, full of cream, and of no nutritional value whatsoever.) In his brief scenes, Joey seems barely present.

Joseph Yale was born Joseph Yanoska on Christmas Day 1949 in Harlan County, Kentucky, and went to high school in Speedway, Indiana, the home of the Indianapolis 500. Michael Yanoska, his elder brother, was a bluegrass musician of local repute, and he left the Midwest to seek his fortune in Los Angeles. As Michael explained,

> Joey knew that I had planned to go to the west coast to get into the music
> business and he asked if he could come with me. We gathered our personal

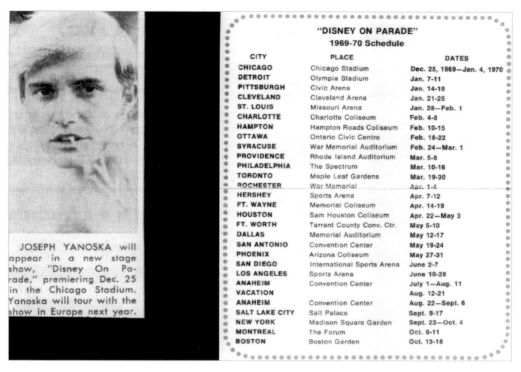

"DISNEY ON PARADE"
1969-70 Schedule

CITY	PLACE	DATES
CHICAGO	Chicago Stadium	Dec. 25, 1969—Jan. 4, 1970
DETROIT	Olympia Stadium	Jan. 7-11
PITTSBURGH	Civic Arena	Jan. 14-18
CLEVELAND	Cleveland Arena	Jan. 21-25
ST. LOUIS	Missouri Arena	Jan. 28—Feb. 1
CHARLOTTE	Charlotte Coliseum	Feb. 4-8
HAMPTON	Hampton Roads Coliseum	Feb. 10-15
OTTAWA	Ontario Civic Centre	Feb. 18-22
SYRACUSE	War Memorial Auditorium	Feb. 24—Mar. 1
PROVIDENCE	Rhode Island Auditorium	Mar. 5-8
PHILADELPHIA	The Spectrum	Mar. 10-16
TORONTO	Maple Leaf Gardens	Mar. 19-30
ROCHESTER	War Memorial	Apr. 1-4
HERSHEY	Sports Arena	Apr. 7-12
FT. WAYNE	Memorial Coliseum	Apr. 14-19
HOUSTON	Sam Houston Coliseum	Apr. 22—May 3
FT. WORTH	Tarrant County Conv. Ctr.	May 5-10
DALLAS	Memorial Auditorium	May 12-17
SAN ANTONIO	Convention Center	May 19-24
PHOENIX	Arizona Coliseum	May 27-31
SAN DIEGO	International Sports Arena	June 2-7
LOS ANGELES	Sports Arena	June 10-28
ANAHEIM	Convention Center	July 1—Aug. 11
VACATION		Aug. 12-21
ANAHEIM	Convention Center	Aug. 22—Sept. 6
SALT LAKE CITY	Salt Palace	Sept. 9-17
NEW YORK	Madison Square Garden	Sept. 23—Oct. 4
MONTREAL	The Forum	Oct. 6-11
BOSTON	Boston Garden	Oct. 13-18

JOSEPH YANOSKA will appear in a new stage show, "Disney On Parade," premiering Dec. 25 in the Chicago Stadium. Yanoska will tour with the show in Europe next year.

Disney on Parade program materials from the season that featured Joey Yale as Mowgli in *The Jungle Book*

belongings and packed them into a 1953 Willys which would not exceed 50 miles per hour and drove for a few days to get to California. Although we had very little money (I read an interview that he gave where he stated that he arrived in California with only $100 in his pocket... I would not disagree with that), we soon had "day jobs" in order to survive while pursuing the entertainment business.

Michael recorded an album for Epic Records and later worked as composer and guitarist with country music stars such as Johnny Cash and Glen Campbell. Joseph pursued an acting career, but his path to fame was not so straightforward.

Joseph met Fred Halsted outside the Hollywood leather bar Falcon's Lair— at 19, he was too young to get in—and performed in the final scene of *L. A. Plays Itself*. Soon afterwards, he joined the touring company of Disney on Parade, as Mowgli in *The Jungle Book*. Joseph Yanoska was not shy about divulging the previous item on his résumé to his co-stars. Somewhat later, he

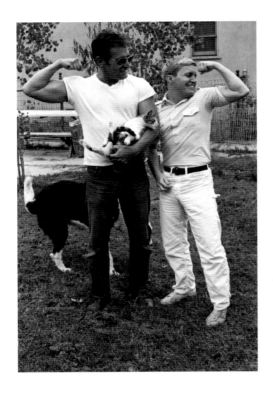
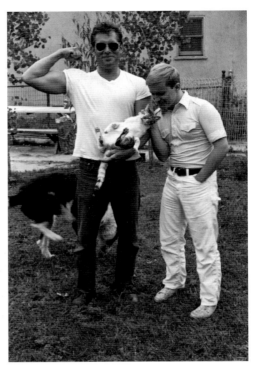
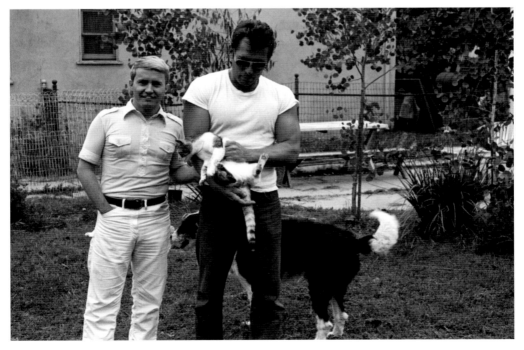

Fred and Joey at home with their pets in the mid-1970s

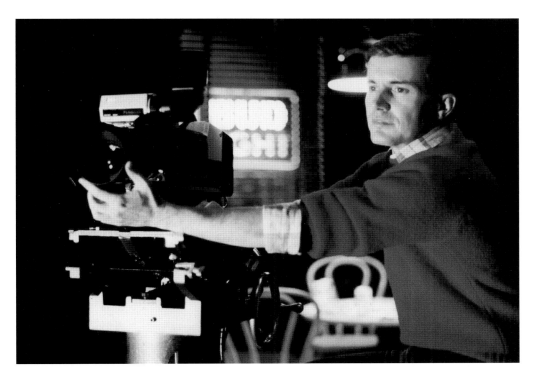

Joseph Yale as director, early 1980s

abandoned his birth name, and was listed as "Joey Yanichek" in early cast lists of *L. A. Plays Itself.* According to Joseph himself, he was given the stage name "Yale" by Henry Willson, legendary former manager of Rock Hudson and Tab Hunter. Following a period of estrangement during the theatrical run of *L. A. Plays Itself,* Joey Yale reunited with Halsted, and the two of them collaborated on many films distributed by the company they founded, Cosco.

What went on between "sadomasochism's heaviest couple" is largely a matter of conjecture, but the two of them admitted publicly to many fraught moments. There were a number of hiatuses in what must have been an extraordinarily troubled relationship, yet for many years they stayed together out of necessity. Fred readily admitted that he had no business sense and was relieved when Joseph took over the managing of his affairs. Michael Yonoska said of his brother, "Joey was successful in business first and in his creative endeavors later…. [He] quickly became adept at many aspects of the business: storyline, script, set design, lighting, directing, acting, marketing, distribution." Halsted

served as producer and encouraged Yale to direct films of his own, though from an aesthetic point of view, there was little to distinguish Joseph Yale as an *auteur*. History has been much less kind to Joseph Yale than to Fred Halsted. With the exception of his brother, those closest to Yale seem to have vanished entirely from the world.

Joey tired of his domestic situation and left Fred in the early 1980s. He took an apartment on Sunset Drive in Los Feliz near the Vista Theatre, where years before Fred had shown sequences of *Sextool* in progress. Halsted and Yale dissolved their business partnership and sold their films to HIS Video, a division of porn giant VCA, for a lump sum in 1984. Around this time, Joey became seriously ill with AIDS, and Fred was completely incapable of dealing with it. Michael Yanoska attended to his brother and was with him when he died in 1986. There was no love lost between Michael and Fred, and Joey's brother reasonably accused Fred of abandoning the man to whom he had repeatedly declared his devotion. Joey Yale's funeral, one of many like it to come, was arranged by his family, and seemed at odds with his public persona. Friends from the porn industry felt out of place, and Fred, wearing an ill-fitting suit, slumped in agonized grief.

Fred and his fellow mourners got little sympathy in the "return to order" that followed the efflorescence of urban gay culture. By way of excusing Ronald Reagan's complete silence on the AIDS epidemic, conservative toady (and Halsted's exact contemporary) George Will, in his nationally syndicated column, cited a dubious statistic: the majority of people with AIDS in the U. S. in the mid-1980s had engaged in fisting. No further elaboration followed his comment. The mere mention of the practice was intended to shock the reader, to suggest that what gay men do together is best passed over in silence, and by extension, that these filthy creatures deserved to die. As if losing friends, lovers and an entire social network wasn't enough, men who pioneered sexual liberation in America had to endure the self-righteous contempt of jealous prudes.

Despondent over Yale's death, suffering from an advanced case of alcoholism, financially and creatively destitute, Fred finally sought refuge with his unsympathetic brother. In return for work as a gardener and maintenance man, Fred was allowed to live in an apartment building that Milton owned in

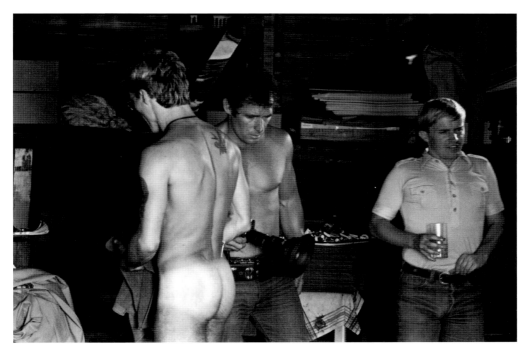

Fred and Joey on the set of *Pieces of Eight* (1980)

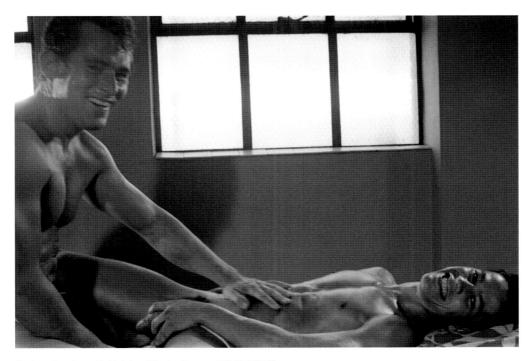

Fred performing with Melchor Diaz in *Pieces of Eight* (1980)

Fred Halsted at home

Dana Point, an Orange County beach town an hour's drive away from the neighborhoods where most of Fred's friends, colleagues and lovers lived. It was in the Dana Point apartment that Fred committed suicide in 1989.

At the end of his life Fred Halsted attempted to redeem his isolation by writing an autobiography called *Why I Did It*. His friend Jeanne Barney gave this account of the book:

> Fred had little-to-no sense of self worth, so he vacillated between "I'm no good and I can't do anything" and "I'm better than anybody and I can do anything." The latter attitude is what led to Halsted's and to *Package*. He assumed that his name alone could sell the former, and because we were doing so well with *Drummer*, that his name alone could sell the latter. Neither, of course, was true.
>
> I encouraged him to write his autobiography because I believed that he needed to keep busy and keep his mind occupied, especially because he was trying to get sober. For some inane reason, he made only one copy, which he gave to me to edit.

Fred submitted the manuscript to George Maveety, publisher of *Honcho*, *Mandate* and *Inches*. It was rejected, since Maveety saw no reason to depart from the formulas he had established with his magazines, and as one of his former employees attested, he "liked nothing but money." According to Jeanne, a single rejection was enough to defeat the neophyte author.

> Fred never spoke of it again and I never again saw it. That he didn't speak of it was not surprising, given his sense of insecurity and the fact that he was convinced that Maveety would give him an advance of $1,000,000. When I told him that I thought that figure a bit unrealistic, he said, "Well, Nixon got $5,000,000, and he was a crook!" He was so excited when told that Maveety wanted to see the manuscript—and he so counted on Maveety's publishing the book—that his hopes were dashed. This reinforced the "I'm no good" thinking.

The title Halsted gave to his autobiography also appeared as the heading of his suicide note. The note read, "I want to be with Joey. I'm a has-been and now I can't get anything produced. I'm broke and can't get a job in my field. My skin is all fouled up. I've had a good life (I was student body president of my high school, the overwhelming passion of my youth). I've had looks, a body, money, success and artistic triumphs. I've had the love of my life. I see no reason to go on." To those who know only the Fred Halsted of the films, it may come as a surprise that his sense of self was so fragile that he had to bolster it by making reference to high school achievements.

Why I Did It: the title indicates that Halsted wished to justify or explain his life and work. He may have wanted to answer a question that occurs in retrospect: why would anyone pursue an artistic career in the field of gay porn? In the intervening decades, a *cordon sanitaire* has come to separate the mainstream film industry from the people who have sex on camera for a living, but in the early 1970s, the boundary was not so clear. At a time when an openly gay filmmaker had no realistic hope of making gay films within the industry, taking the further liberty of making sex films seemed not only possible but necessary. Had Fred Halsted lived a bit longer, he might have

taken heart to find aspects of his aesthetic adopted by Canadian filmmaker and provocateur Bruce La Bruce, whose films pay homage to many early gay porn directors.

The final fisting scene of *L. A. Plays Itself* predictably features a close up of a can of Crisco, vegetable shortening the name of which sounded like Halsted and Yale's company, Cosco, and the substance of which lubricated many a gay encounter. Crisco's slogan, "It's digestible," looks out of place in the film of a man who went to such lengths to be indigestible. It was as though Halsted knew the travails in store for him and decided to mock them. Since Halsted's time, American commercial gay cinema has reached an impasse, with anodyne romantic comedies dissembling their function as blunt social engineering. In this environment, a filmmaker aspiring to anything but affirmation and conformity is courting disaster. Halsted seemed to welcome disaster with a few remarkable films that were never mired in good intentions. He refused to engage with the rules of the game, the ones that directors with better educations or more developed career instincts quickly grasped.

Fred Halsted took advantage of a window of opportunity that subsequently closed and left him stranded. Pornography made its gradual transition from monstrously profitable and intermittently interesting outlaw form to almost respectable, formulaic corporate content. The fabled largesse of the porn industry became concentrated in the hands of the bosses. The sexual underground in which Halsted had played a role had no place for him once it became one big costume ball. Expensive attire and props, not conviction, granted entrance to a professional class that saw sadomasochism as a lifestyle or hobby. Nonconformists with screwy politics got turned away from the party as quickly as queens reeking of cologne. Could anyone remotely like Halsted succeed in today's well-mannered crypto-reactionary gay world? This year's model would probably have his head served to him on a platter for attempting to disturb the hypocritical voyeurism that sustains contemporary mass culture and the pornography with which it has a symbiotic relationship.

Untimely deaths, financial problems, and the day-to-day indignities of living in a city devoted to ruthless development harassed Fred Halsted the

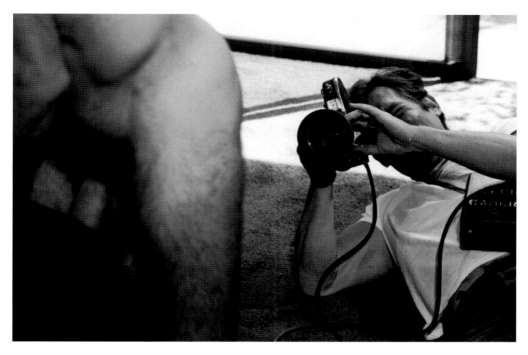

Fred Halsted shooting *Pieces of Eight* (1980)

artist. At the time of this writing, access to his legacy is difficult. Most of his films have fallen out of distribution, though scenes from them can be seen on compilation DVDs. Many of the magazines that published interviews with him have ceased publication. Only a handful of his friends have lived into the present century. The city that *L. A. Plays Itself* makes available to us, the Hollywood of lost boys on mean streets, has nearly been eradicated. To reconstruct Halsted's story is to imagine another world, a time when a man with no formal training in filmmaking and a small amount of money could make a sexually explicit experimental film starring himself, and the result could become a hit that enabled him to embark upon a career. It may yet be possible to salvage the memory of Fred Halsted in opposition to our current cinema of distraction, an era of failed blockbusters and cynical rip-offs. Halsted may even serve as an exemplary figure, a filmmaker capable of devising new ways to make movies, and of finding ways to invest those movies with a sense of fascination.

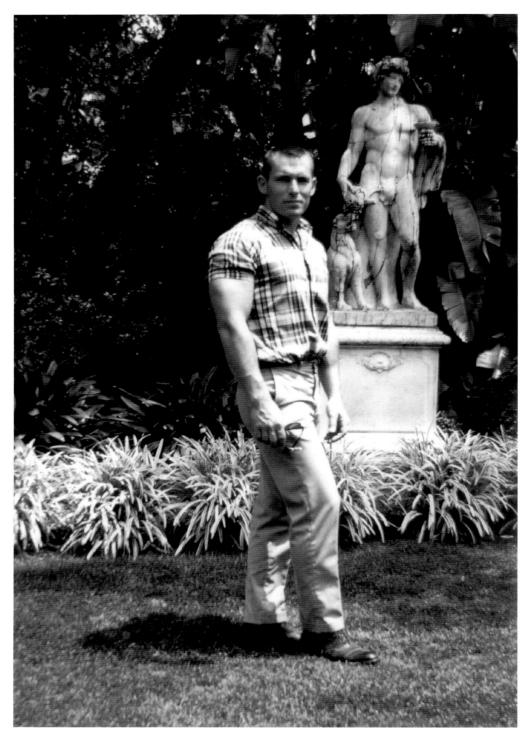

Fred Halsted at Huntington Gardens, San Marino, California, in the late 1960s. Photo by Tom Harvey.

Blind Items

Several days after completing a draft of the preceding text, I received an unexpected email.

> Dear William,
>
> Fred Halsted and I were close friends for about ten years in the 60s and 70s. Most significantly, he was one of the most influential persons in my life (he brought me out, and had me move to Silverlake in Los Angeles). I, in turn, was influential in his life. I got him started in making films….

I hadn't contacted the man who sent this message, nor was I even aware of his existence. He explained that he had been cleaning out his desk to fulfill a New Year's resolution and had found a picture of Fred. He searched the internet for information about his old friend, he came across my website, which at that time contained a request for interviews with anyone who knew Fred well, and he contacted me.

Hardly believing my good luck, I saw this man as soon as I could. I took a train to northern San Diego County and spent most of a day with him. When he picked me up at the train station, he told me that he had shot part of *L. A. Plays Itself.* I mentioned that for a while I had worked in the industry, by which I meant adult video. He thought I meant the mainstream film industry, and he told me that his boyfriend of 36 years had been a dancer in Hollywood. In fact, neither of them had been involved in the porn industry in any formal way. A retired academic, he asked me to call him "Tom" in order to prevent misunderstandings and embarrassment.

Tom gave me a precise account of the years he knew Fred well, from the time of their first encounter.

> I met Fred at Cal State L. A., which was California State College at that time. He was a student there, and I was doing some work and needed an assistant.
>
> I was in my office one day, and in walks this incredible creature. I had never seen anything quite like him. Exceedingly handsome, very innocent looking. He

was about 5' 9" or 5' 10", and in a tight white T-shirt, with bulging muscles. I had not come out at that time, but I had rumblings within me that there was something amiss. And I almost literally shit in my pants when Fred walked in the door.

It was very difficult to explain how beautiful he was in every way, physically beautiful, but also beautiful in his manner. He was very soft-spoken and gentle and kind. I could tell he was a very loving person. But I learned later on in our conversations that he didn't get very much love when he was a kid.

Tom had never acted upon his true sexual feelings until Fred presented him with an irresistible opportunity.

One day after we'd been working together for some time, Fred said to me, "Do you know that you're homosexual?" He couldn't have been more direct. I said, "Well, I really think probably I am, but…" Fred said, "Well, I think it's time we proved it." So we went in the bedroom. He took all his clothes off. I took mine off. We got in the bed, and he proved it *(laughs)* once and for all. But Fred was not a passionate lover. It was just sort of, "Get on your face and let me fuck you." And he did, and that was that. He threw on his clothes and left. That was the only time I ever had sex with Fred.

Apparently, as I understand, this is how he was with most everybody. He was affectionate in a warm cuddly way, but when it came to sexual expression, it was a very cold type of thing. But anyway, that's how I learned the facts of life about myself.

Fred led his elder, a respectable intellectual, into other activities of which he had previously been innocent.

Fred said, "I want to make porn movie. You've got the camera. You know how to run it. I'll be the director. You can be the cinematographer." I was game for anything, even though it was sort of out of character for me. I thought it would be rather fun. I love living double lives anyway. *(Laughs.)* During the day, I was being a very prissy and proper person at the school, while Fred got me into the other side, gave me a Mr. Hyde personality of my own.

He wanted to make this film, but he didn't have any idea what he wanted. His first thought was, "Let's do an outdoor sequence of a couple of boys having sex in the big wild countryside." So he and I went scouting around, and we found Encinal Canyon, which is just a short way up from Malibu Canyon. We hiked down, and we found a little stream and some big boulders, with a pool of water. He said, "This is the ideal place," forgetting that this ideal place where we ultimately filmed the opening sequence of *L. A. Plays Itself* was surrounded on both sides by a road. The road wound around, so there were cars driving above our heads in both directions.

I have to point out that *L. A. Plays Itself* was made from random footage that we took. There was no plan to it. It makes me laugh when I read on the internet that the screenplay was by Fred Halsted. Fred Halsted was incapable of writing a screenplay. He just filmed whatever he saw. Then he had the genius, I suppose, of being able to sort it all out and put it together into some sort of sequence.

Tom shot the climactic scene of *L. A. Plays Itself* with Fred's new boyfriend, Joey Yale.

I knew they were both play-acting. That's all S&M is. But I was feeling sorry for Joey because Fred was really knocking him around. It gets to the point where he throws Joey on the bed and is ready to fist fuck him. At that point, cut. Joey had made it clear from the beginning that he was not going to be fist fucked.

A few weeks later, Fred called me and said, "Bring your camera. I found a guy who says he likes to be fist fucked. He lives in Hollywood." The guy wasn't young like Joey, but he liked this procedure. And I proceeded to film it.

Fred relied upon Tom for his camera equipment and ability to use it, but further material support came from another older man (and erstwhile sex partner) who served as Fred's patron.

Russell Padget was the source of the money that Fred had from about 1970 to about 1975. Fred had an endless amount of money to play with. Russell,

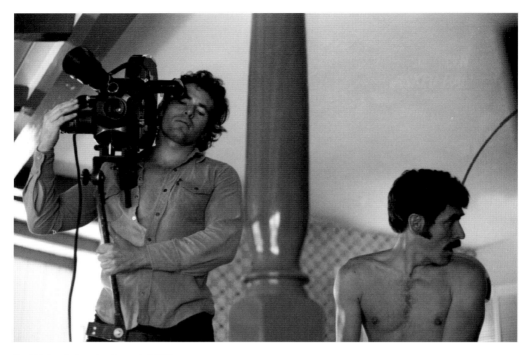

Fred Halsted shooting *Sextool* (1975)

besides being wealthy, was a hopeless alcoholic. When they went to London, they stayed at the Savoy, only the best hotel. Fred went out catting around, and Russell started to drink. He was lonely, poor thing. Fred came back to the hotel and found him blotto out of his head. The next day, Fred got himself a return ticket back to Los Angeles and left Russell in London. This is how he was. He could be cruel, too.

Tom was unaware of it, but Fred had actually made the trip to see William S. Burroughs, who was living in London at that time. Arizona State University's collection of Burroughs' correspondence contains a text explaining their relationship:

In the spring of 1972 while I was in New York trying to sell the *Naked Lunch* film script I saw a number of hard core porn films including Fred Halsted's *L. A. Plays Itself* and *Sex Garage*. This gave me the idea for shooting *The Wild Boys* as a hard core porn film.

I met with Fred Halsted and discussed the idea with him and gave him a copy of *The Wild Boys*.… I then discussed the project with Terry Southern and we considered working together on the script.… During the summer of 1972 Fred Halsted came to London, and we discussed a number of alternative scripts.

I finally decided that the whole idea was impracticable both from a financial standpoint and from [the] standpoint of making a good film within our budget.

During the heady days of Fred Halsted's notoriety, he was considered a plausible candidate to direct the first high-profile, sexually explicit film made in collaboration with a great American author. The next friend of Fred's I encountered gave me an idea of what happened once this sense of possibility evaporated.

I had heard about Andrew Epstein from Joe Gage, who said that this man was eager to speak to me. Joe mentioned a few things that Andrew had told him about Fred, and they sounded implausibly extreme. Those of Fred's friends and colleagues I had met thus far had been reserved in their accounts of Fred's life, perhaps because their memories of that time were still painful, or they wished to preserve a favorable image of their friend. Andrew presented a very different view of Fred Halsted.

To his credit, Andrew let me use his real name, unlike many of my other sources, but he may not have been the most reliable witness. He admitted that most of his memories of the 1970s were lost in an alcoholic haze. No longer drinking, Andrew had been in the process of identifying people and events in the many photographs he took during the period.

Andrew used to work for Allan Carr, the producer of big-budget movies that were legendarily tasteless and sometimes immensely profitable. It was at one of his employer's extravagant parties that Andrew met Fred. Fred was socially successful—Allan Carr was one of his patrons, and it was Fred who introduced Andrew to Rock Hudson—but personally, he was in decline. "Fred had become quite an alcoholic, so we were a perfect match. Actually, we were boyfriends for a while, which not very many people know."

Andrew gave me a brief but tantalizing view of an underground below the mainstream gay scene in Los Angeles. As gay men achieved more social acceptance through the 1970s, a group of nonconformists continued to mingle in private, much as they had before gay liberation. Fred was Andrew's guide to this world.

There was the gay scene in L. A., but then there was this other scene of S&M and fisting and the occult. It was not something that you found in the bars. It was very clandestine. I think that's what lured me into it, how mysterious it was.

I remember going to Kenneth Anger's house a lot with Fred. They were very good friends. There was this demonic edge to some of the groups they were in. It was incredibly terrifying for me and yet fascinating to be around those people. I remember watching *Scorpio Rising* and *Fireworks*, which Fred loved. I didn't know anything about those movies until Fred introduced me to them and to that really strange side of L. A.

The couple also had a professional relationship, since Andrew worked as the art director for *Package*. Fred's short-lived magazine had an office on the Sunset

Strip, in the same building as Roger Corman's office. Fred's publishing endeavor was on precarious footing, but he supplemented his income with money from outside sources, some of them considerably sleazier (and more dangerous) than even the most explicit material in the magazine would suggest.

Fred would do films and get cash for them, private films, some with a guy called Donkey Dan, who lived somewhere between L. A. and San Diego. He had a farm with a donkey and a sling built for him. The donkey had mittens on its feet so that it couldn't kick you and hurt you. They'd hoist it up and people would get fucked by the donkey. And this guy paid Fred to film it for him, just for his own use. Fred did a bunch of commissions like that. He was a hustler, becoming something like a prostitute with a camera for these older guys.

A lot of the stuff that Fred did was under the table. There were usually a couple hundred dollars in the office, and sometimes a couple thousand dollars.

At the center of many of these activities was Joey, whose appetite for cash was insatiable. Andrew painted an unappetizing picture of Fred's main lover and the company he kept.

Joey used the money for drugs. He just kept stealing more and more money and at one point, tried cooking the books, but it became very obvious. He was a big cokehead. I often just left the office when Joey was doing coke. I would wander around Tower Records next door for an hour until things calmed down. I know for a fact that it was Joey and his drug deals that bankrupted *Package*.

John C. Holmes used to hang out at the office. There would be really strange people from mafia to ghetto, gang people, coming into the office doing large drug deals. I was afraid of being alone there with John, because I always felt like he was casing the place. I was sure that he was going to rob it. He gave me the creeps. Several of the people who used the office were involved in the Wonderland murders. And they were people that Fred and Joey knew.

Joey was never nice, and when he started in on the coke, he was particularly vicious. Because he was small and cute and blonde, he thought he had

to be really tough. And he was. He was nasty. He'd backstab anybody, and he was a big gossip. If he didn't like you, he actively went out to destroy you.

Fred and Joey had a very volatile relationship. While everybody assumed Fred was a big hulking top, Fred was very passive. If they had an argument, Joey would just clobber him. And then Fred would wind up at my door at three in the morning, bloody because Joey had beaten him up.

Fred just kept staying at my house more and more. Joey didn't want to break up the relationship because it was very profitable. In fact, Joey said something like, "I'm very relieved that you've taken over my sexual responsibility with Fred, because I can't stand him. So I have no problem that you two are sleeping together. Just don't make it public." It was very important to Joey that Fred was his property. That's how Joey viewed Fred.

A more dramatic contrast to Fred Halsted's public image as handsome, hedonistic stud can hardly be imagined. I asked Andrew if he had a sense of why Fred put up with such abuse, and he gave me his explanation of a fundamental conflict within Fred.

I think in reality Fred was a masochist with people he really cared about, which would surprise a lot of people. In his sexual conquests, he had to dominate. Fred took out his anger sexually on other men. I saw it often, but I personally didn't experience that with him.

Fred told me about being raped. The rape was brutal, and he put up a struggle, but when he ultimately had to surrender, and he was getting fucked by his stepfather, he really got off on it. And it shaped the way Fred saw having sex for the rest of his life. He said it was a turning point in his sexual identity when he realized he had the power to terrify and to fuck guys. He didn't really care about the sex, but he liked to own the power.

Fred's casual acquaintances saw the man they knew from porn films and expected him to act the part. When Fred disappointed, they came to the conclusion that he was an aloof poser. Andrew saw a different person.

Fred on the set of *A Night at Halsted's* (1981)

We would walk into Cliff's or one of the other bars, and he would say, "You know, I'm the loneliest person in this bar." And I said, "Why? Everybody here wants you." He said, "Oh, nobody will come up to me and talk to me. Absolutely nobody." And they wouldn't. They would stare at him. They would clearly want him, but everybody was afraid to come near him, because he was Fred Halsted.

To deal with his shyness, Fred drank to excess, and this had a disastrous effect on his mental state. Diagnosed as bipolar, he took Thorazine, a powerful anti-psychotic medication that had the unfortunate side-effect of ruining his skin (a condition he mentioned in his suicide note). Andrew was unaware of the specifics of Fred's illness, but he often saw its consequences.

I believe Fred had mental problems. He was on something, because I remember him taking pills. There would be really radical mood changes. The more he drank, the more of a rollercoaster ride it would be emotionally. He would say, "Don't tell anybody this, but I'm going to kill myself."

Fred was constantly talking about killing himself. He was going to kill Joey and then kill himself, and they would find their bodies. Whenever that came up, I always thought, no, it would be the other way around. Joey would kill him, and then Joey would kill himself.

He was such a mess, literally falling off the barstool and unable to walk to go to the bathroom. I tried to get him into a program or to get him some help. He just absolutely refused.

He told me something very interesting that I never forgot. One night we were very drunk, and he was very unhappy. He said that the happiest time in his life was when he was Vincent Price's gardener, and he always wished he could go back to that time.

By the late 1970s, Fred was falling apart, but there was little anyone could do to help. On his worst days he wished to give up his celebrity and achievements, preferring the life he had before he made films. I could hardly imagine what that life was like. The period was almost unknown to me, because I had found very few people who knew Fred during those years. I thought the key to understanding the young Fred might be speaking to the man who changed the course of Fred's life while he was still a teenager.

I had first heard about this man from Tom:

If you thought Fred was a hunk, his first lover was a double hunk. He was taller than Fred and very good-looking. I think this man was Fred's ideal for his whole life. The person who brings you out, particularly somebody who was as gorgeous as Fred's first lover was to him and Fred was to me, becomes the ideal that everybody else has to measure up to.

Fred's first lover had an uncommon, alliterative name that sounded appropriate for a porn star, but he requested that I use a pseudonym for him. He chose "Frank," the false name he gave to tricks with whom he didn't want to get too familiar. There must have been many tricks, because even in his seventies, Frank

was handsome in a rugged way, the "double hunk" Tom had described to me. He was also a tormented man, as was obvious from the first words that came out of his mouth.

> I've never believed in homosexuality. I was raised in our society at a time when there were fairies and so forth, but it was something that I never accepted. The sex scene was very active, and there were a lot of things happening, but they were all quick one-night stands.

Frank described his meeting with Fred, who changed his mind, at least for a while, about the possibility of having a relationship with a man.

> I remember it was about five in the afternoon. I was driving down Sunset Boulevard and came to the stop light at La Brea and looked over to my left. I was in a little Mercedes convertible and Fred drove up in a new powder blue Chevy convertible with the top down. I looked over at him, and he looked over at me. It was really one of the fastest pickups. I said, "Hey, you want to get a beer?" He said, "Yeah." I said, "Well, follow me." He got behind my car and made the turn down La Brea, to Santa Monica Boulevard. I picked a bar on Santa Monica that had nobody in it. I think it was a straight bar. We pulled into a side street. I got out of my car and he got out of his car, and he had a hard on. And this wonderful face. He was 17, and excited just to meet. So we went into the bar and had a beer, and then we went back to my place.
>
> We connected. I introduced him to my friends, and, of course, he was a big hit, but he wasn't interested in having anything to do with anybody except me. He was totally interested in just that one relationship. It was a surprise, because I had never had a relationship. He created a situation, and we moved in together. That went on for quite a while. There were just the two of us.
>
> My nature was promiscuous, and it was a few months later that he found out I was having sex on the side. And so he picked up somebody. The guy had a place in Laguna Beach and took him down there for the weekend. I totally went berserk. *(Laughs.)* I think he was teaching me a lesson.

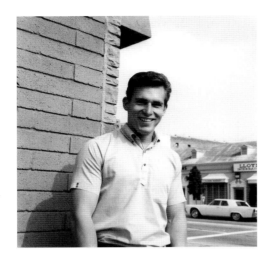

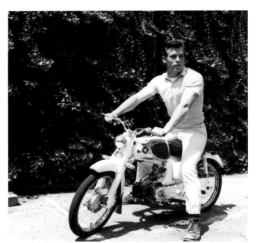
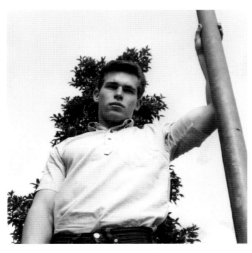
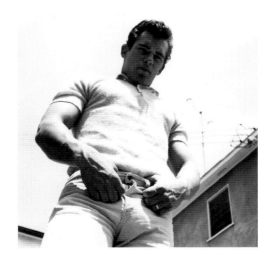

Self-portraits of Fred Halsted at 19

Instead of coming to some sort of agreement with Fred about their relationship, Frank drew his mother into the drama.

> I remember calling up my mom and putting her through hell, because she never accepted the fact that I was gay. In fact, until that time, she never knew that I was gay. It was very traumatic for her. I called her up and I said, "Please call Fred and tell him that I love him." My mom could tell by the state of my voice on the phone that I was serious, so she did it.
>
> Anyway, Fred and I got back together, and we moved to another apartment in West Hollywood.

A few months after their reconciliation, Frank made an important decision based upon a night at the movies.

> After seeing *Breakfast at Tiffany's*, I called up a friend and said, "Hey, I want to go back to New York and get into advertising. Can you set me up with some employment?" He said, "Yeah, sure." It was because it was raining that day in L. A., just like at the end of the movie, and I missed New York. The film changed my life.

The couple moved east not long afterwards, but Fred found that he didn't like New York, and soon moved back to Los Angeles. Frank didn't want to leave, so they broke off their relationship.

Once he was home, Fred sent Frank a group of self-portraits to remind him of what he was missing. Fred was 19 years old at the time and looked like a "greaser" showing off his new motorbike. Frank treasured these pictures and showed them to me during our talk, but they did not have the effect that Fred intended. Frank remained in New York and continued his life as a confirmed (and very sexually active) bachelor.

Frank had extreme difficulty in talking about his emotional life—he was much more comfortable talking about the on-screen emotions of Audrey Hepburn and George Peppard, or those of the mother with whom he still lived—but he acknowledged that the responsibility for the failure of their relationship lay with him.

We had a nice time, but Fred knew there was something wrong with me, that we were not really connecting. He was totally accepting of what he was about, and I was totally incapable of it.

His Uncle Charles had a lover and they lived in Costa Mesa, so we went down there a couple of times. Terrific guy. Big, tall, gangly guy, a great sense of humor. He and his lover were a very solid couple. They were older. And I remember thinking at the time, it was kind of amazing that two people had been together that long, two guys.

Fred would never have what his uncle had, a house in the suburbs with a nice lover, perhaps because he was a much more complicated person than Frank could fathom. In addition to Fred's desire for domestic stability, there were other desires and other ambitions.

Around 1970, he told me, "I'm going to make a porno movie." I said, "Oh, yeah. Far out." *(Laughs.)* So I asked, "What kind of a porno?" and he said, "I want to make a film about fist fucking." That threw me.

I asked Frank about Fred's sadism, at least as it was represented in *L. A. Plays Itself*. There was an abrupt change in Frank's demeanor, and he asked, "Is *that* what interests you about Fred?" I thought it might be the end of the conversation, but after a bit of explaining, I was able to continue the interview. Clearly shaken, Frank began to talk about conspiracies and AIDS, Rock Hudson and the early years of the Reagan administration. He asked me not to reveal the details of what he said, which was not a problem, because I didn't understand it. Frank seemed no closer to dealing with his contradictions than he had been decades before, and his conservative politics were of little help in disentangling the confusion. He couldn't bring himself to talk about certain aspects of his sex life, but he readily admitted to having voted for Richard Nixon for president twice—not three times, since he couldn't vote against a man as handsome as John F. Kennedy—and to having visited a number of psychiatrists to "cure" him of his sexual orientation. After his digression, Frank returned haltingly to the film.

I told Fred, "It's going to show the end of homosexuality." I just thought that this film would... because I really felt that homosexuality was a phase that everybody was going through... all of society was going to move out of it. There was no... homosexuality was wrong. There was nothing to... it was just wrong. Every analyst that I went to, they all gave the feeling that it was wrong.

It is doubtful that Fred had much patience for Frank's anguish. Fred projected an insouciant disdain when it came to questions of sexual orientation. He wrote in one of his *Package* editorials, "Are heterosexuals born straight or did they learn it from Daddy or the school nympho nurse? Who gives a shit?" By coincidence (or not) the highlight of Fred's career, his evening at the Museum of Modern Art, occurred at the exact same time that the American Psychiatric Association removed homosexuality from the list of illnesses in the *Diagnostic and Statistical Manual of Mental Disorders*. Frank, who could not quite grasp the implications of one historical event, was in attendance at the other.

Adrienne Mancia [the MoMA curator in charge of the evening] came out onstage and said, "I think this film needs a little explanation," or something like that. "A lot of people consider it a porno film, but we don't. We consider it a work of art." Then she said, "There are some scenes that are a little unusual and may be disturbing." Every time she'd say something, there would be laughter because they knew how difficult it was for her to go ahead and explain. She finally said, "There's a scene of... it's, well, you can call it anal manipulation, better known as..." and her voice just blurted it out: "fist fucking." With that, the whole auditorium burst out laughing and applauding. You could see straight people looking around asking, "What the hell is this?"

I asked Frank which version of *L. A. Plays Itself* he had seen at MoMA. I mentioned that in the original version of the film, described in many early reviews, the reels were in reverse order: first the alienated sexuality of the city scenes, culminating with fist fucking, then the long, idyllic (and anticlimactic) nature scene. Frank knew exactly what I was talking about; indeed, he took credit for convincing Fred to arrange the film in its present order.

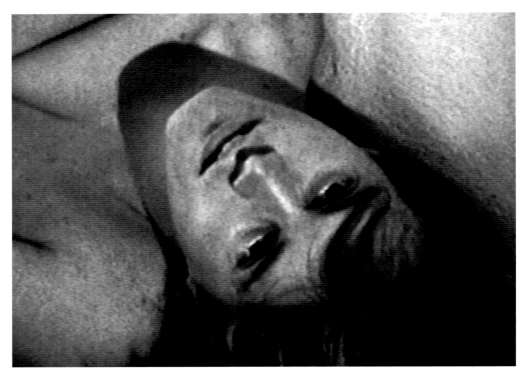

Joey Yale in *L. A. Plays Itself* (1972)

His life became just like the film. Do you see that? When I first met him, for that first year and a half, how beautiful and how fine he was, and homosexuality really did destroy him. He was more interested in putting together a hopeful film that went from bad [the urban sex scene] to good [the nature scene], from anonymous pickups to a one-on-one relationship. I was more interested in making it bad, ending with the dark, awful scene. That was the difference between Fred and me, but my pessimism won out.

Fred Halsted, the tongue-tied hick, arrived in Hollywood from San Jose not long after graduating from high school. An older man showed him the ropes, and the young man, hungry for experience, got more than he bargained for. *L. A. Plays Itself* gives us a view of this scenario, if we imagine that Joseph Yale is playing not himself, but a younger version of Fred Halsted.

When Fred called his film an "autobiographical homosexual story" in a *Village Voice* interview, it was generally assumed that he was referring to his

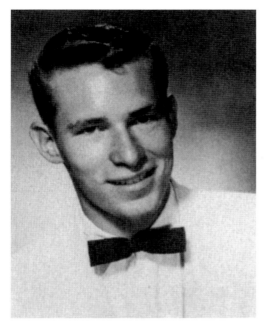

SENIOR SPOTLIGHT

Karen Pope	MOST LIKELY TO SUCCEED	Lee Cox
Joyce Bianco	MOST POPULAR	Dan Landes
Priscilla Thomas	BEST LOOKING	John Paulson
Janet Garner	SENIOR WHO HAS DONE THE MOST FOR THE SCHOOL	Lee Cox
Janet Garner	SENIOR WHO HAS DONE THE MOST FOR THE CLASS	Mike Apra
Karen Pope	BRAINIEST	Larry Daubek
Janet Garner	FRIENDLIEST	Fred Santos
Ruth Emery	QUICKEST WIT	Fred Halsted
Ruth Emery	FUNNIEST LAUGH	Art Pacheco
Linda Carter	MOST SOPHISTICATED	John Childrey
Norville Mercer	MOST NAIVE	Bill Moyer
Arlene Jung	MOST RESERVED	Al Aguirre
Wendy Kirschner	FLASHIEST DRESSER	Brad Della Valle
Hene Tamarkin	BIGGEST CHARACTER	Gene Yamasaki
Judy Krell	BIGGEST POLITICIAN	Fred Halsted
Pat Naylor	BEST ACTRESS OR ACTOR	Max Crumley
Camilia Piazza	MOST TALENTED	Brad Della Valle
Darlene Gallegos	BEST FIGURE OR PHYSIQUE	Frank Strouse
Joyce Bianco	BEST LINE	Dan Landes
Darlene Reeves	BEST DANCER	Dan Landes
Sally Camou	BIGGEST FLIRT	Dan Landes
Hene Tamarkin	MOST LOQUACIOUS (TALKATIVE)	John Barnes

Fred Halsted as 1959 senior class president at Abraham Lincoln High School, San Jose, California

own sadism, but Frank, the older man of the story, knew differently. He was taken aback when I brought this up, not because such things shocked him, but because if anyone was a sadist in their relationship, it was him. He was vague about what the two of them did, and what Fred was like, other than being a cute kid with a hard on, when they first met. Perhaps the older man's dialogue from *L. A. Plays Itself* can provide some clues:

> I know a few friends. We can maybe get you a job…. It'd be kind of easy work. I've got these friends that… you know, just a little bit of stuff here and there…. You've got some attributes…. We'll go drive around, and I'll show you spots. There's lots of spots in L. A. They're each different, and there's all different kinds of people…. And you, like, sort of specialize a little bit, and make a little bread…. You don't give stuff away free.

So said the pimp daddy who had just found himself some fresh meat. Frank was undoubtedly a bit surprised to see the fisting scene in *L. A. Plays Itself*—it is a provocation on the order of Divine's coprophagy in *Pink Flamingos*—

but aside from that, he must have recognized the greater part of the film's "dark, awful" second reel. Almost fifty years later, Frank still felt guilty about being a bad influence on Fred.

> I think the worst thing that ever happened to Fred in his life was meeting me, because he met me with all the trust in the world, all the belief in the possibility of a relationship, completely comfortable with that, completely giving, completely honest with it. I was the wrong person because I didn't believe in gay life. I didn't believe that a relationship was possible, and society at that time didn't allow us.
>
> Now if I had been as good a person and as fine a person as Fred, he probably would have become successful with his own nursery. He would be in the garden business. He'd still be alive. He'd have a relationship like his Uncle Charles had.

As far as Frank was concerned, Fred could have led a happy, conventional life as a businessman, if only he had never encountered the older man who introduced him to a vicious, corrupting lifestyle. (It seemed not to have occurred to Frank that if it hadn't been him, Fred would almost certainly have found another partner in corruption.) Frank's notion of success was entirely acquisitive—of material goods or of sexual partners—and even though he had witnessed Fred's triumph at MoMA, a sense of art making and its demands escaped him. During our interview, Frank repeatedly asked me why I would bother doing a book about his former lover. He had a fantasy of a "successful" Fred who never felt compelled to make films, and thus did nothing to deserve the extended reflection of a biographer.

After Frank's interview, I thought that I would find no more people close to Fred, and that my project could end at a beginning, with Fred's first lover, but as soon as I began envisioning a conclusion, several more people came forward to make their contributions.

I received an email from a person named Bobb, who offered to provide me with information that would sell a large number of books. In return, he

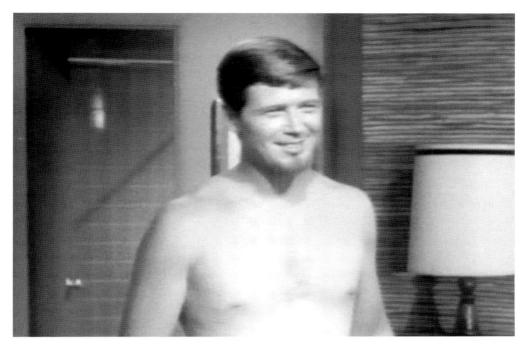

Curtis Taylor in *Once Upon a Coffee House*, aka *Hootenanny a Go-Go* (1965)

requested a credit for "celebrity services" and the right to distribute several hundred copies of the book, a substantial portion of the first print run. He probably supposed that a biography of Fred Halsted would be a mass-market paperback or would be transformed into one with gossip of sufficient interest. I wondered which celebrity name he wished to sell me. I had heard a number of my sources mention Rock Hudson in connection to Fred, but this sort of news was unlikely to hold much shock value. Bobb's idea of the book and his numerical calculations tended toward the grandiose; whether his revelation was also grandiose, I never found out. We were unable to come to an agreement about his participation in the book, so Halsted's celebrity trick remained a secret.

Though the main morsel of gossip eluded me, I did find out a few things about a man named Curtis Taylor, whom Bobb knew far better than Fred.

The year I arrived in L. A. ('74) a model buddy of mine from New York pro-duced a gay, pornographic film [*Sextool*]. Curtis Taylor was a major male beauty who managed to snag the daughter of the family that created the Reuben

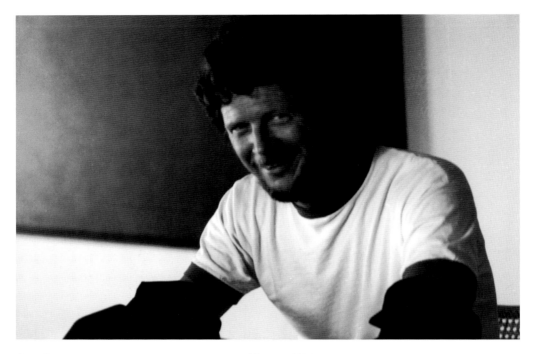

Curtis Taylor loading a camera magazine on the set of *Sextool* (1975)

sandwich (their name) and featured it at their famous late-nite NYC restaurant, Reuben's. We shared my Miami Beach hotel suite when we first worked together on a lame indie musical feature called *Once Upon a Coffee House*.

Fred mentioned his producer in the interview he gave to Paul Siebenand for his dissertation:

Curtis has helped me enormously, because I am not social. I don't know anybody and I don't care to know anybody and I am not social and I don't go to bars and I don't go to parties and I don't care to meet anybody. But Curtis gets fucked three times a day and knows every fucking person in this fucking town…. He is getting cock up his ass and down his throat. It doesn't wear him out. As I said, I don't know anybody and he knows everybody, so our partnership works out quite well. But he has no sense of art, absolutely none. And that is all I know. I don't have any sense of people. We will probably end up suing each other, but we will get the movie made.

Curtis Taylor, born 1933, appeared in the pages of *Esquire* and other men's magazines during the early 1960s, as well as on television, in series such as *Naked City*, *No Time for Sergeants*, *Gomer Pyle USMC*, and *Wild Wild West*. He played a rich, well-dressed patron of the arts with a taste for bohemia in *Once Upon a Coffee House*, also known as *Hootenanny a Go-Go* (1965). The film is still in distribution, partly because it features the movie debut of Joan Rivers, who appears in it briefly doing a stand-up comedy routine. After his only starring role, Taylor took a ten-year hiatus from show business, presumably the period when he had a relationship with the Reuben's heiress, and returned, known variously as Curtis Brown or Taylor Brown, to produce Fred Halsted's film *Sextool*. He died on the last day of 1978 in Lake Park, Georgia.

Bobb added little to my knowledge of Fred's life, but he used a striking word to describe him. Bobb thought that Fred, alone among the independent filmmakers he had dealt with, was "saintly."

The next lead in my quest for Halsted came from an unexpected place. I discovered that the godmother of one of my friends had known him, because she was married to a man who had appeared in *Sextool*. She did not wish to be identified as a source, but she did invite me to a party hosted by two men who knew Fred well, Rick Herold and Dale Matlock.

Rick and Dale met Fred while he was still a gardener, and they remember his gardens as being based upon forward-thinking environmental principles. To conserve water, Fred planted only native vegetation for one client—now a common practice in Southern California—but this garden proved a bit too advanced for the city of Los Angeles, which issued a nuisance citation for "noxious weeds."

Rick Herold originated the white party, a theme that later became commercialized on the gay "circuit." The event coincided with the full moon of August, and white attire was mandatory. In 1971, Fred came to an early white party as Billie Jean King, to the puzzlement of many in attendance but to the delight of his hosts. He had a dildo rather than a racket swinging from his white tennis dress.

FRED HALSTED, Filmmaker

"Breaks all the stereotypes." -William Burroughs, Author
of Naked Lunch

". . . moving on to greater glory in porno flicks."
-Daily Variety

"New information for me." -Salvidore Dali

Among many distinctions, Fred Halsted's films LA Plays
Itself, Sex Garage and Sextool are in the permanent film
collection of The Museum of Modern Art. His films have
also shown at The San Francisco Art Museum, Nether-
lands Film Museum and in competition at The Deauville
Film Festival in France.

A Fred Halsted bio from the box cover of the original Cosco release of *Pieces of Eight* (1980) on video

The couple provided a bit more information on *L. A. Plays Itself*, identi-
fying the butt double who received Fred's fist as one of his patrons, a concert
pianist in his sixties who had contributed money to the project that immor-
talized his fetish. Unfortunately for the historian, they had forgotten the
man's name.

Like some of his other friends, they thought that Fred's sexuality had been
deeply disturbed by childhood trauma. They described him as "not a happy
gay camper," consumed by guilt and hostility that left him barely able to
function. In the mid-1970s, around the same time that Tom and his lover took
their distance, Rick and Dale drifted away from Fred.

They also told me about a lover who was quite close to Fred for many years.
According to them, he had been the source of many of Fred's ideas. Even
though he was involved with other men after they broke up, he still had a
lingering attachment to Fred. Dale gave me the last phone number they had
for this man, and I called it the day after the party.

Before I had a chance to meet this important ex-lover of Fred's in person, I
received another email from a stranger, a man named Bill Patterson, who had
known Fred at the end of his life.

I met Fred at Griff's Bar on Santa Monica Boulevard at their Sunday beer bust. It was in the summer of 1985. Fred was dressed all in black—black t-shirt, jeans, leather jacket—with his hair slicked back like Elvis in the 50s. We just hit it off and talked about the L. A. gay scene, which was in a state of panic due to the arrival of the "plague," AIDS. For months, we met every Sunday and talked, but we never socialized outside of the bar.

Then Joey died. That was when Fred began to reach out on a more personal level. I often visited him at his apartment on Hammond in West Hollywood. He was severely depressed over Joey's death. Fred told me that he had gone to visit Joey in the hospital, and that Joey had looked at him and said, "You did this to me." Fred was devastated and never got over it. I thought it was a horrible thing for Joey to say, and I told Fred that. Joey also said Fred had corrupted him, which was absurd. Joey corrupted himself. Fred idolized Joey for some reason, and he took Joey's cruel remarks to heart. That was really the beginning of the end.

Fred and I began to meet at Hamburger Hamlet on Beverly Boulevard every Saturday in the afternoon. He said that my interest in writing had sparked an interest in him to work on *Why I Did It*, the story of his life.

He later gave me the manuscript for safekeeping, and I foolishly gave it to a friend of Fred's after his death. To be very honest, when I read *Why I Did It*, I thought it wasn't very good. I had hoped Fred would have gone into more detail about his personal life, but it was more his philosophy than anything else. No juicy details were forthcoming as far as I can remember.

Fred moved to Silverlake, and that was when he really began to decline. He smoked a lot of weed and drank, went to bars and became more masochistic in his sex life. He said he wanted to go to San Diego and find some Marines to beat him up. It was very strange. He had lost his looks and body, but he didn't seem to care. He even took out an ad in *Frontiers* magazine as an escort for a short time, but when clients saw what he looked like, they weren't happy. Fred told me he went to a party, and some guy came up to him and said, "So Fred, how does it feel not to be the most beautiful person in the room anymore?" Fred tried to laugh it off, but he was hurt by that remark more than he let on.

The last time I heard from Fred I was out of town. I got back to my apartment, and there was an urgent message from him asking me to call. By the time I did, he had already committed suicide. I often wonder if I had been there to take his call, I might have somehow talked him out of it, but I don't know. Fred was already dead in so many ways during those last years.

I would also like to add that Fred—despite his macho reputation—was always very sweet and kind to me. I never saw his "dark/sadistic" side, even when he was drunk. He reminded me of an overgrown boy in many respects, someone who had seen and done it all but still had a sense of wonder and humor about life in L. A. during those tumultuous years. He was never bitter or angry or remorseful, unless he brought up Joey, who seemed to possess him in ways I can never quite understand.

I called the number Rick and Dale had given me, and the man on the other end of the line immediately told me that he couldn't help me. He made the odd remark that "a hundred million publishers" had approached him about a Fred Halsted book, but that he couldn't cope with their requests. I told this man that I was working on a book of my own about Fred, and I invited him to lunch at his convenience. He told me that he had just begun a new series of paintings, and that he had no time to spare. Finally, after a few more phone calls, I got him to commit to a meeting. He did not want to be recorded, nor did he want to be identified by name. He chose "Craig" as a pseudonym.

Craig met Fred in 1966 while cruising in Griffith Park. Fred was carrying a butterfly net at the time. The two of them exchanged numbers, and after "forty phone calls," Craig consented to see Fred. Craig was in his first year of graduate school as a painter, and he lived in Echo Park. He threw a party for his art school friends and invited Fred, who, unaware of the customary informality of such gatherings, showed up in a suit with a gift in hand. When Craig's best friend saw Fred at the door in all his youthful beauty, holding a small tree in a terra cotta pot, she turned to Craig and whispered,

"Marry him."

And marry Fred he nearly did. The two were a couple during the period after Fred's first boyfriend, Frank, and before Joey Yale dominated Fred's attentions, though the chronology is a bit vague. As Craig put it, they got together at a time when everyone had sex with everyone, and boyfriend stealing was great sport. A number as attractive as Fred had many men after him, and conflicts ensued, much to his amusement. At one point, Craig discovered that all of Fred's possessions were missing from the apartment they shared. After some frantic telephone calls, Craig found that Frank had "kidnapped" Fred and invited him to live at his place, without anyone bothering to mention it to Craig.

Craig asserted more than once that Frank was a bad influence on Fred, who was indeed very young when they met. Frank had gotten Fred involved in sex scenes that messed with his mind and gave him perverse ideas. I mentioned that Frank bore a burden of guilt for ruining Fred's life, but Craig dismissed this notion as self-dramatizing. Over two decades after Fred's death, the rivals for his attention were still sniping at each other.

Craig claimed the major role in guiding Fred, and "if he had only listened to me, he wouldn't have come to a bad end" was a refrain in the conversation. A property owner who came to lead a settled, bourgeois life after a wild youth, Craig wanted the same for Fred, even if it meant forgoing artistic successes and the risks they entailed. In fact, Fred's other friends considered Craig the bad influence, because he had introduced Fred to drugs, but Craig admitted nothing so unsavory to me. Sanitized pasts, guilty consciences and selective memories seemed to have been common among Fred's most intimate friends. It was no wonder that they tended to favor pseudonyms.

Craig scoffed at any mention of Fred's famous sadism; he was a shy, retiring man who preferred to stay at home reading or gardening. Fred may have been gentle, but he had no qualms about manipulating circumstances to his advantage. He would have sex with unattractive men who had something he wanted, especially money. Russell Padget had been the great victim of this hustle, but he was by no means the only one.

Fred made a lot of money, but as Craig put it, he pissed it all away on drugs, on good times, on men. He had a weakness for what Craig called

EDITORIAL

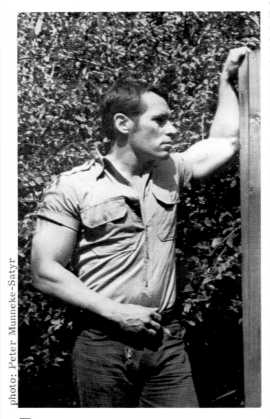

photo: Peter Munneke-Satyr

The wonders of modern psychiatry never cease to amaze me, how they program and control us. Recently we were declared officially to not be sick. Great, really great. Here is the newest thing in psychology, one you will be hearing a lot about in the future.

University of Minnesota psychologist Norman Garzemy has discovered that some children as they grow into adulthood are "invulnerable" . . . invulnerables are people who thrive despite genetic, psychological or environmental disadvantages. They have not been discovered by psychol-

ogy until now because psychology traditionally focuses on pathology or illness and is just now studying how emotionally healthy people develop.

Two other theories of psychology are being exposed as the inhibiting frauds that they are. "Parent Caused," that says your parents are to blame for whatever you are or become and "Trauma," that says that traumatic events in one's life will "cause" you to be harmed. Psychiatrist Richard Farson of San Francisco says, "It may be that the situations that we try hardest to avoid, for ourselves and our children, would actually be the most beneficial to us." Both the "Parent Caused," your dominating mother and weak father theory, and the "Trauma," your camp counselor putting the make on you as a kid, theories have been used to infer that men loving men is somehow deviant behavior and must be explained and cured. Are heterosexuals born straight or did they learn it from Daddy or the school nympho nurse? Who gives a shit?

The Human Development Institute in Berkeley, Calif., did an interesting study of what they termed "eminent" people or people who have achieved some kind of recognizable prominence. Analyzing the childhood of 413 people they found that thirty percent of them had healthy childhoods and seventy percent were raised being despised, rejected, abused, abandoned, ignored or brutalized; their parents were cold, cruel, bizarre, insane or alcoholic. Sounds like one of my movies. Maybe I should film the findings of the various new studies. I think it shoots quite a few holes into the old ideas that a happy normal childhood is inherently good for you as an adult . . . and maybe in fact being exposed to adversity can really help and teach you how to be successful later in achieving your personal aims.

"Invulnerables, especially when they are leaders, tend to be brighter. But we have some who are not outstanding in any way except for the quality of 'plugging away' at making it. They know how to make something out of very little, instead of blaming, they have a tendency to work at finding solutions. They attempt to master their environment." Those are the new wonder words, men . . . like even if you're not an absolute genius, you can still get your life going by simply doing it. This revealing bit of information should make everyone rush out to do it . . . except for the fact you already are.

Now that the love of men for men is becoming an open part of our worldwide society it is time to bring out the obvious fact of the matter. The love of men for men is the oldest continuing culture, through the eons of time we have handed down to each other and have an On-Growing culture that influences and at times rules the specific civilization we currently are a part of. The issue is not gay pride or gay equality but rather the obvious fact of **GAY SUPERIORITY!**

—**Fred Halsted**

harebrained ideas, like moving to New York after seeing a movie, or making his own movies. Fred was captive to whimsical inspirations, which he held as convictions in the face of criticism or hardship. This attitude towards inspiration reminded me of the Doukhobors, and I asked Craig about the influence Mrs. Halsted exerted over her son.

Craig described Fred's mother as "a piece of work," blond and solidly built like a peasant, with a peasant's cunning. Craig told a story about Fred cooking dinner for his mother one evening when he had trouble finding the cheese. Craig and Fred searched without success, but Fred's mother found it right away in an obscure corner. Craig said that she had only just arrived, but she had already "cased the joint." Nothing got by her.

When he had had enough to drink, Fred would regale Craig with stories of the mother he could not allow himself to hate while sober. He told Craig about Four Corners, a bleak desert town where he lived as a small child. Every weekday, his mother went off to work, and his brother Milton, who was four years older, went off to school, but little Fred was left alone, with only lizards to play with. Earlier remarks Tom had made expanded on Craig's account.

> Fred used to tell me about being hauled from one place to another as a child, living in raunchy motels, particularly up in the desert. His mother was always changing jobs, and as soon as he made friends in the schools, she would take him off.
>
> I actually had a great admiration for his transcendence of the hardships of his childhood. He took every day as it came and screwed the past. But you can't discard the past. I always recognized it deep inside of him.

In the first issue of *Package*, Fred included an editorial about a group of people who put their pasts behind them: "invulnerables… thrive despite genetic, psychological or environmental disadvantages." Fred thus made an argument for having benefited from his deprived childhood, and he explicitly mentioned his own relation to the question, though only as possible source material for his work.

The Human Development Institute in Berkeley, Calif., did an interesting study of what they termed "eminent" people or people who have achieved some kind of recognizable prominence. Analyzing the childhood of 413 people they found that 30 percent of them had healthy childhoods and 70 percent were raised being despised, rejected, abused, abandoned, ignored or brutalized; their parents were cold, cruel, bizarre, insane or alcoholic. Sounds like one of my movies. Maybe I should film the findings of the various new studies. I think it shoots quite a few holes into the old ideas that a happy normal childhood is inherently good for you as an adult, and maybe in fact being exposed to adversity can really help and teach you how to be successful later in achieving your personal aims.

Fred came from nothing, and whatever he learned, whatever he owned, he acquired himself through guile and exploit. Craig implied it was somehow unfair that Fred used his good looks for economic gain, but he had the luxury of other options (not to mention the luxury of still being alive). Without supportive parents, sufficient money or education, Fred had little choice. His looks were what he had to work with, and selling his body to a generous older man was more palatable than selling it on a construction site, in a factory, or on a farm. That Fred was able to achieve the success he did qualifies as a triumph, though when his "attributes" began to fade, the situation became dire. The first time Craig saw Fred piss his pants in a bar, he thought of Jackson Pollock pissing in Peggy Guggenheim's fireplace. At some point, the antics got stale, and the pisser became just a smelly middle-aged man with problems.

Craig described himself as a multi-millionaire, but this was not the achievement that he truly craved. Frustrated ambition was the subtext of much of our conversation, and while Craig was self-aware enough to recognize it, he could not keep his jealousy entirely in check. Whereas Frank had been clueless about the merits of Fred's work, Craig knew all too well what set Fred apart. In whatever field Fred tried his hand, he made an impression. Under the chatty exterior, Craig harbored a bitter resentment. He couldn't understand how this charming upstart could have become a star, while he, with good sense, ideas and education, remained alive to tell the tale, but in obscurity.

Craig asserted that the very notion of Fred becoming a filmmaker came from him. Fred had no particular interest in film until after he had seen Craig make a film, go to a film festival, and receive attention for his work. While admitting that Tom had helped to shoot *L. A. Plays Itself* ("the dark, underexposed parts"), Craig claimed credit for the shots of Fred walking and driving around Hollywood, material that the director himself couldn't have shot, since it is all hand-held camera work. Fred also painted, and though he had few fans in this endeavor, it must have been extremely galling for Craig, the serious painter, to see the exhibitions and notices that Fred's paintings received, most of them arranged by Russell Padget, Fred's sugar daddy.

I asked Craig about *Why I Did It*, and without hesitation, he said that he had the manuscript. I asked if Fred's autobiography was interesting, and he flatly answered, "no." The problem with autobiography, Craig explained, is that "it's all 'me me me' without acknowledgment given to the people who shaped someone's life." I imagined a scenario in which Craig, very distraught, yet mustering all his charm, pried Fred's manuscript away from Bill Patterson. I had originally thought that Craig wished to suppress the book due to unflattering references to him. His comment on autobiography made me suspect that he discovered, to his chagrin, that the book didn't mention him at all.

In early May 1989, Craig took a vacation with his boyfriend to Hawaii, where they visited friends Rick and Dale at their house on Kauai. Before they went away, Fred asked Craig for money, then left and returned soon afterwards to ask for more money. Craig assumed that Fred was buying drugs. A week later, while napping on a Hawaiian beach, Craig abruptly woke up, realizing that Fred must have used this money to buy enough barbiturates for an overdose. He had the feeling that Fred was dead, and he insisted on returning to Los Angeles as soon as possible. Once he was back home, Craig called Milton Halsted to check if Fred was still alive. Milton at first said that his brother was fine, but admitted that he hadn't talked to him for a few days. An hour and a half later, Milton called back to say that he had found Fred dead, sprawled in his Eames chair, with a will and a suicide note at his side. He asked Craig to come over and "pick up his shit," but by the time

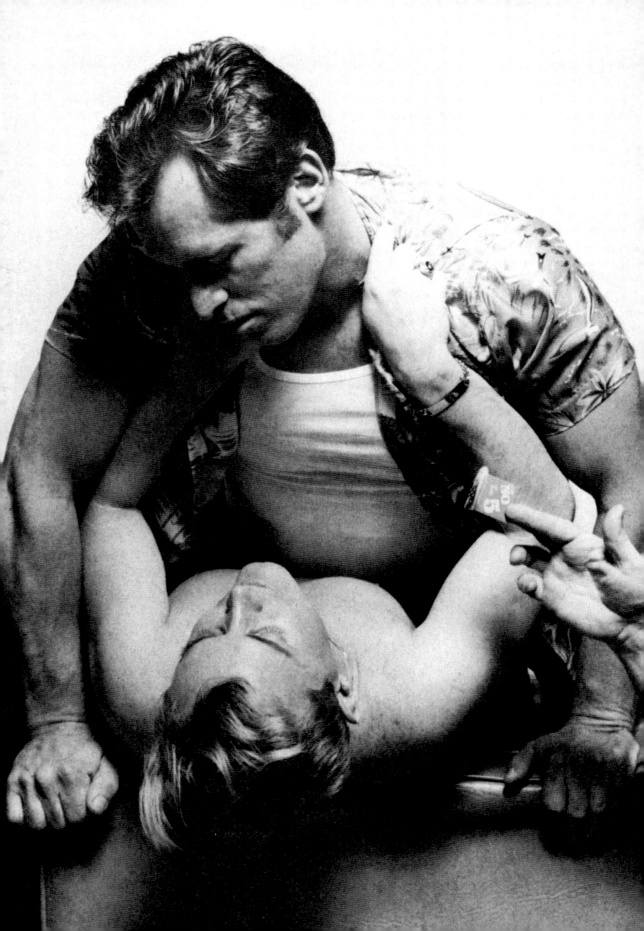

that happened, Milton had already put down the cat that Fred wanted Craig to adopt after his death. In the end there were few possessions to deal with, since Fred had sold the Cosco films and all related materials to VCA some years before. When an autopsy was performed on Fred's body, the cause of death was determined to have been acute pulmonary edema, acute intoxication, and the combined effects of ethchlorvynol and chlorpromazine, in other words, suicide by ingestion of drugs. Fred died on the evening of May 9, 1989.

Beloved Pariah

My search for the manuscript of *Why I Did It* became a running thread through the research I conducted on Fred Halsted's life. The man I believed to be in possession of the manuscript gave me a number of answers to my inquiries: I have it; I read it, but it wasn't very good; I can't find it; Fred's brother has it; *et cetera, ad nauseam*. Since Fred had only one copy, and as far as I was able to determine, nobody saw fit to make another, at least one of these answers must have been a lie. We spoke in person only once, and subsequently, I got no more access to him or his memories of Fred. I was left with a question as important as the contents of Fred's autobiography: Why was he playing games with me?

I could not dismiss this man as a solitary kook who took pleasure in thwarting me—though he may have been just that—because he wasn't the only one offering resistance. No single person I interviewed was an excellent source, speaking openly, for the record and for attribution to a real name. Most required anonymity to loosen their tongues, while others seemed to withhold much more than they disclosed. Everyone added the proviso, "Please don't mention…" whether the taboo was an especially salacious story, a paranoid theory, or facts that would reveal an identity. Some sources meant well, but when pressed for specific details, couldn't remember anything substantial. I got the impression that Fred kept his friends separated, which would have suited someone given to self-mythologizing. When I passed a phone number from one friend to another, it struck me as odd that the two

had never met, since they lived in the same city and were friends with Fred around the same time. Perhaps one had an entrée into the Hollywood occult S/M scene of which I had heard tell, and the other one didn't. Perhaps the two of them had had sex once but couldn't recollect meeting socially. It was, after all, decades ago.

Though they could be skittish, Fred's friends were positively verbose compared to the Halsted family. The brother who could have confirmed or refuted Fred's assertions about their childhood remained silent, and furthermore instructed his daughter to stop communicating with me. I compensated for the lack of direct contact with the family by searching genealogy websites extensively. I was aided by Lillian Halsted's conversion to the Mormon religion late in life. (She must have missed following a prophet.) When I discovered her maiden name, not only did a whole subculture of Doukhobor genealogists open up to me, but I was able to obtain a copy of Fred's death certificate from the State of California. By happenstance, I got a sense of what was at stake in the family's avoiding the publicity of a Fred Halsted biography when I saw that renovations to my local pizza parlor were being done by an Orange County firm called Halsted Construction. Or perhaps this was only a coincidence.

Fred's former colleagues tended to respond to me in one of two distinct ways. Those who knew Fred from his porn productions and who continued to work in the adult industry were completely forthcoming, but since their connection to Fred was mainly professional, there were certain limits to what they were able to tell me. The film or video makers with some claim on wider recognition admitted knowing Fred and volunteered little else. From them I collected bland and useless emails that I took to be testaments of historical revisionism or professional jealousy. One of my friends called the phenomenon "when queens collide." I can only hope that their biographers prize stories out of them before it is too late, as it was in Fred's case.

The cultural establishment offered inconsistent help to me during the research for this book. Curators failed to remember much or were unavailable for comment. A number of video and audio recordings have disappeared. Events were arranged and accessions made, but no one wished to take credit for them. Archivists were much more helpful, and I was thankful that the

written word, once published, cannot be completely obliterated. But I found that in the case of an artist or author working far beyond the pale of official culture (as Fred certainly did), finding and retrieving archival materials posed serious challenges. A multitude of publications—occasional, homoerotic, frankly pornographic—have never been catalogued, and I wonder how many decades will pass before they finally are.

After many frustrating detours and dead ends during my research, I came to the conclusion that everyone with a respectable career and an intimate connection to Fred Halsted chose to honor the demands of the former rather than the memory of the latter. I can't blame them for their reticence. This is what the world requires of them.

Halsted lived in disregard of what the world required of him. He made his own way. For a handful of years he made something extraordinary seem possible. Some saw him as the man who introduced sex without censorship into avant-garde film; to others, he was an experimental porn director; but Halsted himself had no interest in maintaining those boundaries. He believed in sexual liberation—indeed in a kind of utopia—and he was willing to sacrifice any possibility of a conventional career for it. Detached from practical realities and courting controversy, he inspired intense reactions, and at their best, his films did the same. An historical divide separates us from his achievement and causes us to wonder how he got away with it. Fred Halsted continues to be a polarizing figure, a reminder of a golden age now definitively over, perhaps one day to return.

REVIEWS

The following articles give an indication of how the press responded to Halsted's films at the time of their first release. Halsted's early works gained considerable notoriety, due partly to their unprecedented content and partly to their aesthetic merits.

Jonas Mekas' perceptive piece, one of his "Movie Journal" columns for the *Village Voice*, is the first published reference comparing Halsted to Rosa von Praunheim, a figure who would cross Halsted's path a number of times over the course of his career.

Publicist Stuart Byron praised *L. A. Plays Itself* in another *Village Voice* article appearing three months after Mekas'. Byron's denial of conflict of interest drew criticism at the time, but his article gives a sense of the terms of the debate around Halsted's work. His comparisons, while far-fetched, suggest useful coordinates for understanding Halsted's ambitions, or at least those ambitions imputed to him by his supporters. (Note: Byron mentions the two "halves" of the film in the reverse of the order they have today.)

William Moritz wrote an atypically positive review of *Sextool* for the Los Angeles magazine *Entertainment West*. By the time of its publication, Moritz had already known Halsted for a very long time. The two were classmates at Abraham Lincoln High School in San Jose, California.

"Movie Journal," *Village Voice*, April 20, 1972

Jonas Mekas

I was sitting with some friends and drinking dry Californian Chablis at the Carnegie Hall Tavern after seeing Fred Halsted's movies, *Sex Garage* and *L. A. Plays Itself.* I swear, I have never watched a movie in a more smoke-filled theatre than this particular time at the 55th Street Playhouse. Everybody was smoking continuously. I could barely see the screen through the smoke. The only explanation I could give for this was that everybody was very very nervous. In case the reader doesn't know, both movies are billed as erotic, homosexual movies. The first one involves a woman and three men; the second involves a series of men.

As I said, I was sitting and drinking wine, with a few friends, and we talked. We all enjoyed the movies and we thought they both were unusual and unique and good movies, as far as "sex" and "porno" movies go. We agreed with no big arguments that these were two movies we won't forget soon. Then, of course, we wished they were better. And Jimmy, he said something to the effect that, of course these movies are only the beginning of a movement of the porno cinema as art, and, he said, of course, soon there will be others who will do it better than Halsted and there should be some great porno movies coming soon. And as I was drinking my Chablis, trying to wash that 55th Street Playhouse smoke out of my system, I said, yes, it may be very true what you say. But something else keeps knocking at my mind. And that is, it seems, somehow, no matter what genre, what subject, it seems that always the very first works are the most dynamic and original and exciting, and that applies to the same treatment of nudity and sex in movies. Didn't everybody say the same after *Flaming Creatures*? Ah, Jack broke the ice, and now we'll have an upsurge of tremendous, liberating and liberated movies about sex, and the body, etc., etc. And, of course, they said *Flaming Creatures* wasn't perfect and it was amateurish and there will be others much more perfect. And, of course, other movies followed and

they were more perfect, more balanced, and more calculated, like, for instance, Steven Arnold's movie shown at the Whitney recently, *Luminous Procuress*. And still, when you look back now at *Flaming Creatures*, from all this perspective, it remains the unique and classic masterpiece of its genre, one that crackles with strange and inimitable dynamics, and it seems it said everything that had to be said on the subject, and nobody has added a bit to it. Same goes for Barbara Rubin's *Christmas on Earth*, for Genet's *Un Chant d'Amour*, and for Anger's *Scorpio Rising*—they are simply inimitable, and they explore their worlds so totally and so deeply that there is nothing more to say on the subject.

So now we have Fred Halsted, and Rosa von Praunheim, and everybody's saying the same about them: Yes, fine, very fine, but we hope this is only the beginning, and others will come soon and will do a real good and perfect and just job—justice to everybody. It was very funny, during the MoMA screening of Rosa von Praunheim's *It Is Not the Homosexual Who Is Perverse but the Society in which He Lives*. There were homosexual lib groups in the audience, and they attacked the film for not doing justice to the homosexual cause, etc. It was funny, because justice, balance, perfection is neither here nor there when we come to art. Justice and balance matter only in social documentaries and second-rate works. Praunheim shouted it out, (her?) his film is a direct, shrill, immediate voice, now, today. And there it is, this film, an undeniable cinema fact, with its shrill voice, its uncontrolled heat, and with its imperfections—a passionate, total uncompromising statement. And, of course, there will be other films later on the subject, and they'll be more quiet and more sober—some of them may be even made by the UN…—but I can almost bet that none of them will have the fire, the energy, the uniqueness of Praunheim's film. And the same, even if in a smaller way, goes for the films of Fred Halsted. There is something about the first cries, first loves, first journeys abroad, first almost everything—and they are inimitable and they are total and very very real and they sum up once and for all everything that there is on the subject.

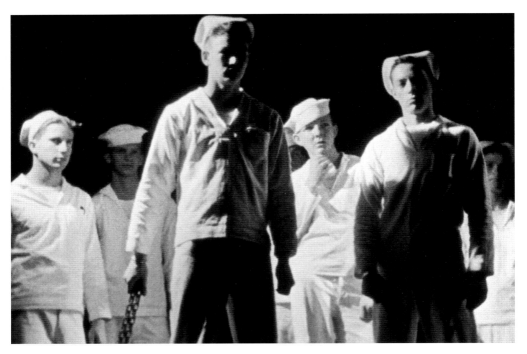

Still from *Fireworks* (1947) by Kenneth Anger

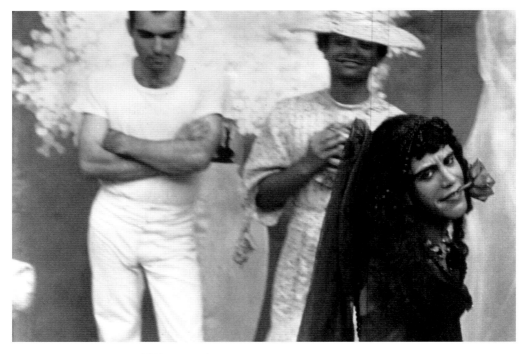

Still from *Flaming Creatures* (1963) by Jack Smith

"Brothers Under the Skinflick," *Village Voice*, July 20, 1972.

Stuart Byron

To me, its former publicist, has fallen the responsibility (perhaps I should say the opportunity) to review (perhaps I should say defend!) *L. A. Plays Itself*, which recently completed its run at the 55th Street Playhouse, at which point my own involvement with it, and thus any possible conflict of interest, ended. Fred Halsted's film, as everyone knows, was advertised and promoted as a gay porno flick, or rather as some sort of unique admixture of that and of an underground tradition lately dormant in light of current "structuralist" experiments—the "personal" film of homoerotic sensibility (Anger, Markopolous, Smith), including all its attendant emphasis on montage rather than camera movement—though it differed from its predecessors in being done from a "butch" rather than "femme" aesthetic which may have accounted for its critical and commercial problems: people had to learn to come to grips with John Rechy's *City of Night* at first. It was as if the sailor rather than Kenneth Anger had made *Fireworks*, as if Joe Buck rather than James Leo Herlihy had written *Midnight Cowboy*.

That of course was only one of its difficulties, though the one, probably, which accounted for its run being moderately successful (the film made money) rather than a smash: *L. A. Plays Itself* was done so relentlessly from one point of view that the "passive" homosexual had scant opportunity to identify with much of it. The film had its defenders, straight and gay, some of whom got into print, editorially or via advertisements (Jonas Mekas, Arrabal, William Burroughs, Al Goldstein), others who spoke to me and expressed reactions, ranging from "of some interest" to "fantastic" (Molly Haskell, Adrienne Mancia, Larry Kardish, Taylor Mead, Elliot Stein, Richard McGuinness, Foster Hirsch). Despite all this, despite a regular series of press screenings, despite some admittedly pushy telephone calls and letters from me to prestigious critics, *L. A.* was not reviewed very much, largely because of anti-porno policies at most periodicals (though I do think that if some hetero skinflick like

Hot Circuit had attracted praise from Arrabal and Burroughs, a few of the major media would have seen fit to talk about it).

Otherwise—though this may be typical press agent's paranoia—I seemed to face a sea of hostility, the rudest and most insensitive wave of which appeared to emanate from industry nellies who were so "offended" by the picture's "disgusting" sadomasochistic elements that they assumed to my face that only money had attracted me to promote a "bad" film, that I was insincere in my claim that my involvement in *L. A. Plays Itself* was a one-shot return to a profession I left five years ago and that my involvement occurred because this was a film in which I believed and which I thought of great importance. Except to say that the film is more than mere pornography, I can understand better those homosexuals for whom the picture did not work in that way; different strokes for different folks, and there are those who came back day after day, who were turned on sexually for weeks as they've been by no other film. Of least comprehension to me were those who felt that I had "ripped off" the movement via my pair of gay lib screenings, screenings which resulted in some initial ad quotes from movement figures. Surely there are problems inherent in the idea of "using" pornography to convey a message that, in its widest implications may be anti-pornographic, and had this been the complaint I would have understood it.

But it wasn't; what shocked me more than anything in the whole affair was that so many movement people I respected didn't even get the message. I will never again take a ho-hum attitude toward Marshall McLuhan since it has been brought home to me so forcefully how "linear" most people's perceptions are, how the very ideas that some people talk about every day can be missed if presented "visually." Some of the ranting and raving came from the movement's right wing, from sadomasochists who resented Halsted's intercutting of newspaper headlines about weird cults and the Manson murders during the film's notorious "fist fucking" sequence, a scene which showed no reaction (another complaint) on the part of the receiver. Halsted, to me, was simply and honestly presenting thoughts that might go through his head, with no comments on whether or not these thoughts (as Reik and Lorenz might argue) expiate such acts. As for what might be called the fist fuckee, I see hiding his

reaction from the camera as in keeping with the movie's relentlessly personal view; true, tied down on the bed, he shows no pleasure, but he also shows no pain. Art and politics rarely mix, to a right wing or a left.

And it was from the left that there came the most shocking shock of all. For the very same people who argue that the straight world's sexism carries over into the gay, that gay men are socialized to be Don Juans and to treat the potential partner as nothing but a sex object, that all of this results in the tradition of promiscuity and one-night stands—these were the very people who so totally misunderstood the film. A radical homosexual newspaper like *Come Out!* never ceases its reportage of the Marcusean sexualization of consumer objects, yet its editors and contributors saw none of this in Halsted's continual intershots of billboards, of ads pushing "101 varieties of meat." Did not see, really, that the one long impersonal cruise which is so much of urban gay life has never been presented as forcefully as it is in *L. A. Plays Itself.* Cruising, passing a billboard in a car, kicking a backside as if testing a steak's tenderness, fist fucking, fantasizing oneself (as does Halsted, who "plays himself") into the image of the ultimate male stud—all of this intercut so that it could be taking place (in the director's words) in "a day, a month, a year"—this is the nature of male gay life as it is presented to us by the movement's more radical elements. And to even ask the question as to whether the three objects of the Halsted character's desires are one and the same (the "kid from Texas" on the soundtrack, the blonde boy tied up in the closet, the fist fuckee) is to miss the entire point; they were, in fact, played by three different people, but does that matter? They are meat, machines, "numbers," (in the gay parlance Rechy used as the title of his second novel,) impersonal sex objects. This is the paradox of urban life *in extremis*; for while it is true that there probably was no gay subculture in the West until the Renaissance and the consequent rise of cities, it is also true that urbanism only encouraged chauvinism and sex objectivism.

To which the American's traditional response has been a wish to escape to the country, at one time the Western frontier, except that after California there was no more frontier, a historical fact that we've come to learn to accept in the East. In the West, where gay liberationists dream of taking over whole counties (the abortive Alpine project), less so—which makes *L. A. Plays Itself* very

much the film of a Californian. The Arcadian dream of its misnomered "second half" is of course a total fantasy, as the director clearly knows, the intercut shots of flowers in the Decker Canyon sequence of two men having pastoral sex being so insistent as to be almost (but not quite) parodic. Almost, but not quite: it is a certain ambivalence that makes *L. A. Plays Itself* great or near-great to me. Though the director himself, if only for convenience, refers to a "first half " and a "second half," in reality the film is one of those pioneering works (Whitman, Eliot, Ginsberg) which uses a simplistic structure to work against a detailed complexity. Los Angeles plays itself: the Angels vs. the Dodgers, neither of them necessarily superior to the other, the first half only perhaps the "bad" side of gay life and the second only perhaps the (impossible) "good." For the director is playing himself in that first "half," which makes *L. A. Plays Itself* the first "confessional" film, as those of Lowell and Plath are confessional poems: the person who likes both sadism and flowers, exactly like Barry Foster in Hitchcock's *Frenzy*, except that Halsted rejects completely Hitchcock's classically Freudian view that these are components of the homicidal personality. But he has the courage to present himself and to say, "Think of it as you will." Has there been another film quite like this?

The cars, the machines, the dirty stairs, the casualness of urban Los Angeles turn the director on at the same time that they foster a certain amount of guilt, which is why the near-final image of the bulldozer destroying Decker Canyon is both tragic and relieving and leads to the last shot of an American flag, symbol of the country of the violent pacifists. Each "half" has elements of the other: listen closely to the carefully recorded soundtrack and hear cricket noises during the fist fucking scene, as if to convey that this seemingly unnatural act might be the most natural of all. Note that the motorcyclist who is to be seen as part of the couple in the second "half" is already on his way to Decker Canyon during the first, and with Halsted in car following him—the country scene being but a continuation (though a fantasized one) of the endless voyeurism of the city scenes: the director is hiding in the bushes. The film is made by a man brought up an American (therefore a Christian, therefore in the Puritan heritage) who now claims to be a Buddhist; if you can wrench your mind from the coordinates of a Christian culture (the coordinates

which function in *Frenzy*), you can see the two "halves" of *L. A.* as kind of yin and yang. To prepare for the fist fucking Halsted masturbates in a Buddha-like position, and superimposed over the seemingly "normal" sexual act in the country is the bulldozer suggesting that all lovemaking is sadomasochistic.

Like Mizoguchi in *The Life of Oharu*, Halsted accepts destruction (theatricalized in his film as sadomasochism) as part of a natural order. Bruce Baillie's most underrated film, *To Parsifal*, also in two parts, is perhaps its only real harbinger—because there, too, a Christian-cum-Buddhist was trying to reconcile contrasting beliefs, trying to understand his attitude toward, say, tuna-fishing. Rossellini's *Stromboli* makes an interesting cross-reference; there, too, tuna-fishing was seen not as destruction but as part of a natural order, and in light of it the making of the Christian-Buddhist *India* eight years later seems less surprising. It is, finally, to this tradition, and not to that of the underground homophile fantasy nor in that of the gay porno film, which Halsted's film belongs, and I am not surprised that, save for a few exceptions, it was misunderstood by most homosexuals and most film critics.

"*Sextool*: Fist Fucking the Mind?" *Entertainment West*, March 28, 1975

William Moritz

There was a time when one could be justifiably outraged at being asked to pay $5.00 to see the sort of poorly made exploitation films shown at gay porno theatres. In fact, many a piece of film trash is still being shown today, and even the finest available gay sex movies, like Wakefield Poole's *Bijou* or Arthur Bressan's *Passing Strangers*, imaginative and "artistic" as they are, often suffer from cheap production values, low quality, non-synch sound, and other shortcomings.

Well, Fred Halsted's films have always been an exception to the general standards, and his new feature, *Sextool*, is really worth the money. Ironically, it's not yet scheduled to open in L. A.

SEXTOOL

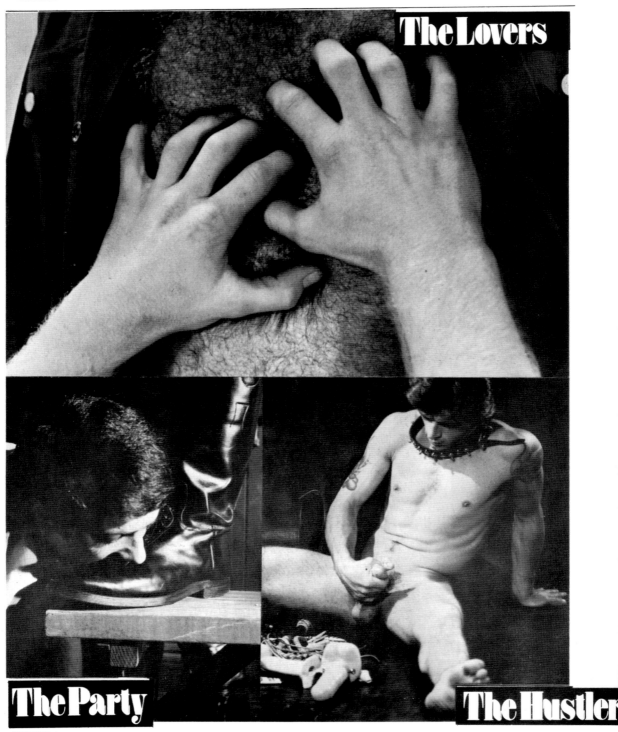

The Lovers

The Party

The Hustler

FRED HALSTED'S NEW MOVIE IS NOW A PICTURE BOOK.

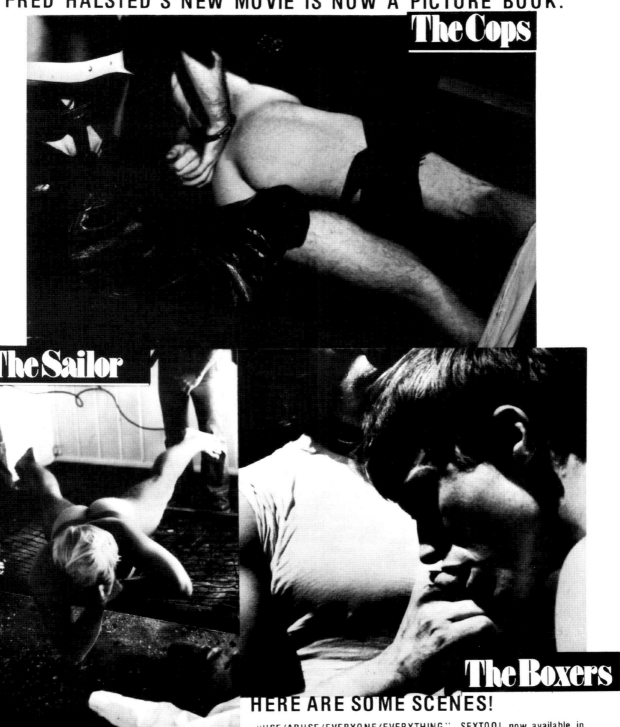

The Cops

The Sailor

The Boxers

HERE ARE SOME SCENES!

"USE/ABUSE/EVERYONE/EVERYTHING" SEXTOOL now available in 48 pages of movie stills in book form from ROBERT PAYNE, 5466 Santa Monica Blvd., Los Angeles, CA 90029 priced at $7.95 (plus $1 for First-Class postage).

Like his earlier films *L. A. Plays Itself*, *Sex Garage*, etc., it is produced, written, directed, edited and photographed (as well as starred in) by Halsted himself, who brings a cogent excellence to each task. However, unlike Halsted's earlier films, *Sextool* is shot in 35mm like a "real" movie, which allows an even more brilliant clarity of image and precision of sound than before.

One immediate measure of Halsted's artistic and conceptual excellence is that he does not waste energy trying to simulate a "plot" in the old-fashioned sense, but rather works with parallel ideas which set up a critical dialogue directly in the viewer's mind.

Sextool's structure is a refinement and development of *L. A. Plays Itself*. Whereas *L. A. Plays Itself* showed us two contrasting worlds—the idyllic, romantic garden vs. the sadistic, concrete city—*Sextool* centers around a party where a relatively innocent married young man discovers the diverse sex-practices of a dozen people. Shades of Jean Genet!

In the opening shot, the camera pans across and down the ropes and scaffolding of a backstage area (where? why? no matter: all the world's a stage) to show Gloria, an oriental transvestite (played with a little stiffness of dialogue by Charmaine Lee Anderson). She is taking Jeff (Gus Harvey from *Sex Garage*) under her wing, saying that if he thinks she is wild, he should meet some really heavy friends of hers who will be at a party that night.

We then cut to a powerful shot of filmmaker Halsted emerging from a tunnel, staggering drunkenly toward a huge prison-like gate-grid; breaking a bottle against the metal. Again there are no plot connections: this is merely the introduction of a counter-idea, a hard and violent contrast to the swirling chiffon of the transvestite's stage-borne caprice.

The journey to the party itself is a sex fantasy: two black dudes in the back seat of a limousine are given head by a white hippy prisoner while the white chauffeur watches in the rear-view mirror and beats off.

At the party, the charming, neat social façades of the guests cut away to their sex roles—to uniformed cops who beat their victims with billy clubs; to bikers who fist fuck a sailor; to a young man who masquerades as a Marlene/Cabaret-type singer and merely watches as another rather depraved-looking young man wearing a "Rent-A-Kid" T-shirt tortures himself with

various sex-toys, from clothes-pins to condoms; to a boxer who brutalizes his waterboy, ripping his jock-strap off, piercing his nipple, etc.

Sextool is primarily an art work (it has already been shown at the Museum of Modern Art in New York and the San Francisco Art Institute) and some people who really like ordinary porno films might not immediately get off on it.

Though it is quite "explicit," as they say in the ads, it is the subtlety of the eroticism, and the conceptualization of the images that linger in the mind: the flesh of the sailor's back pressing through the bare springs of a barrack bunk bed; the fingers of the Cabaret queen curling slowly around the edge of the frame, then seeming to pull the camera over to reveal one made-up eye peeking out; the dynamism of Buddah Mae and the other party guests with Rick Herold's magnificent blue neon cock looming above and behind them; the waterboy slowly licking the blood from a cut on the boxer's knuckles.

Furthermore, each of the sex fantasies is perfectly realized in purely cinematic terms. The limousine ride is formulated with jerky, dimly-lit shots and quick, fragmentary close-ups that render the experience of the chauffeur, glancing covertly in his little mirror and over his shoulder, as it must seem to him.

The voyeurism and exhibitionism of the Cabaret queen, "La Belle Eccentrique," and the "Rent-A-Kid" sex-toy man is vividly expressed by having their activities cut together so that we feel they are performing simultaneously for each other, but we never see them together in the same space.

The erotic subtlety of the act of fist fucking has never been better represented than in the exquisite scene in which the biker with enormous, pumped-up biceps begins to grease his hands with Crisco, slowly working the white film up over his forearm like a silk opera glove until he reaches the bulging bicep, then over that mighty muscle too, blowing the mind (fist fucking mind?) with the thought that this, too, might penetrate somebody. Slowly the hand reaches up through the bedsprings… cut away to the upper bunk, leaving the action to finish and linger in our memory.

All of the scenes are underscored by excellent electronic music composed by Donald Geoffreys, who gives us rhythmic whirs, swishes, and pulsations that extend the sexual actions onto an auditory plane as hearing gestures. This

music is further mixed with layers of sound effects, voices, noises, in what Halsted and co-producer Taylor Brown call an homage to Robert Altman, their favorite feature director.

As the title of the film itself implies, Halsted is interested in coming to terms with sexuality in its own right. Unlike sentimental, bourgeois mush such as *A Very Natural Thing*, *Sextool* depicts forbidden though common fantasies and acts as valid expressions of human relationships.

The closing shot of the fist fucking sequence is the biker bending down to kiss his sailor-"victim" with such tenderness and eroticism that we must understand all at once (if we don't already know) the fine and delicate balance, the true trust and love that must flow between the master and slave in an S&M ritual.

The heterosexual, middle-class concepts of marriage and morality that have been foisted upon gays by society are ruptured and banished. The performers are not sex "objects" like the women in straight gigs, to be used and dropped, but rather sex "tools," instruments to play out fantasies, implements to realize dreams.

Nowhere is this more clearly stated, perhaps, than in the end of the scene in which Halsted plays the boxer punishing the waterboy (played by Joe Yale, Halsted's slave-lover in "real life"). As Joe is knocked into the corner of the room, his face strikes against a mirror, assuming the famous narcissist pose of the poet in Cocteau's *Orpheus*.

Slowly from above, a stream of piss pours down the glass, down the face, rendering the image and the image-maker liquid. As Joe's face turns upwards with a look of joy and satisfaction, the master transcends: Fred's boot, punishing, comes crashing in to crack the mirror, scattering the fragments of fulfillment in slow motion to the ground. This is personal cinema at its finest. Use the right tool for the right job!

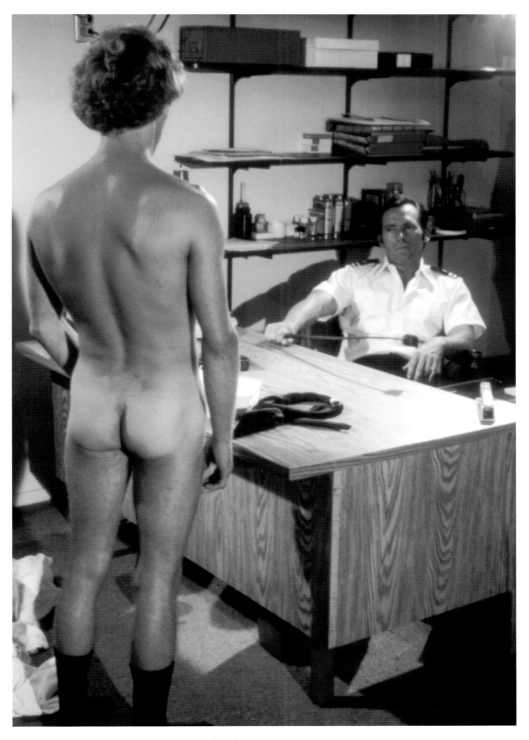

Shawn Victors and Fred Halsted in *Three Day Pass* (1979)

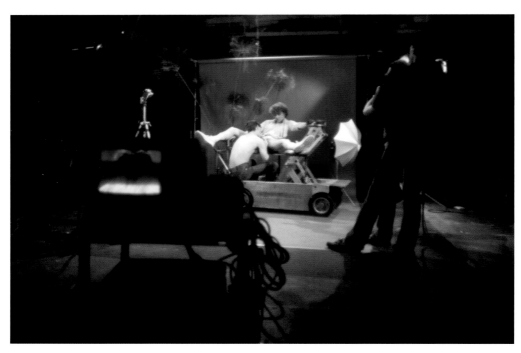

Jeremy Scott and John Ayres performing on the set of Fred Halsted's *Move Over, Johnny* (1985)

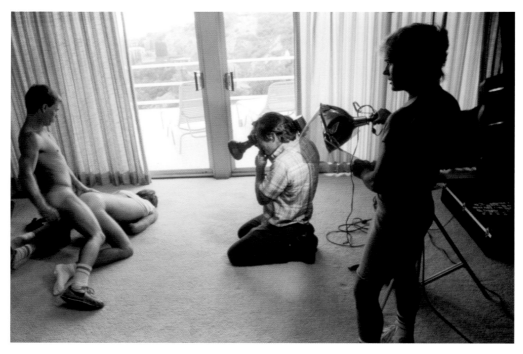

Chris Burns, Paul Monroe, Fred Halsted (with camera) and Joseph Yale on the set of Yale's film *Alleycats* (1983)

Return to Malibu: Fred Halsted during the filming of *Alleycats* (1983)

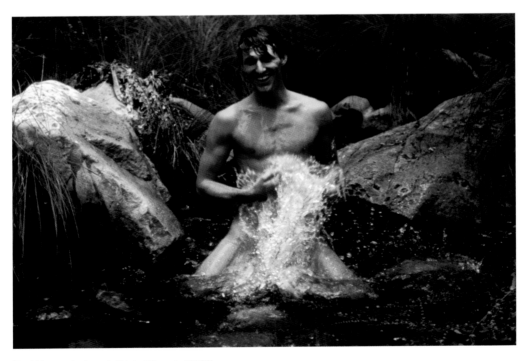

Paul Monroe in Joseph Yale's *Alleycats* (1983)

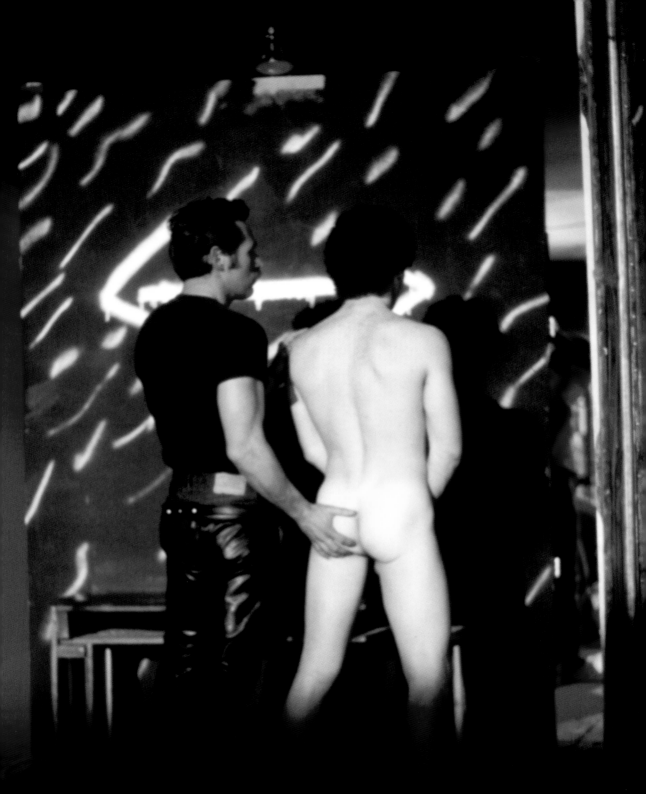

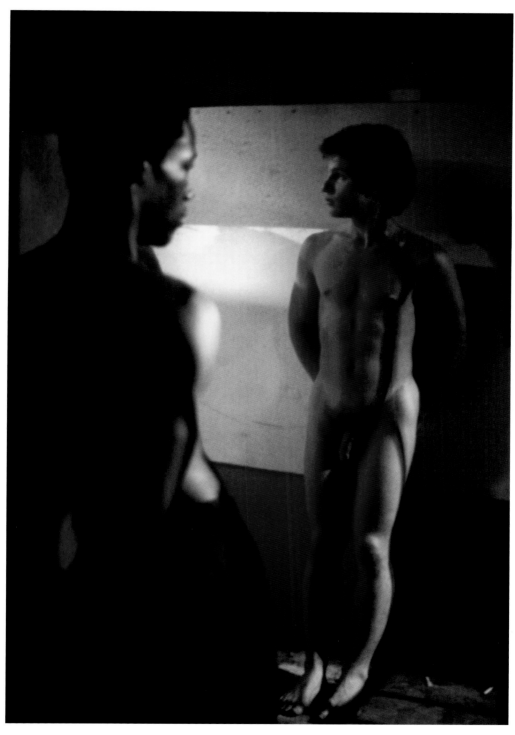

On the set of *A Night at Halsted's* (1981)

Opposite page: Fred Halsted directing Greg Dale on the set of *A Night at Halsted's* (1981)

Page 134: Fred Halsted filming J. W. King in *A Night at Halsted's* (1981)

Page 135: J. W. King and Gary Sikes in *A Night at Halsted's* (1981)

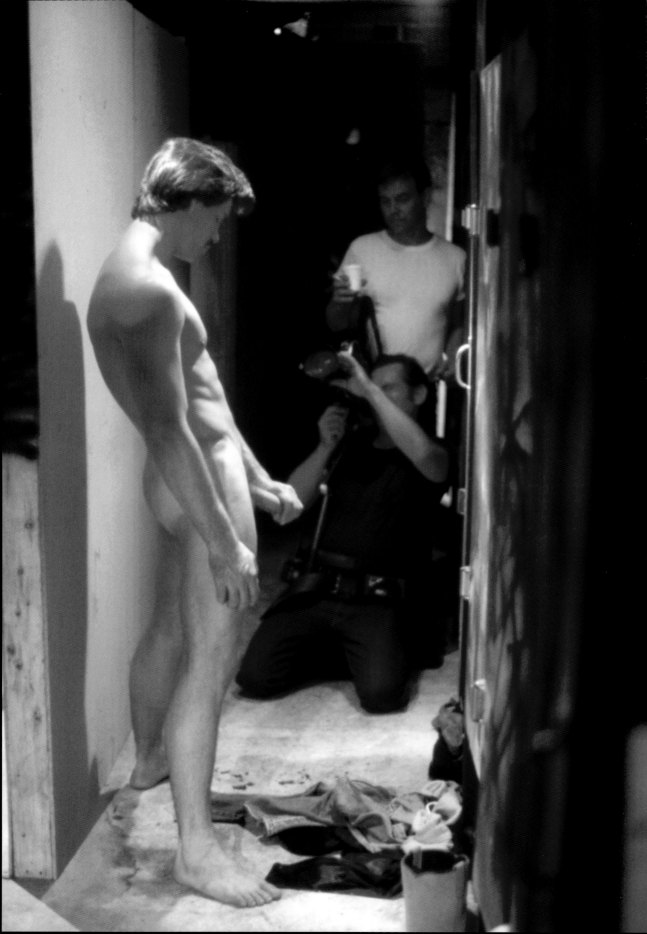

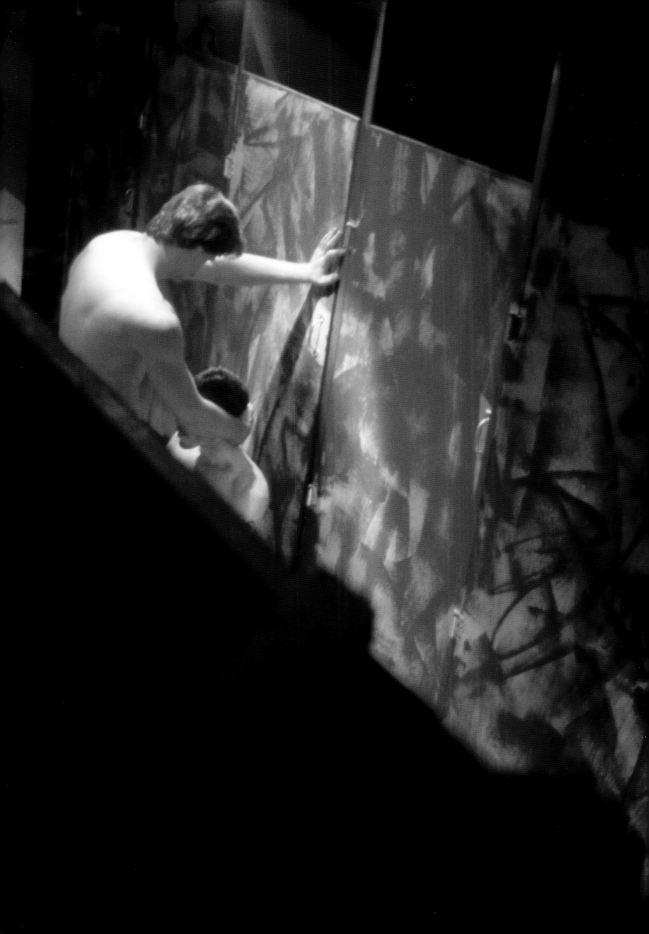

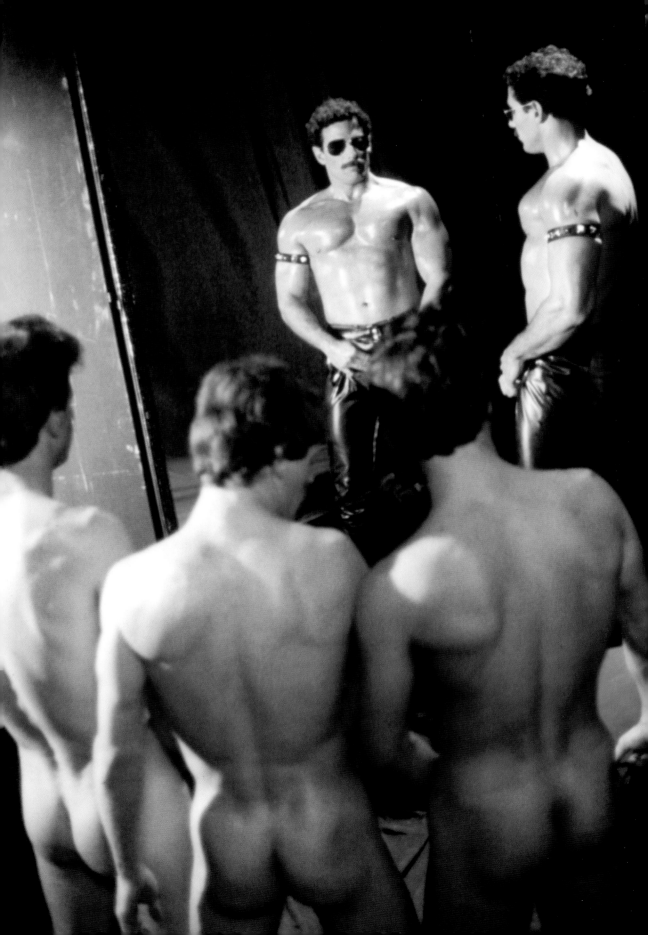

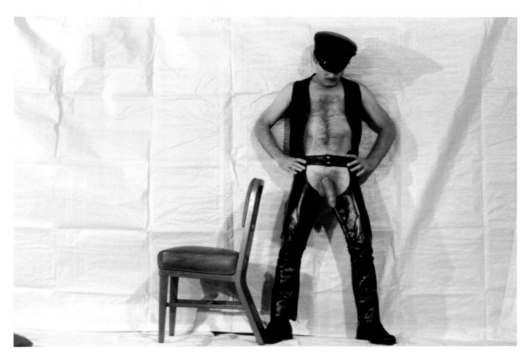

Donkey Daddy in *Revenge of the Nighthawk* (1983)

Production still from *Revenge of the Nighthawk* (1983)

Opposite page: Clay Russell, Johnny Dawes, Jon King and Shawn Thomas in Joseph Yale's *Trick Time* (1984)

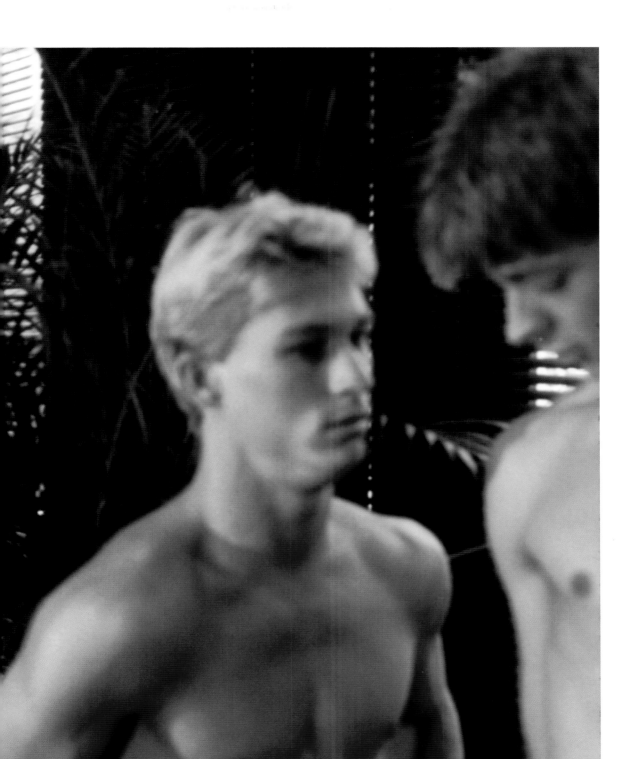

Chris Allen and David Ashfield in Joseph Yale's *Coverboy* (1984) shot and produced by Fred Halsted

Rocky Genero, a. k. a. Dan Pace, in *Pieces of Eight* (1980) directed by Fred Halsted

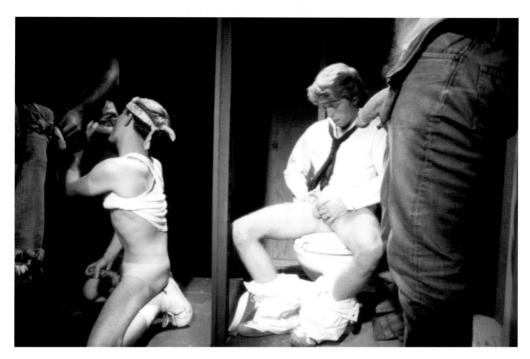

Production still from *Three Day Pass* (1979) directed by Nick Eliot and produced by Joseph Yale, who appears on his knees in this scene

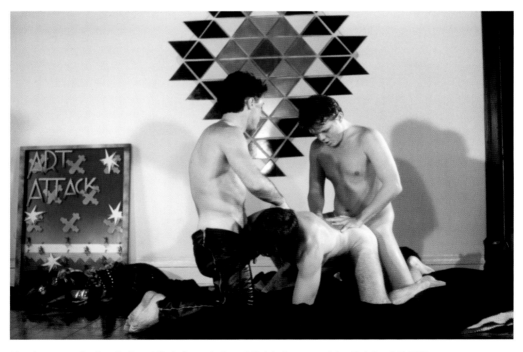

Kurt Sampson, Jim Stanford, and Chris Burns in Joseph Yale's *Revenge of the Nighthawk* (1983)

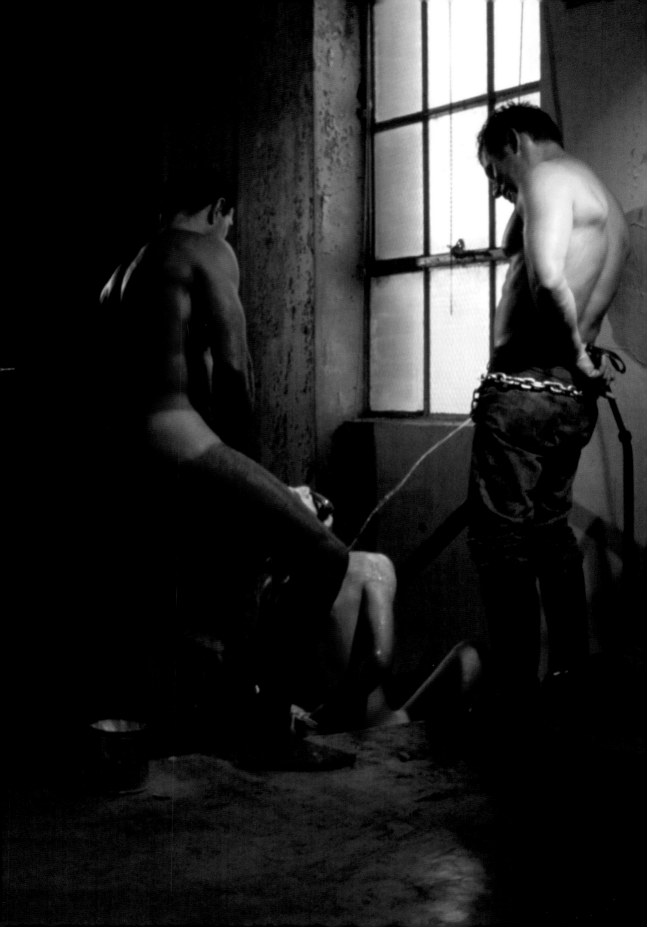

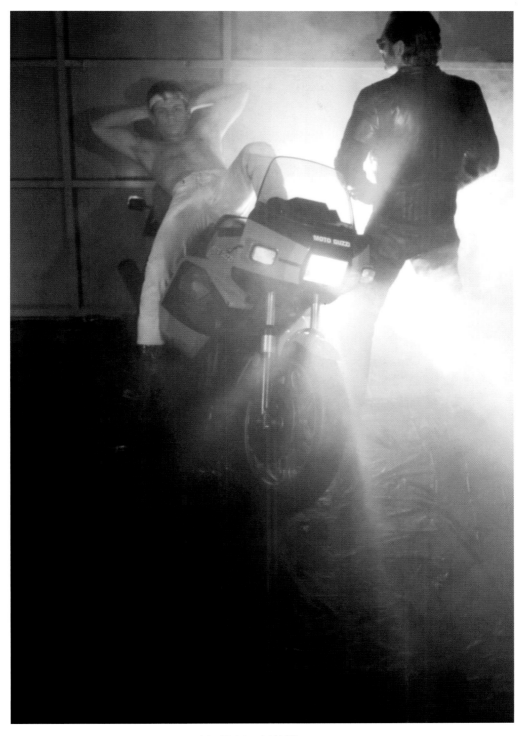

Chris Burns and Fred Halsted in *Revenge of the Nighthawk* (1983)

Opposite page: Fred Halsted in a water sports scene cut from his film *Nighthawk in Leather* (1982) but appearing in the accompanying magazine

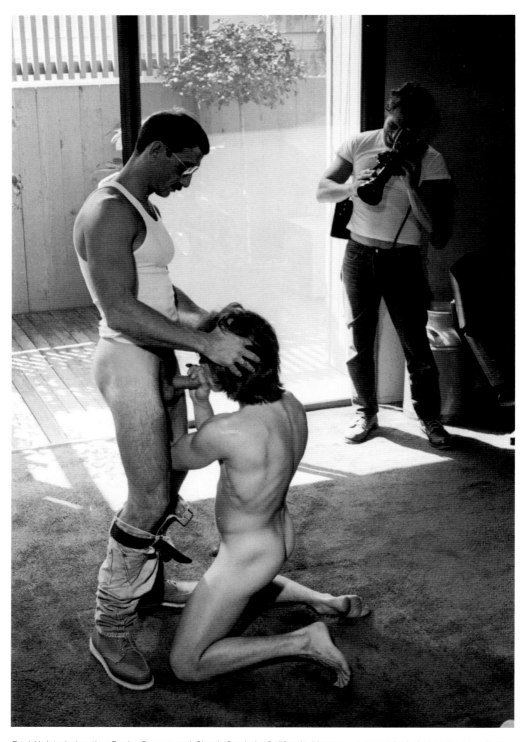

Fred Halsted shooting Rocky Genero and Chuck Grady in *California Lineman*, a scene included in the compilation *California Fox* (1979)

INTERVIEWS

These interviews are a small sample of Fred Halsted's many interactions with the press. Halsted had a way of charming even the most hardened skeptic, and he often did so by resorting to outrageous rhetoric.

Mikhail Itkin's interview reveals that while Halsted's credentials as a provocateur and sex radical were beyond question, his politics could be more conservative than his public image suggested. Had he lived longer, Fred Halsted might well have become an outspoken (and un-ironic) reactionary.

Halsted made some of his most intimate disclosures in the *Advocate* interview with Charles Faber. In addition to the story of his childhood molestation, Fred announced his decision to give up directing sex films—one that economic circumstances forced him to reverse—and discussed the unsatisfactory financial arrangements forced upon him as an independent porn producer.

Rosa von Praunheim included an interview with Fred in his film *Army of Lovers* and the book that accompanied it. Though von Praunheim had personal affection for his filmmaking colleague, he presented Fred and the American gay scene in general in a critical light.

America's first Gay family of S/M

Fred Halsted and Joey Yale

MIKHAIL ITKIN: Okay, just as a kick-off question, Fred, recently you mentioned the sexual politics of your work. Just what do you mean by "sexual politics" in that context?

FRED HALSTED: That's about a three-hour talk; but let's see if we can do it somewhat more briefly. Number one, I think the term *Sextool* itself defines a lot of the ground. I define the word as use/abuse, everyone /everything. As for politics, I mean political in the sense that it sort of breaks the stereotyped roles that are supposed to define us.

I think I'll pass the ball along to Larry Kardish from the Cinema Collection of the (New York) Museum of Modern Art, who says that *Sextool* redefines the great American blond beauty who, he thinks, is represented by the sailor, the All-American thing that everyone wants to get and can't.

When the sailor is assaulted by these three guys and enjoys it, Kardish feels that this is a complete reversal of all that we've been told. If he gets in this situation he's supposed to fight back, not enjoy it. In this case, he doesn't fight at all and he quite enjoys the whole thing.

Oh, yeah! And the black scene has a lot of political implications. The blacks now have the money and the Cadillacs and they have white chauffeurs and white slaves. You know, it's a sex scene, but also a lot of political implications.

And the cop scene, with two cops raping a guy in a police station. They're not supposed to do that. They're supposed to be protecting us, but this other exists a lot more often than we ever hear about.

MIKHAIL: You mean not only rape, but other forms of police brutality and social oppression?

FRED: Oh, yeah! Actually, Joey has a lot of insight on this whole sexual politics thing.

MIKHAIL: Joey, anything on that which you'd like to share?

JOEY YALE: Oh, sure. Really, we run the gamut in *Sextool*. It covers the whole broad spectrum of gay sexual politics. Sexual politics defines itself as opposed to political structures of any other kind.

FRED: In terms of Joey's and my scene, both in the film and in our life, he's free at all times to split if he wants, but he doesn't.

JOEY: That's pretty much true in every other scene also.

FRED: No one's ever forced into anything against their will. They're all...

JOEY: Just different aspects of the sexual politics that are going on all the time.

MIKHAIL: Joey, recently you made a statement that one reason you use the term "sexual politics" is to distinguish it from the black liberation movement and other liberation movements.

JOEY: Yes.

MIKHAIL: But we can take this further into the philosophical and theoretical area of those people who've been writing on sexual politics—as far back as Edward Carpenter at the turn of the century, or Elizabeth Gould Davis, Kate Millet and others more recently. They maintain that sexual politics underlie all other class and social divisions. As such, this is a primary form

of oppression which provides an arena in which liberation must be won. If that be the contextual basis, then sexual politics does relate to all other liberation struggles.

In light of this, can you still make that separation?

JOEY: Oh, yeah, definitely! You see, what we're involved in is that as a unit the thing that binds us together is our sexuality. We really have no ethnic background to come from. Our heritage is the gay culture that we're surrounded with today.

You know, we have nothing like what we would have if we were in the black movement, with the whole of black culture to fall back on and, in retrospect, to look at, study and compare to see what we should do. But as gays, we grow up in a basically "straight" environment and then discover that we're gay and go on from there. But we're surrounded by a gay culture that is strictly sexual, as opposed to ethnic.

FRED: I think it's the oldest, continuously existing culture in the world.

JOEY: See, we're a cultural phenomenon versus a genetic one.

MIKHAIL: Oh, yes. Certainly. But Fred's statement that he thinks gayness is the oldest continuously existing culture in the world is a very tempting hypothesis; it leaves several questions open, however. If that's so—and it probably is, at least partially—then the only real difference between our position as gays and that of blacks, or any other oppressed people, is that we grow up in the house of the enemy and have to rediscover our own culture.

Each new gay generation has to discover it again, rather than being raised in it.

But aside from that—and that's really very basic and a major factor of difference—there don't seem to be that many differences between our liberation struggle and that of other oppressed peoples.

JOEY: But, you see, I don't feel that we're oppressed, at least not in the same or similar ways. That part of gay liberation disturbs me, because people speaking for gay liberation come out and demand—as in other groups—equality in housing, and all that. I don't really feel that it's necessary for us to make a statement about our sexuality when we are applying for a job or, you know, when applying for housing. It's not really necessary, at that time, to make a statement about your sexuality.

FRED: But, Joey, sometimes they won't rent to single people or two men or two women, which is an implication of condemning gayness in itself.

MIKHAIL: Of course, some people in the gay liberation movement would share part of that position. Not the part that implies that it's okay to maintain a closet when going for a job or housing, but the part about law reforms for equality.

There's a minority perspective held by some in the movement who don't support—certainly who don't oppose, either—but who just don't really believe that any of the law reforms (other than decriminalization) do any good, except as a form of consciousness-raising.

Law reform just doesn't seem—to those holding that position—to be where any true liberation is coming from, anyway.

However, going on... recently, Fred, you described your socio-political perspective at one point as gay supremacism, and at another point as a position of fascism, implying that you somehow equate the two. How—and why?

FRED: Gay supremacy is fascistic! What's the difference between gay supremacy and Nazism?

MIKHAIL: The difference can be readily seen in the quarter-million gays murdered by the Nazis in the death camps, as part of the eleven million people they slaughtered in totality.

FRED: What Nazism is saying, though, is: you're Aryan, you're white, you're better. Gay supremacy is very similar to that. So I think it's a new kind of fascism—which I wholeheartedly endorse.

I really do think we're superior and that thesis is fascistic. I don't believe in equality, and I think it has been proven that at times when you have a great renaissance in culture and

the arts, it's always gay people who are leading the whole thing. We are now starting such a renaissance again.

And finally, I equate what's happened in the last five years or so with the rise of birth control devices. Heterosexuals can now have sex together and don't have to have the worry they've had throughout history: having children.

So, Mikhail, the way I see it, that makes them functioning homosexuals even though they're practicing heterosexuals. They're stuck with the same basic problem that we've had all along.

Having sex without the danger of procreation brings up all the other questions of promiscuity, sex without love, alienation, isolation—those kinds of things that homosexuals have had to deal with ever since Cain and Abel, or whoever started it all. That's why I feel we have an ongoing culture which we've developed over thousands of years.

Heterosexuals have never had this. With the rise of birth control devices which free women from childbirth, they can have children or not by choice. So, practically, I consider them functional homosexuals. So what do they do? What happens? There suddenly arises glitter rock, fag rock, punk rock, gay porno movies, suddenly taking off big.

I think there's a distinct synchronization going on between the two. We now have to teach the heterosexual masses how to deal with all these massive new problems which they've never faced before, which we've had since the dawn of time.

We have to lead cultural development and tell these people how to act, set new examples for them, set new norms for them. We have to set new values based on the fact that everybody's going to be a sexual being.

That's why I think we are the new leaders, and I think you'll see it increase and increase and increase. And then they'll just—you know, we'll probably always be in a numerical minority, in terms of a man and a man, and a woman and a woman, in that strict sense—and then they'll be like breeders that simply want children, because people love their children.

But the whole thing, I think, will break down completely sexually, and we're the ones who'll have to teach them how to create new structures. We have our own customs, and we have our own methods of relating and dealing with each other, and they now have to be taught. And we're the ones to teach them.

And a new renaissance will come out of this. The last two—the fourteenth century Italian Renaissance and the earlier fifth century B.C. Grecian Renaissance—were both gay. I think we're heading into another one, and I think we're definitely going to get there. But this time, we're also seeing the rise of female gay people, who were always suppressed before.

In the two earlier renaissances the role of females was always pretty much suppressed. Sappho was an exception; but, even later, George Sand had to write as a man. But now, we see in the arts, in film and in television, a lot of female artists who may, or may not, be gay.

And this factor has joined the input that's going to make it all the stronger. Gay women are now rising up. I think that's really important. That adds all the more power and thrust to the cultural explosion through which we're going. They've not only got the whole gayness—we've been repressed from time to time—but they've also been repressed as women, while we've been able to pass ourselves off, to enjoy the privilege of being male and remaining sexual.

MIKHAIL: Well, even agreeing with a large part of that, I remain anti-fascist and still fail to see the analogy to fascism which you've drawn.

FRED: Well, fascism maintains that something is better than something else.

MIKHAIL: By that analysis, all functional and critical evaluation could be called fascistic, which really seems to stretch the term beyond any value-meaning. The point is that fascism is a socio-political system which oppresses and seeks to destroy that which it finds different or which it calls "inferior."

The "better," as viewed by fascism, is never willing to teach others—and that's where your theory completely departs from anything that could be called fascist in any meaningful way. It's a whole different approach—and hardly fair to call it fascism—when you're willing, and even eager, to teach others instead of exterminating them.

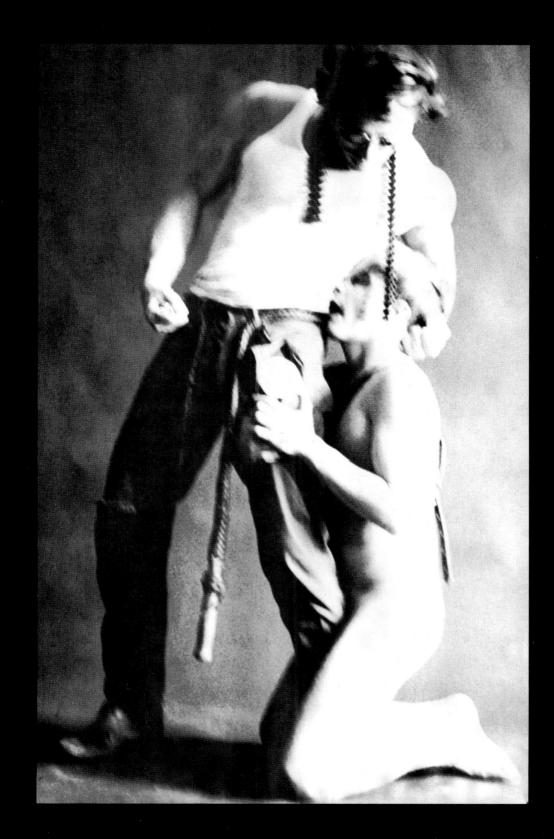

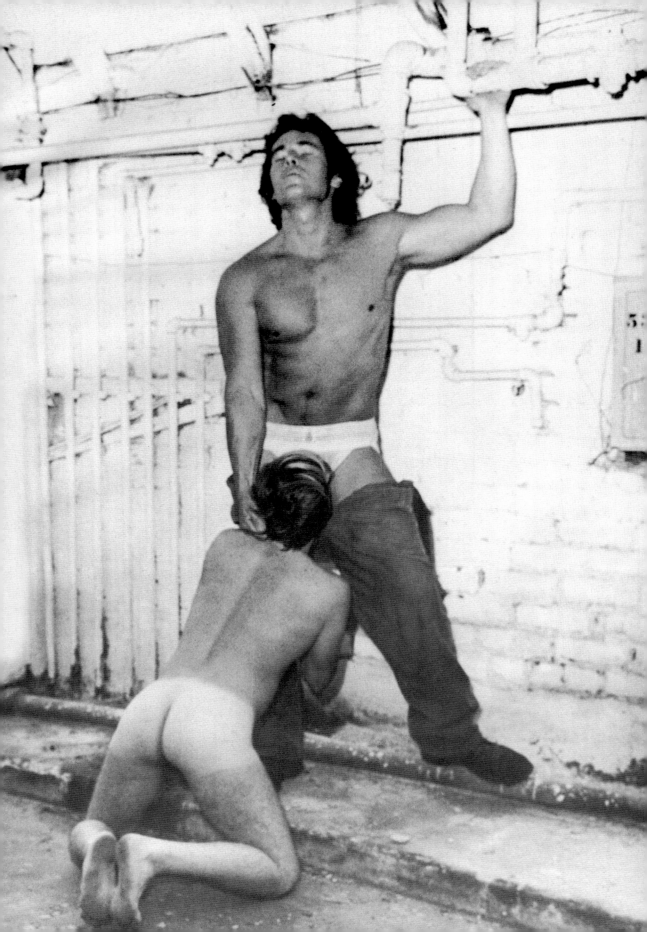

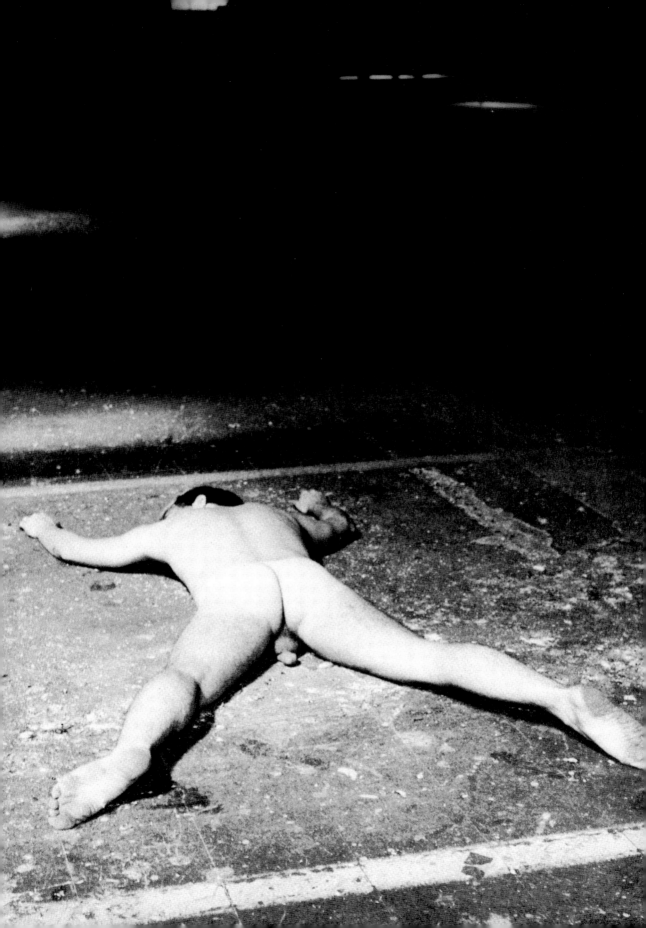

FRED: Well, Hitlerism is dead. I'm glad it's dead, and I'm certainly not equating my approach with Hitlerism.

MIKHAIL: But you were the one who drew the Nazi parallel at the beginning of that statement.

FRED: Well right, it was a fascistic concept they were working with. But then, these dictator-type people gained control and turned it into a horrible nightmare. That doesn't mean that the sort of point behind it doesn't have a certain essence in it.

MIKHAIL: But socio-political ideas don't exist in a vacuum. They exist only as they relate to and exist in the real world. And in the real world, fascism requires dictatorship, fascism is totalitarian.

Your use of the term, considering your definitions, seems to be downright wrong because it denies the consensual and general meaning of the word, and beyond that, it's just totally a-historical and inaccurate.

However, as I said, aside from your adherence to what you call fascism, there's a significant part of what you've said that many gay liberationists might agree with. For instance, at the turn of the century Edward Carpenter, who was sort of the John the Baptist of the gay movement, and who defined himself as a gay anarchist, stated virtually everything you've stated here, but in a clearly anti-fascist context, which I share.

FRED: What I'm talking about is cultural fascism not governmental fascism.

MIKHAIL: But words have a consensual meaning if they're being used to communicate rather than simply to express nonsense syllables. And within that consensual use, there's no way to separate concepts of "cultural fascism" from those of "governmental fascism."

As a matter of fact, speaking of Carpenter in this context, he not only stated virtually everything else you said—in anti-fascist terms, however—but he also documented it precisely in regard to the periods of renaissance and gay leadership in those. And

Carpenter also wrote about the need for gay people to teach society as a whole.

Now, Fred, that really sounds very much like what you've been saying; but Carpenter's emphasis is clearly anarchistic rather than fascistic.

FRED: That hadn't occurred to me. Perhaps then, I am closer to being an anarchist—but at any rate I certainly wasn't talking about any form of governmental fascism.

MIKHAIL: Let's backtrack for just a moment, to the gay liberation question. What would your solution be, instead of striving for law reform, to the whole question of gay and sexual oppression in this erotophobic society?

FRED: Try a "fuck-in" of a million people on City Hall steps in any one major city.

MIKHAIL: Interesting idea! Some of us were talking about that back in 1960, but we had thought of the White House lawn as a place.

FRED: That would do.

JOEY: It would probably be more comfortable than City Hall steps.

FRED: If we got a million of us together, there are so many varieties, a million different ways, and then the networks would have to cover it. Everyone would have to become homosexual to be chic. They'd just have to be homosexual for at least six months, and then they could revert back to their usual practices, if they wanted to.

The reason I don't support the principle of gay liberation laws is that you're changing laws that say you're wrong to begin with. That's propping up the whole system.

The concept is wrong! I'm not saying it's wrong there should be equality in laws dealing with sexuality, but what's the root of all those laws? You're propping up something that shouldn't be propped up. I guess I am an anarchist after all!

MIKHAIL: I think you're basically asking—correct me if I'm wrong—what the sense is in trying to

I can't remember who I balled last week. Sometimes I can't even remember who I balled yesterday. So I guess we've already had it a couple of times. But I wouldn't mind having it again.

MIKHAIL: Joey, you started to say something about when you were 19?

JOEY: Oh, when I was 19, I first met Fred. We had gotten together a number of times but hadn't really gotten into balling with anything heavy at all. I was extremely curious, and he was extremely attractive, and right in the middle of a fuck I looked up at him and said, "Are you into S/M?" which completely blew his mind, because he was approaching me the way he just described, as if I was this naive kid who didn't know anything, and he had to ease into it gradually.

FRED: I was slowly easing him into this...

JOEY: ... thing, and I kept thinking, "Well, when's the action going to start?" You know, "When are we going to get into something?" So, he was fucking me and I said, "Are you into S/M?" and it just totally freaked him out.

FRED: I went into shock for about 60 seconds and then thought what an ass I am, how stupid and naive I was; and then we got into S/M very quickly after that.

MIKHAIL: Somehow, that brings up a question I wanted to ask you earlier. I assume you don't agree with Larry Townsend's theory, in *Leatherman's Handbook*, where he says that any good S has to have been an M?

FRED: I don't agree with much of anything Townsend has ever said!

JOEY: I don't either.

FRED: I think he's one of the most illiterate writers I've ever met.

JOEY: I met Larry about the same time I met Fred, and he was scheduled to debate me at UCLA some time ago.

FRED: Give him the total dirt.

MIKHAIL: For publication?

JOEY: Okay, the total dirt—and sure, for publication. He was scheduled to debate me at UCLA...

FRED: He proclaims himself as one of America's great studs...

JOEY: Studs and sadists. And so he found out that I was to be on the panel opposite him, and therefore he didn't show up. The reason being, I guess, that about 1970 he and I had balled.

FRED: You answered a *Free Press* ad, and there he was.

JOEY: Right. I answered this ad, and he showed up and proceeded to bring out all his toys and everything. But this goes back to what we were saying about attitude and style. His attitude was so completely wrong. He was a phony.

Anyway, after we had a scene, he sent me a letter of apology for being such a bad fuck. Had he shown up at this panel to debate me, I was going to read it to the audience...

FRED: This super-sadist stud sends a letter of apology to a slave...

JOEY: ... for being a bad fuck. And I saved it and I still have it.

FRED: He saves everything unfortunately.

JOEY: And I'm sure he knew this, so he did not show up to debate me that day. And it was so bad. The other M who Fred described was there, and I was there; and there was another guy there, I don't remember his name, but he was supposedly an S, but wasn't. So Fred more or less decided that there needed to be an S represented on the panel, and he came charging out of the audience and sat himself down next to me, grabbed the microphone and said, "Well, since Townsend didn't show up, I'll represent the other side."

FRED: Well, there wasn't any S up there.

JOEY: Yeah! But there wouldn't have been if Townsend had been up there either.

FRED: I hope he gets a copy of this article. By the way, back to the gay liberation thing, I happen to like the word "faggot"...

JOEY: 'Cause it tears down everything. Once you start using the word, then it has neither the effect nor the impact that it used to.

FRED: If you accept "faggot" as an insult that means that you have to accept what is implied behind it: that male/male sex is an insult. But if you take it as a compliment, it's not an insult, and the word develops its own meaning.

MIKHAIL: Lots of us use it proudly these days. I prefer the word "faggot" because of its radical historical implications. We were burned at the stake, and we take the word in defiance of the inquisitors and burners, both those in the past and those today!

FRED: Right! But there've been a few faggots I've wanted to burn, too.

MIKHAIL: If you mean sexually; somehow that's different if it's in a consensual S/M scene.

JOEY: That's a good point. Consensual.

Some time ago, back at that UCLA panel, a very antagonistic fellow kept bringing up the point of why he thought S/M sex was wrong. He raised the subject of the Texas murders a few years back, and wanted me to comment on that. And I really had to defend what we do, because gay S/M sex between two people is consensual between the parties involved. I said that what happened in Texas, which is really unfortunate for us as a community...

FRED: It was really unfortunate for the people involved!

JOEY: Well, yes, of course. But then for us, too, because it's rubbed off on us. But what

happened among those people was not consensual at all. This guy went out and picked these people—they didn't want to participate—and proceeded to murder them. But that's not an S/M thing.

FRED: He was just a creep murderer, and there're lots of them. Charles Manson was one of them, and his bit was heterosexual. I liked what Arthur Bell said in *Esquire* about the whole thing, trying to explain how this happened in a middle-class suburb, with tree-lined streets and all that stuff. He said, "The macabre and the mundane live side by side. They feed off each other."

MIKHAIL: The weird thing is that the hetero incident in Florida happened at about the same time as the Houston murders. But because the Florida one was mixed—male and female, but primarily hetero—it got much less publicity.

FRED: It had much more film potential, though. Like the whole idea of him sitting out there, dead in the rocking chair, out in the yard. He committed suicide afterwards, and just sat. I thought that was a great film concept, the whole bit of him sitting there in a lawn chair. It rains for a couple of days, and he doesn't move from the chair, and the neighbors start to look out the window, thinking, "He's been sitting in that chair an awfully long time. It's been three days, we've had two rainstorms and he's still sitting there. I wonder if he's all right?"

You know, he'd just have been a typical neighbor, probably had a flower garden and shit. So they go over to check and see if he's all right, and they find he's dead. Then they go and look through his house, and they find this whole dungeon. And the whole horror story comes out.

JOEY: Really! They can give all the space in the world to something like the Houston murders, and they don't give a damn about anything else. I knew of a case—repeated child abuse—which certainly could be called a straight crime! I mean, it's one thing, when a kid is nasty, to get slapped. But being repeatedly thrown full

course into a closed garage door till the kid winds up in an ambulance is a little sick.

FRED: Well, a lot of that kind of shit is going to continue happening—along with wars, genocide and mindless brutality—until S/M is sufficiently acceptable as a factor in life that people are able to have consensual outlets for aggressive feelings, so they don't let out their frustrations in unconscious and mindless brutality.

MIKHAIL: Then you view S/M as a means of channeling feelings which we all have, as a result of socially conditioned fear/aggression drives, so that through this consensual and, hopefully, loving outlet, we can free ourselves from functioning mechanically and utilize our energies in creative, rather than destructive, ways?

FRED: Certainly.

MIKHAIL: Well, on that subject then: recently, the anarchist-pacifist Living Theatre Collective created a play, *Seven Meditations on Political Sado-Masochism*. I've discussed this at length with Judith Malina and Julian Beck, the founders and coordinators of the Living Theatre. Both Judith and Julian are into masochism themselves; and Julian's primarily gay, as he makes clear on both points in his several books. Since both of them are M, it must make for an interesting marriage; but that isn't the point.

They've both become heavily involved in gay liberation and feminism, in addition to their long-time dedication to the anarchist and pacifist movements. I find their semantics very curious.

Since they're both masochists themselves, for them to use the term "political sado-masochism" to describe political repression, as well as the brutality and violence of the political state, seems to reflect a self-image that puts down their own scene.

FRED: Well, we've already established that consensual S/M can be a safety valve to prevent that type of political and social brutality and violence, so I think they're just missing

terms—something most of us do, from time to time—or using emotionally charged terms in the same way the mass society and media do.

MIKHAIL: Going on from that, what do you both think about the future of the gay liberation movement?

JOEY: I really think it's more important to act as an individual than as a group. I think we accomplish more within our own lives than we do by banding together in different groups, going out and trying to force change. When we change what we touch in our individual lives, it's going to rub off on more and more people. I think we will have more of an impact that way than by joining any militant group.

FRED: It's more fundamental, too. How much does the federal government actually affect your life, except insofar as you have to pay them money every year? How often do you run into the federal government as a fact of life?

Today, I won't run into the federal government unless I mail a letter.

You know, it's a whole myth they've created. It doesn't exist.

There is no government and the whole thing is a fabrication. We don't need it. It's just a myth. But if enough people believe it, then you have it. It exists if it's a common fantasy.

Politics is the death of art.

Politics is the death of everything.

— Mikhail Itkin, "America's First Gay Family of S/M: Fred Halsted and Joey Yale," *Coast to Coast Times*, August 22, 1978, pp. 20–21, 44; and "America's First Gay Family of S/M: Black and Blue Love, Part II," *Coast to Coast Times*, September 12, 1978, pp. 14, 40–41.

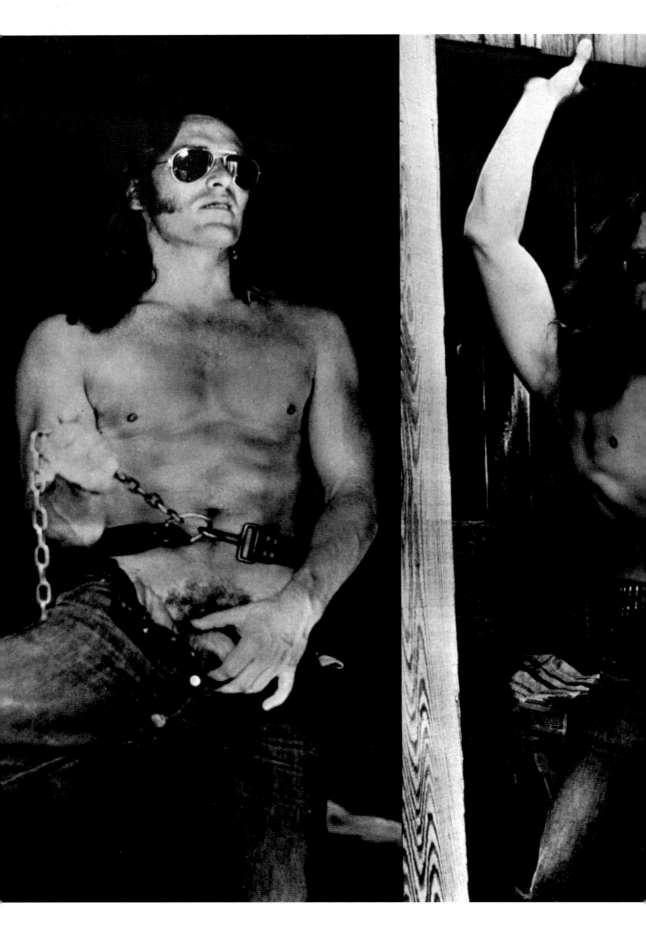

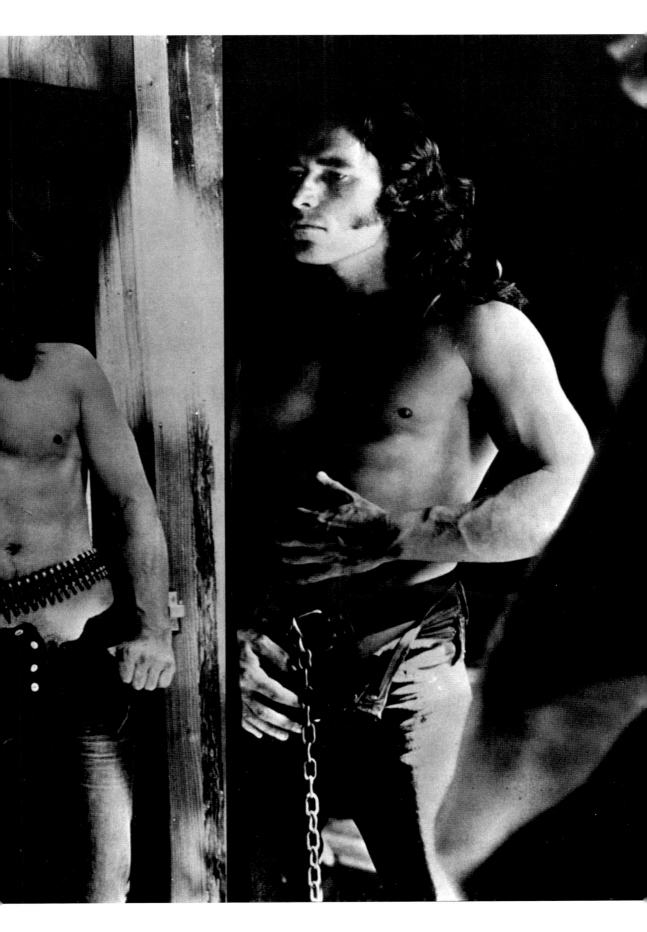

Fred Halsted Looks to the Boards

"I don't need to show skin," said Fred Halsted. The muscular, smooth-bodied star of erotic films doesn't need to show skin? The seductive sadist of *L. A. Plays Itself* no longer wants to peel back his leather? Has the great sexual turn-on of *Erotikus* turned modest? Is the co-star of *El Paso Wrecking Corp.* cloaking his image? How come?

Fred Halsted has gone legitimate: he has embraced the legitimate theatre. Acting his first dramatic role, he served notice that the legitimate theatre would do well to embrace him.

Fred made his stage debut in *News For Tennessee*, a drama by Joseph S. Caruso, at the Pilot Theatre in Los Angeles last November. The play starring Halsted and his lover, Joseph Yale, was enjoying a successful run when I interviewed them at their Los Angeles home. They bought the house recently and spend most of their time away from the theatre supervising the attractive Spanish structure's remodeling.

The new direction in their careers, plus the excitement of working on the house, gives the couple who have been together 10 years a happy glow. We sat on the newly built veranda, invigorated by the slight chill of an unusually cold Southern California winter, and stimulated by the conversation.

Fred was eager to talk about the play. "Joe (Joseph Caruso, who directed his own play) asked my Joseph if he would mind taking off his clothes."

"I told him no," Joseph chimed in. "There's a good reason for David (his character in the play) to take off his clothes. It isn't done gratuitously."

"I don't need to show skin," Fred repeated. "There's no place in the play for Eddie to take his clothes off."

Fred gave me one of his wry, tantalizing smiles when I told him that the opening night audience, more than half of whom were gay and all of whom knew him by reputation, was waiting for him to disrobe. They weren't chagrined that he revealed no more than a bare torso; the unveiling of an actor became more important to them than the uncovering of Halsted's epidermis.

"We did the play just as Joe wrote it," Fred explained. "If there was no place for Eddie to take his clothes off, I didn't want him to. The play is performed as written and directed. That's the way we wanted it." There's a strong possibility the production will move to San Francisco following the Los Angeles engagement.

"All of us are willing to go," announced Joseph enthusiastically.

Fred made a good choice in *News for Tennessee* for his stage debut. The title is derived from a speech Fred delivers as a hustler, a role he's not unfamiliar with before the camera.

He reported: "One night a gay man flipped out when I made that long speech in the first act." The speech amplifies playwright Tennessee Williams's metaphor that people who circle about aimlessly without ever finding a resting place are like those birds of the air unable to light on earth because they have no feet. Caruso added the "news" that even if the birds could land, there's no uncorrupted spot left on earth to receive them.

"When we get a chatty audience," Fred continued, "we can hear them whispering, especially after that long speech. Then they're really excited. I'll never forget the two men sitting down front telling each other, quite loudly. 'That's how hustlers are, that's just how they are.'"

Fred is a compelling stage presence, a highly individual combination of diffidence and arrogance. The diffidence is there in private life, too, and the arrogance seems to be part of his acting style. In person, he's a man of deep self-respect and quiet pride.

His body language is eloquent offstage as well as onstage. His slight swagger speaks volumes. If he leans a little to the left, it could be a subtle invitation to approach him; a little to the right, a red light warning you to keep your distance.

Fred has a disarmingly boyish habit of looking down, but when he does look up, all shyness vanishes; he gazes at you through narrowed eyes, beetle-browed, with intimidating intensity. When he looks away again, you know you've been scrutinized.

Fred plays Eddie, a hustler visiting David, his ex-lover, now married to a woman with maternal compassion for her vulnerable young husband and strong sexual attraction to the hunky stranger. Fred's hustler characterization translates well from screen to stage. The emerging actor has taken his cue to fill it out with a richness of detail missing from largely one-dimensional erotic films.

"Eddie goes to their house to mess up their minds," explained Fred, "and Eddie's own mind gets messed up."

"David runs the gamut," said Joseph, speaking of the husband's role he plays. "David hates Eddie for what he put him through. David's sincere feelings were violated. He loved Eddie, but Eddie didn't know where his head was at."

"It's much better doing a play than doing a picture," Fred confided. "A great challenge. Instead of two-minute bits and pieces on the screen, you have two hours on the stage. You have to stay in character, you can't let down for a minute. You're building something that's all one, continuous, without interruption. And you're being judged every moment by the response you get from the audience. We've been seen by people who have seen the films or read about us."

"Mostly a gay audience," Joseph added. "We took a number of steps to change that. After all, it's a play about people. We were finally successful in reaching the entire community, and straight couples came to see us. Some of them were sort of shocked. There have been comments like, "Gee, I didn't know it was going to be a gay play.'"

Fred was amused that the straights were "surprised by some of the things gays take for granted."

"But the straights like it," Joseph insisted. Blond, blue-eyed Joseph's enthusiasm was in charming contrast to Fred's sober mien and careful weighing of every subject.

Fred wants to do a straight role in a straight play. "Any character that's aggressive—a fighting attorney, a politico, a sports coach." His thoughts turned to a film we want to see made, and made honestly. "I'd sure like to play the coach in *The Front Runner*. I'm going to do everything I can to make them aware of me when they're casting Harlan Brown."

Joseph is certain there are young character parts in his future. "I'd like to play troubled young men, like Brad Davis in *Midnight Express*, or the boy, Alan Strang, in *Equus*." He added, hopefully, "We've gotten casting directors from all the major studios; agents and producers, and they've all come to the play unsolicited."

"They're curious," Fred maintained, "because they can see the awareness of homosexuality spreading in the straight population. Homosexuality's suddenly interesting to America. America votes on it and wants to see it and read and hear about it. To be successful, entertainment has to be in step with what interests the public. There are more gay-themed plays than ever, and the industry people go to see them for business reasons." Fred gave a sly dig with a poker face: "But who wants to pay three-and-a-half bucks for *A Different Story*, to see Perry King with his shirt off?"

Fred said proudly, "I'm an actor now. I don't want to be a producer or director any more." He produced and directed *L. A. Plays Itself*, *Sex Garage* and *Sextool*, pioneer erotic films, unique in the literature and all tremendously successful. "I made those films because I had something to say about gay sexuality; at that time, it was new information. I've said it; it's been assimilated. I'm going on to something else."

Now that Fred has decided to end his 10-year reign in erotic films, would he tell us how it began?

He looked deeply thoughtful, pain showing in his face. "It was 1968, the year Robert Kennedy was murdered. He was my hero. When his life stopped, I stopped everything I was doing. I was a *petit bourgeois*: I owned a nursery in El Monte (California). I started analyzing my life. I asked myself, 'Is selling plants it?' I brooded through fabulously rainy 1968 into the spring of 1969.

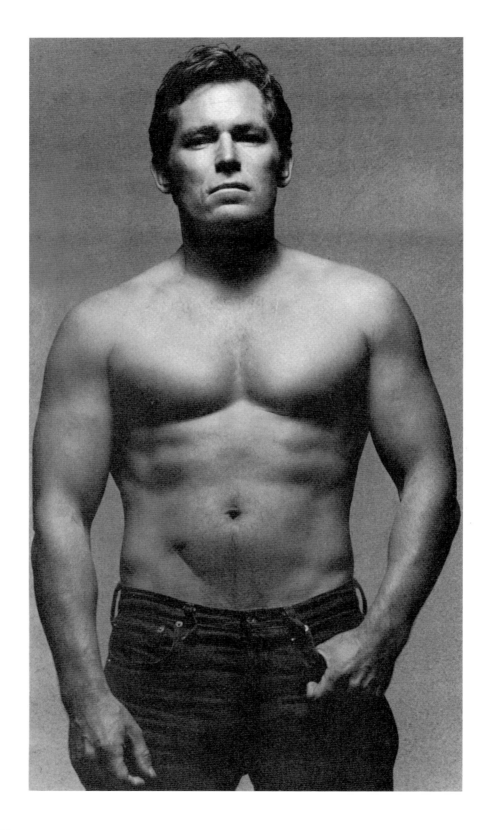

"I sold the nursery. Then I worked for people like Vincent Price, Joey Heatherton, Gary Lewis. I love gardening and plants. Just working took the pressure off. I used to smoke a joint every day and think. I knew something was wrong with the world, with me. I was out of sync.

"I started back at zero. I thought of the earliest things I could remember. I traced my whole life from the beginning. I sat in that room. I sat alone in that room for weeks, my single room.

"One thing had been carefully forgotten. I had been raped by my stepfather in 1949. When I was eight. At that age, I didn't know what rape was; I didn't know what had happened to me. I wasn't repulsed, but I couldn't accept it.

Nineteen years later I introduced fisting to the screen in my first film, *L. A. Plays Itself*, which showed it as intrusion, violence, brute force. My interest in sadism, my fascination, had its roots in that early incident. I never meant to editorialize about it; it was catharsis for me, a little kid picked for a sex-object. Analyze it, and it's myself doing to somebody else what had been done to me."

Will Fred ever make another erotic film?

"Not unless it's something like the Japanese film, *In the Realm of the Senses*. It's man-woman and hardcore, but it's beautiful and has the kind of production values I'd want in any erotic film I might be associated with in future. No more little $20,000 gay features for me.

"Any erotic film, good or bad, is usually well-received, and there's satisfaction in that. But it's a financial disaster for the producer. The distribution split favors the exhibitor; he gets 90 per cent of the take and the producer gets only 10 per cent, as a general rule of thumb. For straight films, it's reversed: the exhibitor gets 10 per cent, the producer, 90."

Does the gay audience go to a man-woman hardcore film like *In the Realm of the Senses*?

"I'd say no," replied Fred. "The gay audience doesn't like to see the heterosexual sex scene. If you introduce a man-woman sequence in a gay film, there's the danger of turning off your gay audience, and still not getting the other audience."

Fred and Joseph have shed the problems of theatrical gay films to pursue other successful ventures. Last year, their Cosco company produced 14 erotic films for video tape and 8mm, including *The Paul Seton Story*, *Hot Jocks in Uniform*, and *Call Me Ruf 'n' Ready*. The films are shipped direct from Cosco to consumer, "skipping the exhibitor nightmare."

The six erotic magazines published by Cosco were designed by Joseph, who said, "They sustain the trip I want to do artistically." He divides his time between art and acting. He made his first stage appearance singing and dancing as Mowgli, the jungle boy, in the touring *Disney on Parade*. He's proud that the late Henry Willson, famous agent who guided the careers of dozens of male screen stars, gave him his professional name. He had his real name legally changed to Joseph Yale.

Fred recently did a cameo role in a straight picture directed by Michael De Gaetano, *Dribble*, a PG-rated comedy about a female basketball team. Fred plays a redneck truck driver. "I got the Rosalind Russell billing: 'AND FRED HALSTED.'" *Dribble* opens nationwide soon after the January 26 premiere in Cedar Rapids (Iowa), where it was filmed. "Cedar Rapids has two gay bars," said Fred. "On Saturday nights, they hit their peak, with about 25 customers each."

Fred has just completed narrating, in English, a documentary on gay America, produced for German television by director Rosa von Praunheim. "Don't let the name Rosa fool you. He's a hot, handsome German, intriguing to work with. His films are sponsored by the West German government; many have been shown at the Museum of Modern Art in New York. He makes the type of film shown at Filmex. They're seldom released commercially, but the one I narrated will probably be shown in the United States. There's been talk of a March opening."

Is S&M still an important part of Fred's life?

"S&M is a healthy thing. I thrive on it. Only last year, it happened that I became S *and* M. Be sure to underline the 'and.' We shouldn't limit ourselves in anything we do, in private life or having a career."

Why does "sexual outlaw" John Rechy inveigh against S&M?

Halsted shrugged and smiled that wry, tantalizing smile, "I'm not against hustling."

— Charles Faber, "Fred Halsted Looks to the Boards," *The Advocate*, no. 263 (March 22, 1979) pp. 31–32, 43.

Fred Halsted

Los Angeles was an exciting place for us, the endless highways and car journeys which lasted hours. Very helpful in all our research there was Fred Halsted, best known for his S&M films *L. A. Plays Itself* and *Sextool*. At first we were somewhat frightened by him. His films are terrible and empty. He has had a strong influence on the American gay scene. Through his films he has made fist fucking famous. He has also made a fashion of the leather scene and the desire of gay men for an exaggerated masculinity. Gay men began to wear chains and keys on their jeans. Suddenly they all had their hair cut very short, to cultivate a brutal appearance. I find this at once repulsive and fascinating. Possibly the root of this is my inferiority complex as a man, or the yearning for someone stronger who will solve all my problems. But it's nothing more than a new fascistic trend among gays. We are ashamed of our softness, our sensibility, instead of being proud that we are not so aggressive and primitive as the majority of heterosexual men.

Fred Halsted looks like a superman, his iron muscles tempered by long years of body building, and with a serious and threatening expression that stares you out. But then he reveals himself as shy and sensitive underneath. He was marvelous to work with. In 1971 he had seen my first gay film in New York. We could both clearly remember the arguments that took place after it was shown. At that time he had long hair, and our films were compared with each other in the papers. Now, in early 1978, he introduced me to the most important leaders of the gay movement in Los Angeles.

He drove us around everywhere in his little yellow truck, arranging interviews and other scenes for the film. Naturally, we often disagreed about things, but we both found this interesting, for my part because he certainly represents a large section of American gays. He is still making his porn films, somewhere in a little house under the palm trees where he has lived for many years with his lover Joey.

Fred Halsted: Fucking in a movie? My personal opinion and my personal work? I would say no, it's irrelevant, when you're a gay porno star acting in a gay movie, I think to be good, you have to be ruled by your head. Of course, my thinking rules me more than my emotion. It's an emotional thing, fucking, but in terms of movies I view it intellectually. I construct an elaborate fantasy that will get me off, and I'm not concerned with who I am with, I don't care how many people are in a production.

Rosa von Praunheim: It sounds harsh and cold.

Halsted: But it's a business with me, I have always wanted to be a porno star, I always wanted to be a star, I am the biggest porno star and I will be a legitimate star, and it's like work, it's vanity, I get my name in magazines and stuff, I'm very thought out about it. I like to smoke a joint before I work out, keep my body going, and then I'll think about all porno star business, and I'll position myself, I'll talk to people, I'll do anything I have to do.

Praunheim: What turns you on personally?

Halsted: That gets a little gross, let me get into what I think could be erotic in cinema and what I do being a sex star type. I think one great value and what turns people on to sex films is to see someone who has obviously masked himself with his particular perversion and enjoys it. This is a difficult subject for me, I'm a Cancer and I'm very private about all that, but

at the same time I'm so fucking public about all that, it's very schizoid. But I think it's very hot to see someone in film who's obviously enjoying some particular fetish, if you think they're really digging it, I think it turns you on. To answer your question, I won't tell you... I started filming in 1970, the year before that, I spent thinking about it. At that time I was 28 and going through some kind of emotional crisis. I always thought I would be a star, at that time I was a gardener and had been in the nursery plant business for a long time. I thought if you're ever gonna do it, the time is now, or you'll never do it. I bought a camera and started filming, going through Los Angeles with rain for like 20 days, and I smoked a joint every day and came to a conclusion for myself that I had to express myself in some kind of erotic film and started then. I've always been out, there's been no problem with me about being a faggot around town, it doesn't bother me, I think I'm better than any of these fucking straight people around and more masculine, and I don't worry about that. I always had a problem about being an S&Mer. I was an open gay but a closet S&Mer. When I started all this shit, it was okay to be openly gay, but to get into S&M was another trip. One of the purposes of *L. A. Plays Itself* was to get S&M and allied perversions out on the screen where people could look at them, think about them, analyze them, let it affect them, whatever they wanted, but not have it hidden anymore, and leave it open where people can deal with it easily. Maybe it affects them, maybe it doesn't, it's irrelevant, the thing is being an open pervert and not being ashamed of that.

It's quite obvious gay rights will triumph across America very quickly, I think the thing to get out and the important thing about homosexuals is the perversion side. I think regular homosexuality is normal, as is heterosexuality, and if this is a political force, that's fine, it should be done and it will be done, I think that's already done, I think the real cutting issue will be the personal thing of getting out perversions. And the political acceptance of all that, I think, will not be legislated, because it is not a broad and important issue, but it is important to the people who do it. It becomes important then for society, and is the cutting

edge, it has more cut than the other stuff. I like it, I like it from both sides, I like to beat people up, and I like to be beaten up, I like all kinds of perversions, with my work I like to express that. I think that one of the great values of media is if you can express dissident ideas, get them on the screen so that people see them. They don't have to be into the trip at all, but after that they'll be more open. It's like when you first smoked a joint, you don't know if you're gonna like grass a lot after that, but after that you have a very hard time putting down anyone who smokes marijuana. I think there's a purpose and a reason, to get perversions out. I think they shouldn't be particularly flaunted, they'll always be a small minority, but they shouldn't be crushed as they have throughout history. It's too important, sex is too important to people, it's more important than if they vote Democrat or Republican, Carter or Ford.

Praunheim: I only know from Germany, the leather people, they have always been an organizing force in the gay community, they built the first community, the first clubs, the first meetings.

Halsted: It's a close community, we have shared up until recently a common harassment, we are all special, but within the broader homosexual community which is itself within a broader cultural community. We've learned to defend each other, stay with each other, and we share common perversions and common feelings, and the leather community is pretty tight. I am not surprised that they are the first to do this, they are the most aggressive, masochists particularly. Anyone who likes to get beat up in any way, especially sexually, is often the most aggressive on-the-job person, the most aggressive community person, they express their frustrations and desires through the sexual act, but that's to give them incredible energy to allow them to go into a broader community very actively. S&Mers are not passive people, even though they may be passive sexually; that increases their business, broader community energy. I would say 90 percent of leather people are masochistic, if not more. I really don't know why, it is just more attractive to be dominated, well I think we all appeal, or

want to appeal to aggressive men... Well, what do I look like? I don't know, I have been up till recently completely one way, sadistic. I'm not typical.

Okay, let's talk about the way I work. I try and drift, subtle, I don't like for myself to go with my keys on the left, and leather jacket and all that, because I really like the trip, I think they can tell by just talking to me where my head is at, and it's worked well for a number of years. I can project to whoever I'm talking to in a sexual manner in a bar, but my trip is without having to have all my paraphernalia. I find that people who rely on paraphernalia often are the most indecisive people and you can do about anything you want with them regardless of what their paraphernalia says. That's probably unusual, an unusual S&M thing I don't get into. I'm probably expected to get into all the paraphernalia, but I don't enjoy that, I don't do it.

I've always been sadistic, but lately I've refined my head so that I can be sadistic and masochistic both, and I like that. I'm getting a lot of static, people don't like me to become masochistic, they don't like that, they want me to stay in my little box. I'm having a good time in the other box, but I enjoy both boxes. It depends on who I'm with, it depends on the person, all I want to know is how they relate to me in bed. I don't care how much money they make, I don't care what their job is, I don't care about if they're breaking up with a lover or not, it doesn't mean the least, the only thing I want to know about someone is I have this man alone with me for a certain period of time, I want to have as strong a relationship as I can with that person who is there at that time. I don't care anything else about that person, he's there with me, he's gonna change incredibly from whatever he thought he was and I may change incredibly from whatever I thought I was. I just want him with me, and I want an intense as I can make it relationship, and anything else doesn't matter. I don't care about top or bottom, as long as the intensity and the vibes and the feeling are there, that's what I want to get out of sex.

Praunheim: How do you handle your emotional needs, what do you define as your emotional needs?

Halsted: They're too much. Joey is wonderful, he can take my shit. I like to drink, I think I'm an alcoholic, I gotta control, but if I take hard booze, scotch, three or four drinks, I flip out, it's predictable, it happens every time. And poor Joey has had to go through my flip-outs, it's very destructive and very bad, but very candid at the same time. I'm working out a need I have and it gets intense and to the point. It may be destructive but it drifts right to the point and I work through whatever my bullshit is that I'm doing, I just cut through that and I get right to whatever it is, and sometimes Joey just leaves, he can't stand it, because sometimes I beat him up a lot, I've broken a lot of dishes.

Praunheim: Are you afraid to get old, older?

Halsted: Not at all. I have made a point of telling a lot of my interviewers that I'm 36 years old, I'm probably the oldest porno star there is. I think I'm a hot 36, a happy 36, and there are a lot of men who want to fuck, or to get it at 36, next year I'll be 37, I think there are a lot of young and older men who want to fuck a hot 37, I think it's important to be together and hot and sexy at whatever your age is. I have no illusions, I never had, about being the young anything. I didn't start until I was 28, not the chicken age when it began and that was quite a while ago. It doesn't bother me. I'm not making a living from being in porno movies now, but I think I will still be in movies when I'm 40 or 50, I think there is a role for a 46-year-old man who's together, I think he'll turn on a lot of people.

Praunheim: So you're not so worried about being a sex object?

Halsted: No. It's always bothered me, sex objects, it's so weird, I have a hard time putting that together, I don't understand why I'm a sex object, I don't see it, I see it but I don't see it.

Praunheim: But don't you work on that?

Halsted: Of course I work on it, it's an obsession. With S&M the older you are the better, I could do S&M in my 40s and 50s, S&M is a dominance-oriented trip, even if you're masochistic, you're gonna like it, it's a dominance trip, the older

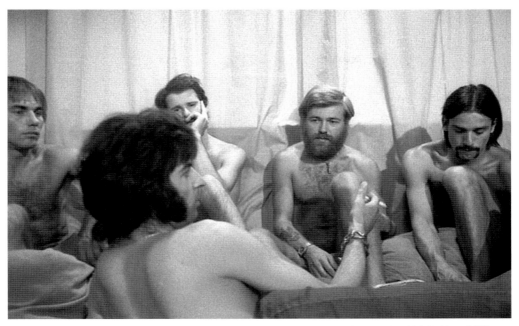

Still from Rosa von Praunheim's *It Is Not the Homosexual Who Is Perverse But the Situation in Which He Lives* (1971)

you are doesn't detract at all, S&M is not ages. You can be hot at 50.

Praunheim: Is making sex films a big psychological problem?

Halsted: In the sense that I'm still shy, as extraverted as I can be, it's a personal thing. I like it, but it's difficult for me to do it. I've already proved to myself what I need to know. I just want to continue on the Fred Halsted character. I've shown, I think I've been extremely influential in terms of breaking faggots out of the swish era. My films present faggots in the macho era, and maybe it's too overdone, but the whole style changed. I think that it had an enormous influence on the style and fashion of gay America, and I think that's good. Gay America needed to get out of the whole swish thing that it was into when I started my stuff. When *El Paso Wrecking Corp.* first opened it caused big shock waves all across gay America, but since then it's picked up as easily as fashion, wear your jackets and chains, it's macho-ed up gay America which I think is a good thing. I don't like to see the soft gay thing as a broad movement and as media, although I do like it. But I don't think it's a good image to present to emerging gay men. I think I've put in my two cents and I think it's worth it, and someone else will take it on, I think my dominance of gay thinking is over. At one time for several years I was the dominant thinker in America in terms of breaking this softness, and I think it's succeeded. And now I'll go on, and I think others will go on. I think the dominance is over and more versatility will come in, which I think is a good thing, because I'm now into that. I've changed, I haven't stayed where I was in 1972 or 1969. I don't want to stay stuck in cement in the past. I've changed.

— Rosa von Praunheim, *Army of Lovers*. (London: Gay Men's Press, 1980) pp. 17, 91—96.

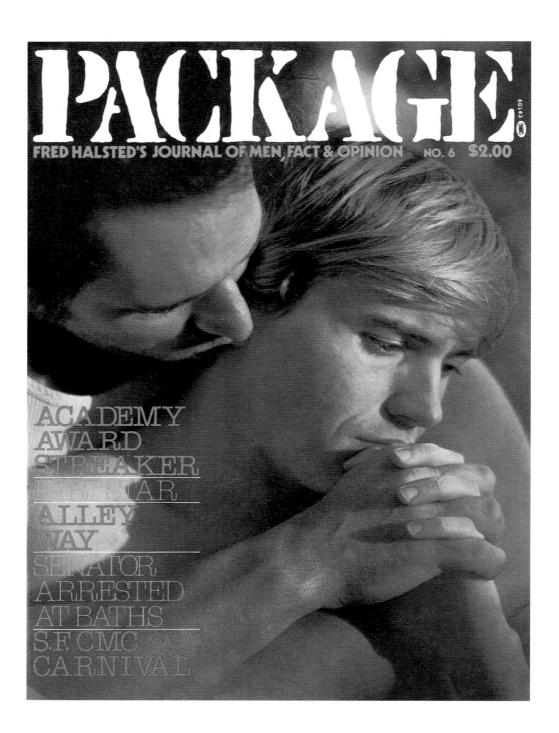

PACKAGE

FRED HALSTED'S JOURNAL OF MEN, FACT & OPINION NO. 6 $2.00

ACADEMY
AWARD
STREAKER
FILM STAR
ALLEY
WAY
SENATOR
ARRESTED
AT BATHS
S.F. CMC
CARNIVAL

EROTIC WRITING

Stories of Fred Halsted's sexual adventures were a mainstay of his magazine *Package*, and a few more found a place in *Drummer*. The texts pose a challenge for the reader with their erratic spelling and punctuation. They have a spontaneous style unlikely to grace the pages of a more formal publication, and they are all the better for Halsted's lack of awareness that he was writing the closest thing we will have to an intimate memoir. With the testimony of Fred's friends in mind, the stories seem to chart the decline and fall of a man who aspired to be a sex god, but Fred as the first-person narrator does not acknowledge this aspect of them. Either Fred was in denial, as a psychologist would say, or else he truly enjoyed himself in pursuit of the raw material of his art.

PERSONAL TRAINING

you wake up FRIDAY MORNING and feel the night's growth of your beard. SHORT & THICK ... you run your fingers across your cheeks ... soon that rough skin will be buried in some HOT TRICK'S ass ... as you chew on his hole and scratch his sweet cheeks with your cheek ... you get home Friday NIGHT lite up a joint pour some brew and relax for a minute ... time to think about the COMING nite's fuck. / .

sitting naked enjoying your company you reach for your LEVIS . / . grab a handful of the crotch and take a big hit ... smells good ... all that sweat and come and piss that's been fermenting in there since last january when some young thing FUCKIN WASHED your levis . / . and you nearly KILLED him for it ... probably what he wanted ... knowing that would get you goin more than any single other aggravation.

next to your bed you got this old wood cigar box and you just pull out some COCK RINGS and look them over . / . which one you gonna use tonite??

that big circumference STEEL RING feels real good so cold and then so hot ... the unyielding steel is a real turn on . / . that new PLASTIC ring your last trick slipped over your meat felt real good ... especially remembering the way you fucked him with the TROJAN RUBBER and then let the base of it stay wrapped around your cock after you tore the rubber to shreds pounding your tool into his asshole . / . the LEATHER SNAP ON

is good for a man. you reach for it and buckle your nuts between the leather bands and feel the raw leather bind up your balls ... and that small ring at the bottom ... good to tie your nuts up to his fucking tongue as he rims you . / . that fucking SPIKED cock ring pounds against his ass so fucking good ... watch him drool as you fuck his face shoving his big mouth all the way down your huge tool ... and those fucking spikes against the inside of his mouth ... good to take it off and use as a tight whip man ... when they gonna invent an ELECTRIC COCK RING? ... that gives out small dosage shocks . . / . .

you reach for the CRISCO and slide your hand over your dick and balls ... gettin the juices flowing for tonite man . / .

pulling on your LEVIS you like the way they grab onto your hairy legs ... roughly you pull them up and slide into the sticky crotch . / . thinking about tonite and that suckling begging to suck on your hard dick but you make him drool onto your crotch and suck your cock thru your pants ... he chews along the smelly come levi and gets to the head of your big cock ... feels good ... maybe later he can suck it out of that basket ... now he can blow hot panting breath into that cold wet crotch ... your dick pulsates ... gonna be a good night ...

your big hands grab the erect dick as you slowly button up your pants ... you laugh as you think of those STUDETTES who wear ZIPPER

LEVIS ... reaching over for some jacaroma or amyl you take a big hit and shoot off a load ... feels good ... and keeps you hornier all weekend ... just the first of maybe 8-10 loads comin out of you this weekend .. / ..

your tongue eats up the load out of your hand ... no one tastes better than you ... time to really get it on . / . easing back licking your come off your lips your eyes cruise the room ... looking for the DEFINITIVE symbol of your masculine pleasure ... the SINGLE most important instrument of satisfaction that you haven't grown yourself ... you got about a dozen BELTS around your bedroom ... WHICH ONE TONITE? wanna get the right one cause you never know where you are going to end up or what is going to be around ... but you DO know your belt ... and it never fails you.

the one you wore to work today is so fucking DECEPTIVE . / . looks like a good masculine regular belt ... no one pays any particular attention to it ... FOOLS... in your hands ANYTHING wrapped around your torso is an instrument of PAIN / PLEASURE ... brown leather strap with parallel rows of punched holes and a simple double buckle ... really good speed style lashing at your tricks ass ... the holes speed it up and leave groovy impressions in his skin ... for closer in work it's fun to double it up ... cuts your leverage but increases the surface area ... good for quick snaps across the ass ... then turn it SIDEWAYS so the raw leather edges cut into his tight skin and rounded buttocks ... then scrape the raw leather across his now pulsating ass ... so you both can really enjoy the fuckin thing ... then you SPIT on his now HOT ASS and gently run your rough coarse hands across it ... feeling the heat pulsate from it ... a quick flat hand slap wakes him up then a hard punch with your fist and things are movin again then return to the flat full swing of the strap and give him a big shot of AMYL ... he's fuckin pantin already ... so are you as you pull out your big cock and stroke it ... watching his ass squirm wonderin what you're gonna do next .. / .. he doesn't have to wait long as you take a hit and then with a hard swing reverse the procedure and slap your steel buckle into his now softened up ass ... he jumps like crazy so you gotta shove his face into your crotch and have him suck on your throbbing dick for a while ... feels good and gets his mind off the pleasurable pain he has been through ...

but you got more for this dude as your fingers spread apart his cheeks .. / .. you can feel the heat pulsating out of the skin as your fingers pry apart his tight asshole . / . fingers of blood

form on his buttocks from your lashing and you reach down and run your tongue along the multi colored lashmarks rimmed with broken skin and you eagerly EAT UP THE BLOOD so slowly oozing out . / . your fingers probe into his hole and make it ready . / . into the pulsing space you fuck him ... your belt TIGHTLY TWINED AND KNOTTED you force it into his OH TOO WILLING asshole ... and how he groans and sucks it up ... to be fucked by the belt that has been systematically raping his buns is a rare treat for any trick ... and you have been good ... MAN ... varying the speed of your thrusts ... he never knows WHEN or HOW you are going to strike ... always guessing always anticipating always being surprised ... the BELT MASTER KNOWS ...

yes ... it's a benign looking belt ... but then maybe you wanna wear the one covered with row after row of studs ... SOLID METAL ... this belt ain't so subtle ... when you wear it A LOT of guys part company with you ... a good warning for them and a test for you ... tricks TONGUES look good as they eagerly lick and glide their wet mouth over the steel studs ... they KNOW the marks this fucker makes ...

when you feel really EVIL you use the SPIKED BELT ... like studs but SHARP ... MAN ... SHARP ... for the HARDCORE cases ... the guys you really gotta get on man ... they come up to YOU when you wear this fucker ... everyone else will leave you alone and try to ignore you cause they KNOW ... MAN THEY KNOW ... you're stomping with this spiked fucker ... makes a good impromptu collar too ... funny how it leaves those small holes and not the BIG BEAUTIFUL BRUISES the other ones do ... you get a dude fingering THIS belt in a bar and you KNOW it ain't gonna stop, with the belt ... you KNOW you got a LONG INTENSE weekend of unremitting pleasure ahead of you ...

OK ... you like your WESTERN SHIRT formfit and those great PEARL SNAP BUTTONS ... long sleeve and fits like a glove ... everyone can see your fuckin tight gut and big chest without you sayin NOTHING ... MAN ... NOTHIN ... then there is that new UNIFORM ARMY SHIRT ... you like the short-sleeved one AND ROLL UP THE SLEEVES ... show off those biceps!! ... the solid brown tight shirt makes a man look good ... really saying S/M is a good formfitting BLACK T-SHIRT ... nothin says it better ... and when you are really relaxed and wanna keep everyone guessing wear a PENDLETON ... rugged good looks and surprises them when they watch you take it off . . / . .

BOOTS MAN ... how do you wanna KICK ASS TONITE ?? those shined and polished BLACK ARMY BOOTS are just waiting for your feet to slide in ... pulling up the laces and showin the spit and polish ... a young dude would look really good at the end of your toes ... POLISH IN HAND ready to serve your boots ... or go WESTERN in rich browns ... real LEATHER COLORS or go crazy in ACME MULTI-COLORED western boots ... or the fuckin CLASSIC BOOT OF THE CENTURY ... the ENGINEER ... you see it all around town at every construction site and every biker ... that STRAP looks right and the dirty broken boot almost goes into automatic as you pull down your trick's pants to his ankles and spread out his buns ... that boot KNOWS what to do and you got that dude kicked across the fuckin room in 10 seconds ... man ... that's what he's there for ... an instrument for your pleasure...

LAST thing you put on is your JACKET ... maybe its the customfit $300 leather ... its so fuckin elegant and relaxed at the same time ... you can wear it to a great restaurant and to a tough bar ... or that washed out LEVI jacket ... that reeks of amyl and smoke ... or your BIKER-ROCKER old black leather ... with zippered pockets filled with sextoys, handcuffs, grass, amyl ... or your NEW AIR FORCE fur-trimmed jacket ... really clean and deceptive ... looks good on the street ... not so menacing but you know how it fuckin attracts TWINKS and TRICKS like crazy ... they just want to bury their receptive orifices in your jacket, your boots, your shirt, your belt, your levis, your cockring and YOU MAN ... YOU ...

— Fred Halsted, "Personal Training," *Package*, no. 1 (July 1976).

FASHION

West Hollywood G.I. Joe Chic

Army field cap
$1.89

Space Inhaler
(w/ amyl)
$3.50

Green issue T-shirt
$1.69

Arm Band
$2.50

Faded dungarees
$8.99

Boot Camp training boots
$12.00

TOTAL $ 30.57

My head gets into some strange places. If I can help you out with a problem you are having... write to me care of PACKAGE and I'll publish or answer your letter

Joseph Yale

STUD SERVICE

PERSONAL TRAINING

It will fascinate you.

Andrew J. Epstein

I like to start at the RUSTY NAIL ... it's a neighborhood bar that also serves hamburgers at its meat rack. The place is always jammed, so the early starting cruiser can go in there and get action fast and early. This is how to do it. It's your basic STUDETTE crowd. Young, hip ... great fucks ... and relaxed. The guys with the huge cocks hang out around the pool table ... as they always seem to at any bar ... that way the light is always on them and they like to turn the guys on and watch them drool as they hit their balls. One guy with the fattest dick I've ever seen followed me into the john and gave me a quick blowjob ... he didn't want one in return as he had to meet his night's hustle in 10 minutes and just wanted to get hot. The bar is long and narrow with a divider going through most of the place. Serves good strong drinks if you want to lush it and also lotsa beer put to you by some of the tightest Levi bartenders in town. The music on the box is mostly disco (which I don't like too much) and very loud. Walk into the place and order your suds from the front bartender. This lets you check out the men and they will have their eyes on you. Beer in hand grope your way along the crowded aisle and go to your specialty. The twinks and young kids

hang out at the end of the counter ... and always flash a lot of nice skin through torn shirts and pants. I have a hard time keeping my hands off their tits and asses cause they look so good for fuckin'. The big cocks show it around the pool table and usually joke and play around there. The group is pretty friendly so walk right up and start a conversation. The studettes are by the jukebox standing against the wall or hanging their boots over the beer crates and boxes. If you want a hard shaft up your ass that's the place to look. In the front the hustlers hang out around the pinball machines. As I said, it's a friendly neighborhood bar that isn't specialized into a type of group. Everyone can feel comfortable there.

After I check it out and say hey to some buddies, I usually split off Santa Monica Blvd. and head for Melrose. Check the street action in this area cause there's gay theatres, restaurants and other bars ... with every type coming in or out. Driving down Melrose in my '55 CHEVY 1/2-ton pickup I usually get a lot of guys pull up alongside to check me out. I like to watch them drool and pull out their cocks and jack off as we are driving along. A lot of guys get off watching trucks and jacking off on the drivers. I think it's

really cool to see them whip out their dicks and shoot off a fast load before the light changes. If the number looks real hot, I'll pull off onto a side street and have the faggot suck me off in my huge truck. Just takes a few minutes as I pop off my load real good and the truck always turns me on. The first time I drove it up my driveway my own little JOEY YALE immediately climbed in, even before it stopped and unbuttoned his pants. I pulled them down to his ankles and sent my big dick hard and fast up his tight asshole and broke in the fuckin' truck the right way. One afternoon he was sucking on my rod in the back of the truck bed and the gas man came up to read the meter. The house I call the FORT cause it looks like something out of Davy Crockett and is surrounded by a forest of trees. Shit, we just kept on going at it and the evidently straight meterman did a fast read.

You always see a lot of bikes in front of GRIFF'S cause they like to hang out there. GRIFF'S is a friendly leather bar where you'll always find your biker buddies. The jukebox has a lot of really good country and western music, so I like to hear that mixed with some Joan Baez and David Bowie. The thing to be careful about at GRIFF'S is the way you walk in. You gotta come in letting everyone know what's on your mind, cause the newcomers always get attention. But the place is dark at first so don't walk in like a fucking stud and trip over the beer crates in the center of the room and don't spill the peanuts at the bar counter. I like the crowd that hangs out there cause they ain't playing games and you can go up and talk to someone and get right at what kind of services you need for the night. The bikers are really cool and the leather jackets combined with the smoke makes the place smell real good. Again the big cocks are hanging around the pool table ... the format being more or less a big square room. The place gets started about 10:30 and unless you're gonna get blotto drunk that's a good time to start into the place. There's usually some twinks and munchkins around the pinball machines cause they can show off their really pretty asses there ... and it's in front of the line to the toilet so it's easy to rub your horny crotch against the tight little asses. GRIFF'S is a good place to find some strange action, muscular bodies and lots of leather. Gets real chummy as the evening wears on and everyone starts to feel the suds. I have a hard time making out sometimes cause it seems a lot of men are fucking afraid of me and think I'm gonna kill them. They always wanna come up and talk to

see if I'm as crazy as they've heard cause I've been fuckin' studs in this town since I found out how to use my cock so there are a lot of Halsted veterans in the bars and I got a reputation ... so it's hard to deny shit that I know is true so I just tell them that it's true but if they want a weird off the wall fuck they'll get it ... makes it easier if they are warned ahead of time cause they can back out while they still got the chance ... cause when I get them at my fucking soundproofed house and am stoned and turned on sometimes the guy don't get out until I'm done with him.

After sopping up a lot more suds and grabbing some ass I usually head down the street to LARRY'S. I like LARRY'S a lot cause it gets the more HARDCORE action types. It's dark as hell in there and I don't help it at all cause I always wear my fucking black sunglasses all night ... LARRY'S has a really neat sound system and he plays the hippest tapes around. The place looks like a fuckin' dungeon and I like the mood it puts everyone in. He's got a really good rack and a lot of other hot toys around so I usually get an immediate hard-on just lookin' at the place.... Then the guys are really strange sex types so I make out good here. If you feel real frustrated and need some strange stuff you'll

find it. The bar is long and divided into sections ... I like to cruise that way cause you can go from group to group and either stand your big muscular body flexed up against the wall or sprawl your big dick over those funky beer crates. Again the guys that got to have a fist shoved up their ass are bending over the pinball machines and the studs with 12-inch dicks are showing their meat at the pool table or by the rack. The last time I was in LARRY'S, I met this fuckin' 4' 2" DWARF who wanted to get into his FIRST S/M sexscene ... as soon as I told him my name he got a huge hard-on even though he hadn't seen any of my perverted movies. He knew my reputation and knew he had found the stud to bring him out. I was turned on to the little guy cause his proportions were perfect and his size was a real turn on. Needless to say I'm soon taking this guy out of the bar and going over to some place he says we got to go to ... sounds like some kind of adventure to me so I go ... there we get drunk on cheap California wine above a poolhall and I start to tear the fucking clothes off this little man. What a fuckin' surprise to grab his 8-inch cock and start hitting that body that's as hard as bricks ... well this guy gets so fucking turned on he's

begging me to hit him harder (which can be the wrong thing to say to me) so I do and man I just beat the fucking shit out of him ... the fuckin' little guy gets propped up in the shower where I piss all over him and make him suck up that sweet liquid he's so fuckin' turned on because like I said he ain't ever done it before ... I next fistfuck his virgin asshole and really get off on sending him through the roof with pleasure as I thrust my big wide russian peasant hand into his asshole ... I then go over all his body parts in detail having him tightly gagged and in bondage head to foot ... I torture anything that interests me and the fuckin' little man has already shot 3 loads over it all. I later untie him to give him a break for awhile and then I proceed to pass out from all the beer, wine and action ... about 2 hours later I wake up as this guy is chewing on my toe to try to get me aroused again. Just thinking about what we had just done sends my 8-inch cock straight up again and I slap him around a lot more and fuck the shit out of him. I got his phone number as I left cause I think I'm gonna get some more of this guy down the line ... I crawl into bed at about 5 AM and my little Joey gets all pissed cause I been out gettin' strange stuff. Shit he's been at the tubs all night sucking off the biggest dicks in town so I think he got no reason to bitch at me ... so I start to get mad and decide that the only way that ever really works to shut him up is to give it to him ... so I fuck the shit out of little Joey using that new 7 gates of hell steel dick harness I had just bought at the PLEASURE CHEST then I use the leather dick harness all covered with studs ... after I shoot a couple of loads I look over at Joey's face and I see that fuckin' cute smile that he has and shit ... I think it's time for a blow job cause I know my man has the best fuckin' mouth in town.

— Fred Halsted, "Personal Training," *Package,* no. 2 (September 1976).

PERSONAL TRAINING

The invite said ... "HEAVY S/M PARTY" so i trotted on over to MAX'S ... cause it sounded like right up an alley ... the door was open so I stomped in and looked around ... no one was there ... as i searched the house i heard some good sounding groans and knew i was on the right path ... finding the secret stairway i followed the scent down down into the house ... on the first landing i ran into a really hunky dude in full leather and grabbed onto his jacket and forced my hands through onto his smooth skinned rippling with muscle chest ... my fingers immediately found his hard erect nipples and pressing them between my big fingers i squeezed them real good as he took a hit of amyl and was OFF ... MAN OFF ... grabbing this muscular passive i immediately went for his crotch and knew what was there ... the largest most solid LOW RIDING BALLS i've groped in a long time ... squeezing them real hard and gathering them up in my wide hands i applied full pressure to all parts ... slowly turning and rolling them over in my hands so i could work them over real good with heavy pressure that almost brought the kid to a climax ... which i stopped and let him enjoy the climax of the non climax ... KNOWING all that sex energy is so near to erupt i SLAPPED his face real hard and then pulled him against the wall and bit real deep into the strong muscles at the back of his neck ... as i was there getting a lot of biting and chewing in he was pulling out my huge tool and jacking it ... it felt so good i shoved my knee into his nuts and that immediately brought him to the floor where i had a hot load of stud cum for his big mouth ... he was really ready and gasping after being hit in the balls grabbed his own and whacked off real fast ... my juice still flowing into his eager mouth ... being curious and wondering where the party was i continued down the spanish cliffside mansion....

Taking the sights in as i wandered there were rooms to the side that reeked of marijuana and hash ... the panting breathing told me that secret delights were being enjoyed ... being an enjoyer i stepped in and my lungs pulled into the hash pipe offered and i immediately tasted that good

sweet taste and got that INSTANT ZAP ... which for me brings out my ANIMAL QUALITIES ... like i never sleep on it at all ... affects ME like SPEED does to others ... i can't take speed cause i go through the roof ... but i dig dudes on it ... I like to work out that energy ... so i'm tasting the nectar of the gods when this really hairy hand is crawling up my pants ... knowing it ain't mine i think that the rest of this person must be like a rug and solidly hairy bodies being one of my natural fetishes i follow this arm back to where it

originates ... not to be disappointed at all cause this guy would make a GREAT RUG ... getting all turned on i grab all over his body and quickly have his legs between my face and that solid hair mat rubbing against my cheeks ... whipping out my dick i got this man almost on his head as i pump away on his cushions as he wraps his knees around my neck ... stroking and feeling all over his belly i can't believe the discovery i made ... like he got NO SKIN and like I got NO HAIR ... i must have the smoothest non-hairy body a faggot could have ... my body hair stops at my neck ... and from there it's smooth sailing... ANYWAY ... i pump a quick load into the darkest hairiest ass i ever buried my tongue and dick into ... LEAVING

this den i soon find the trail of the elusive party ... remembering the invite i KNOW somewhere there is some action ... suddenly i burst into a mirrored bathroom and there must have been 15 leather studs in it ... all sucking and fucking in so many ways i can't describe what it looked like ... but being quite drunk and having alot of sweet hash it seemed to be the world's largest S/M laundromat as the jackets ... whips ceiling mirrors i thought that THIS room should be investigated ... realizing the FOLLY of ever trying to leave it i had the cutest blond eating my shit out of the toilet. As he looked up at me with those INNOCENT (but really decadent) eyes i thought that it was time to split ... after all i had just dumped a load ... TRYING to find the party i followed that unique CRISCO smell ... thinking that there may be some action somewhere.

The red light soon enuf woke me to my senses so i shot a quick load into the guy strapped to the wall ... ASS UP MAN ... hope i don't get clap from him ... but what the fuck ... an itchy dick needs MORE SERVICING than a regular dick so what the fuck ... after fucking the dude strapped to the wall i think my only protection is to eat my cum out of his ass which i quickly do ... aided to a great degree by his natural movements ... FEELING SECURE i continue on looking for the party.

SUSPECTING that CREAKING might be the cue i burst into a smoke-filled basement (basements being rare in l. a.) and see my own JOEY YALE in a SLING suspended from the ceiling and being deep FIST FUCKED by that really HOT MUSCULAR COWBOY from TEXAS ... seeing he had on only his cowboy hat i thought i would go ask him about the BULL ... recognizing me he gives me a wink and then as i look at JOEY IN BLISS he TOO gives me a wink so i think THIS GROUP is doing well without me so i decide to leave and find the party ... realizing my folly i grab the next in line ... a big ROUGH STUD with keys on the LEFT SIDE and looking all horny ... i think it's time for stud PROOF so i grab this dude and start a drunken punch-out ... quickly throwing him onto the floor and landing on him with all my weight (5' 10", 175 lbs) ... i start slugging this stud only too soon find myself on my feet as 5 other guys jump me and pull me off saying i can't fuck on studs ... SHIT how does a stud prove he is a stud unless he beats another stud?? realizing the error of my ways (the obvious fact what had LOOKED like a stud in fact was a PUSSY) i angrily agreed to the LOW CAL TAB COLA they thrust in my hands after taking my beer away from me... SULKING AND PISSED but feeling overpowered (MAN ... they all were onto MY number) ... i watched the proceedings....

To my great fortune some really cute blond twink stuck an amyl up my nose as i was observing from my dark corner and motioned

me to the toilet ... thinking i have FINALLY found the party i stupidly follow those tight-jeaned and beautiful KILLABLE BUNS ... man, i really get off on young blond twinks and this one seemed to have it all ... 5' 3" and eager i figured he really needed a 35-year-old STUD DADDY like me ... soon enuf he had my 8" down his throat and was giving me an incredible blow-job ... really liking to be sucked off by cute young blond things i remembered what JOEY says about "BLOND TWINKS" and gave him an EXTRA INCH raising up to my FULL 9 INCHES ... you can ALWAYS pull out an EXTRA INCH if you REALLY are into what you're into ... so i did and he really got excited and sucked all the more ... making those sweet appreciative kissing/ slurping sounds that all studs love to hear.

Thinking the party MUST be close by i naively crawl out of the toilet and soon find myself UPSTAIRS in a glaring white KITCHEN ... and not knowing what to do and having already being censored for beating a stud i apprehensively approach the guy passed out over the kitchen table ... not wanting the hassle i got downstairs i listen for sounds ... SILENCE ... taking that as my cue i pick this guy up by his long hippy hair and smash his face real good ... MAN ... AFTER ALL ... i gotta find the party and get my VIOLENCE NUT OFF ... this dude is so wiped out he mutters a low groan and i just continue to beat his face ... eyes ... (however i don't give him a busted nose cause i just had a kid i did that to 5 times and the bandages and straws are too much so i avoid his nose cause i already done too much of that) ... but that sweet face is TOO MUCH so i gotta destroy it and make it look right ... like it has paid ALOT of attention to alot of different crazy studs ... slapping this dude around i quickly get a big hard-on and jack my huge load onto his busted-up face ... FEELS REAL GOOD and he likes it as i pry open his mangled mouth and pump in my hot STUD JUICES ... he just groans and falls off the chair ... thinking i had enuf of the kitchen i walk back (hanging onto the walls cause by now i'm really wiped out) i think ... SHIT ... I'M NEVER GONNA FIND THIS PARTY ... then by great luck i run into JOEY in the middle of the living room and tell him i wanna go home and get in some REAL good sex he quickly agrees and looking OH so relaxed and ready i know we're gonna have a REAL PARTY when we get home.

— Fred Halsted, "Personal Training," *Package*, no. 3 (October 1976).

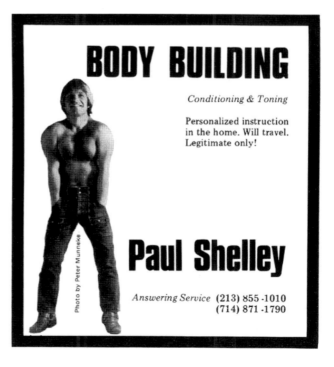

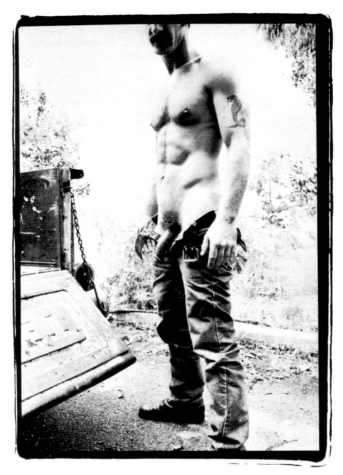

I GET INTO MY PICK UP...

DOWN SOME SUDS

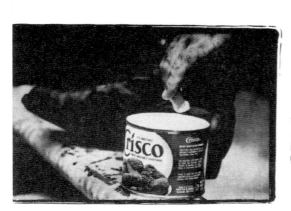

AND TAKE OFF!

PERSONAL TRAINING

I started out about 6:30 Sunday evening ... feeling horny but mellow ... i like that time cause few people are out ... things are more relaxed and i drink less ... I started at the STUD cause i thought it would have some interesting men ... two guys in full leather were sitting out in the late afternoon sun ... they seemed to be interested in each other but the bottom was cruising me and his buddy soon hauled him out of there ... i was wearing my LEVIS & LEATHER SHIRT... NO BELT ... and my TIT CLAMPS hanging from a pant loop ... // ... I shuffled around being pretty relaxed and in a good mood ... i even talked

to a couple of guys ... then this solid curly haired guy comes up and talks as i am watching him and another dude play pool ... he says his name is DAN and he met me at CURTIS TAYLOR'S ... I told him i didn't remember and that i probably was drunk at Curtis's party ... he said i was ... i said it doesn't matter and it looks like you're cruising that dude you're playing pool with pretty heavy ./. he says he hates the dude cause the dude is ARROGANT ./. I told him I thought the dude needed a tough ass D. I. to turn him around and DAN AGREED .. // .. I smoked a couple more cigarettes and thought DAN had the best body in the place ... although his pool buddy was HOT I wasn't into doing a PRODUCTION NUMBER for him tonight ... i'll get into my army fatigues and kick ass soon

enough ./. DAN SAYS HE'S INTO EVERYTHING BUT FISTFUCKING ./. I noticed the GOLD RING through his TIT and thought that he might be somewhat correct ... i hate to fuck around with belt teasers ... DAN said he wanted to get into everything ... he also said he quit smoking 4 months ago ... and do i want to come up to his house ?? i said buy yourself a pack of MARLBOROS on the way out and i'll watch you smoke ... He gave me a funny smile and made for the door ... we met back on the street and i followed him across town ... my truck breathing on his CUTLASS ... things went pretty good at his place ... he kept the dog out ... but it was a sweet dog ... and i sat in the big leather chair ... he lit me a cigarette and asked for permission to get me a beer ... the talk went on from there and it was all pretty good ... he started sucking on my boot and running his tongue across my crotch ... my DICK'S HARD AS A ROCK ... cause I KNOW a good trick is coming up ... his need becomes more apparent and i figure its about time to get onto some of MINE ... his place is a mishmash of lamps, crystal and a lot of crap like that but that doesn't bother me ... a hard flat bed is all i'm looking for in the way of furniture ... on it i notice the wall behind is all mirror and there's enough pillows for me to stretch out ... relax ... smoke a joint and watch this panting little faggot service my cock ... which happens in short order ... said he wasn't really a cocksucker and always a top but a man like me is hard to find ... I agree with him and instruct him to become a better cocksucker and that he would be a very good bottom ... indeed ... tonight ... but i'm really relaxed so the vibes are real assured and there's NO ANXIETY ... WE BOTH KNOW ... I grab him into me and hold him real close ...

we take hits of LOCKER ROOM ... and i start to do that

BONE MANIPULATION

that i get off on ... he never had this done so he gets even MORE TURNED ON ... as i take his arm out of its socket and put it back ... bone and joint manipulation turns me on cause i can adjust the dude to be just right for me ... he wants to show me his "TOY COLLECTION" and of course i am ready by now to start in ... it looks like a PLEASURE CHEST SHOWCASE ... man EVERYTHING is in it ... i rummage around while he is pouring me a BOURBON & WATER in the kitchen ... finding what turns me on the most was easy ... this PILE OF CHAIN ... i pulled it onto the bed and ENJOYED THE SOUND AND WEIGHT OF IT ...

he comes back in and tells me he dropped ACID about an hour ago ... i tell him that's real good and no i don't want any ... I got him back sucking on my cock and start playing with the chains ..//.. they sound real good and I start to sling them around his crotch ./. the guy's hung pretty good and has nice sized nuts ... he just gets hot as i wrap about 100 miles of steel around his genitals ... getting turned on and stoned with the beer, bourbon, grass, cigs, and aromas i start working on the dude ... making a tight fist i grab his cock N nuts tightly in the chain and hit him REAL HARD with my fist right into his crotch ... he gives out a loud groan and i just slug on ... making that cold steel bite into his soft flesh turned me on a lot and i really beat the life out of his cock ... using my hand as a reflector i was able to beat onto his nuts in a real satisfying way ... he soon half sat up and asked me to stop ... i already done a lot of satisfying myself so i say

SURE and slowly crawl up his body ... at his chest i sink my fucking TEETH INTO HIS NIPPLE and chew the roots off it ... he likes that a lot and tells me his tits are mine ... that just gets me going more so i rake my teeth across his pecs and zero in on the base of his nipples which is about 3 inches into the body ... but you CAN reach it and work all the internal genitalia and glands over with your teeth if you are really sensitive to the continuation of the body organs into the body and their connections with other parts ... I do this for quite a while and then tell him to get me another BOURBON ... like I wanna relax and cool off for a while ... cause the guy is REAL HOT and it gives me time to poke around his toy box and think of a few other things to do ./.

—

— Fred Halsted, "Personal Training," *Package*, no. 4 (November 1976).

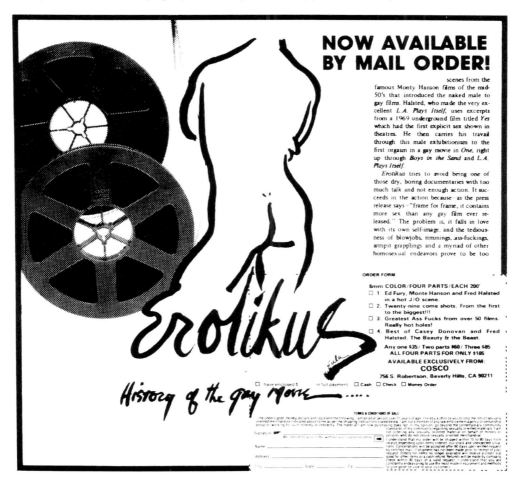

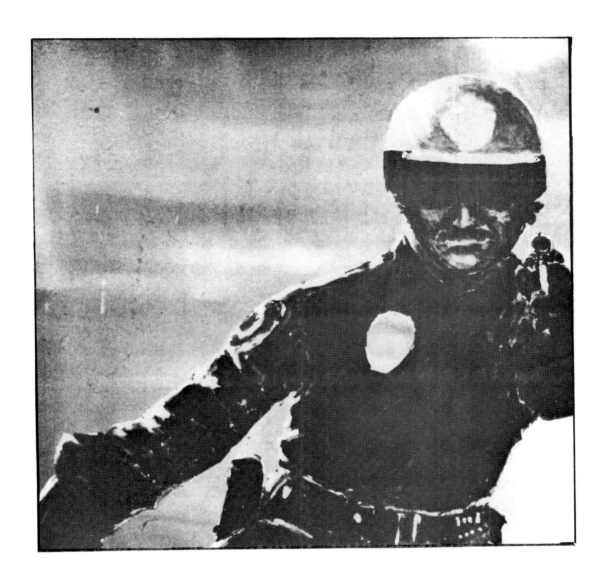

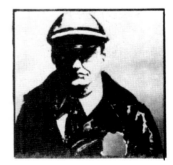

PERSONAL TRAINING

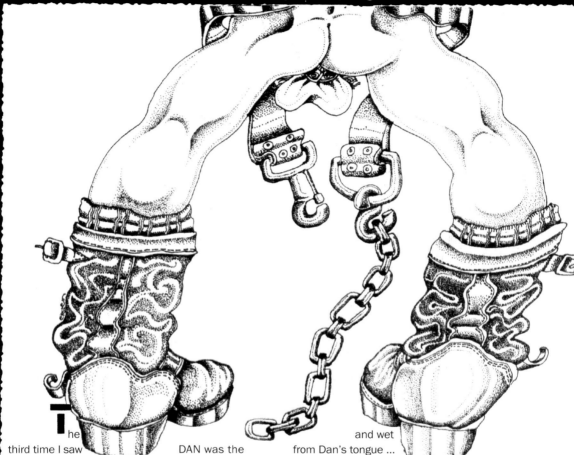

The third time I saw DAN was the HOTTEST yet ./. I dropped by unannounced and Dan was ready ... he just finished balling a real cute hung GERMAN and I came in at the tail end ... but the action was already over ... did talk to the dude though ... and we're gonna have a 3-way soon ./. anyway ... I plop into the big leather chair and Dan is real quickly pouring me a stiff bourbon. I haven't been eating much lately cause I get real bored with food and eating so the alcohol went to work fast ... as I sat in the big chair Dan's tongue eagerly started at the bottom of my boots ... these old boots I've been wearing for over 10 years ... the same ones I wore when I shot "L. A. PLAYS ITSELF" in 1969 ... when I go into have them resoled the cobbler looks at me like I'm crazy and tells me to throw them away ... but like they're a well-worn part of me and I'm NEVER gonna take them off ./. they quickly grow dark and wet from Dan's tongue ... slowly he works his way up till he gets to my crotch ... then he salivates a lot as I get a HUGE HARD ON and he sucks it through my LEVIS ... then blows air into the crotch to make it feel real good ... then he slowly bites along my dick and that just makes it get bigger... I'm starting to think it's time to get into some action ./. I order Dan to put on his chain vest which he does with remarkable speed ... Dan's all hot and anxious now ... I check out his tight body and start anticipating what I want to do with it tonight ... then he suggests he go clean himself out so that I can fist fuck him (he's got a virgin knuckle ass) ... and I already had laid my claim so I say sure go ahead if you want to ... but I also like the feel and smell of an ass filled with shit ... turns me on ... that fucking stench will knock you out but it smells real good to me! I like to see the

194

raw shit clinging to my arm and those small traces of blood from broken capillaries ... anyway Dan wants to douche and do a clean job and I like that TOO so I say OK.

First I order him to refill my bourbon and then I sit back in the chair reading NATIONAL GEOGRAPHIC while Dan is on the pot. That fucking magazine is the most beautiful in the world ... I read a story on the CALIF CONDOR ... I really get off on strange animal life ./. anyway I remember my belt ... the one I ripped off Vince's gym ... it's real functional and I think the best belt ever made ... I handed it to Dan when I first came in and now felt hot and started thinking of it ... it's a 3-inch brown leather strap with a clip and about 2 feet of chain ... the so-called purpose of it is to snap on a dumbbell while the belt is around your gut and do knee bends ./. great for the calves ... but I had been eyeing that leather and chain belt for a long time to adapt to my own uses ... I already got big calves from walking this fucking hill up to my house from Sunset.

It took me 3 weeks of watching for the timing to be right to tip the belt off Vince. A lotta guys use it to work out with ... anyway I got it now and have enjoyed its many complexities for several years ../.. so I yell out to Dan who seems to have maybe fallen into the L. A. SEWERS ... and soon find my belt and go looking for Dan ... he's plotzed on the toilet so I stand over him and take a hit of amyl ... feeling real good I unbuckle the chain and lock his head into place around my throbbing crotch to get some quick stud service ... Dan is REAL GOOD and starts sucking right away ... I got him chained up in a good position so I just fuck his head for a while. He's so fucking good that I shoot off a quick load down his throat ... he starts whacking off in the bowl ... next I unbuckle my belt and let the ice-cold heavy chain run down his back ... a few fast whacks with the leather strap of the belt gets him real hot ... then I follow it with some MEAN beats of

the chain ... we both start to get turned on a lot so I very roughly scrape the chain from his butt to his neck where I wrap it tightly around his throat and pull real tight on the fucker ... the bourbon is getting to me and I'm feeling real good ./. having him now tantalized and me horny I leave the asshole in his bowl and go looking around the house for some more goodies. I remember the IRON VEST he wore the last time we fucked so I grab it from his PLEASURE CHEST and stumble into the bathroom ... there I wrap his head in it and start pounding real hard on his skull he's pretty ripped and evidently has a thick head thicker than my big fist ... so I go BACK into the bedroom and find a pair of leather gloves which I quickly put on ... they feel good ... it had been a while since I had worn any....

Back into the john and that dumb asshole is still sitting there ./. I come up and pound on him some more this time with gloves on cause my KNUCKLES WERE BLEEDING from hitting the chain against his skull with my fist ... this time it feels better for me ... next I take out my chained tit clamps ... they ain't clothespins but the kind JIM-ED the editor-master of the HOT NEW MAG "ACTION MALE" wears ./. strictly HEAVY DUTY ... I like the grimace on Dan's face as those fuckers bite into his tough nipples ... now I take the chained vest off this dumb ass (ANYONE has to be a dumb ass to fuck with me while I am drunk) and wrap it from his neck DOWN his tight body (still sitting on that fucking toilet) and then I start to get turned on and whip his back REAL GOOD with the chain of my belt //

the chain eating into his chained vest on his back, sounds real good and he moans A LOT ./. I figure it must be hurting the fucker so I do some fast punching with my tightened fist to make sure Dan doesn't miss any action ./. since it seems like this is STEEL NIGHT I leave and go back into the bedroom leaving a low moaning stud on the can ... but he's still there and I KNOW he is just waiting for me to think of SOMETHING NEW to do ... that's the way masochists are (if they're any good) ... from his toy box I retrieve a pair of BATTERY CONNECTIONS ... now I figure they ain't there to start any car but may be there to cause sparks so I bring that in and poor Dan gives me a plaintive look but doesn't move so being the sensitive sadist I figure that's an OK it was. Dan has on a steel cock ring so I open the JAWS of that fucker real wide and to show what a nice guy I am I clamp them onto his COCK RING primarily and the other teeth happen to eat into Dan's erect dick ... LOTSA GROANING at this point but I did it the right way ... not too much blood and he seems to get real turned on ... like he's slurping on my dick right away and I figure the dumb ass must like this kind of treatment so I grab onto the clamps and give them a squeeze ./. he seems ready to pass out so I just leave him there and go crash on the bed ./. figuring at some time he's gonna come to and finally GET OFF THE TOILET././.

— Fred Halsted, "Personal Training," *Package*, no. 5 (December 1976).

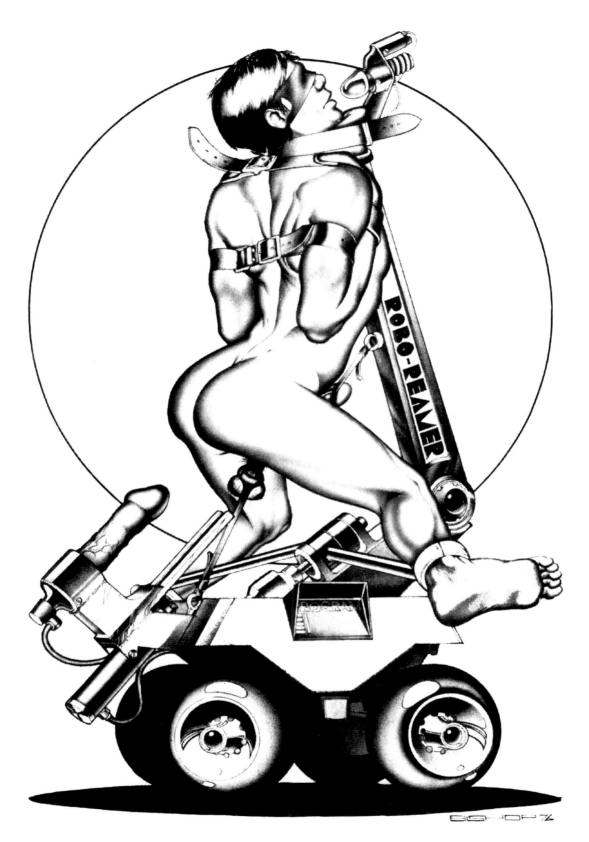

PERSONAL

SAN FRANCISCO'S CMC CARNIVAL was really a trip. Nothing like it could happen here in gestapoland. I wore my new western boots from the PLEASURE CHEST and my PROPERTY OF LARRY'S T-SHIRT that I got at LARRY'S bar here in L. A. The day before I had stopped by THE TRADING POST on Folsom Street and bought a real mean spiked/studded belt ... looked and felt real good ... I like that store a lot cause it's got EVERYTHING you will ever need for a good night. I been working out a lot and the T-shirt fit good and tight ... in the line in front of the Seamen's Hall they were selling LOCKER ROOM at 3 bottles for $10. As I stomped around the joint I noticed I was getting a lot of strange looks with guys coming up to me and asking me if I was Larry or was I property of Larry and who is he to have me as his slave...//... it felt real strange but I talked to a lot of studettes that I normally wouldn't as they were looking for a good slave and thought I was one ... I straightened them out FAST!! The place was an unbelievable mass of LEATHER/LEVI MEN and a huge hard-on to be in this mad crush of bodies ... you couldn't really walk around cause the crowd just had a movement of its own that you were shoved along with ... the top floor ... basement and parking lot was solid skin ... with everyone stoned out of their gourds and feeling NO PAIN ... there must have been 10,000 men there ... early in I talked to a real dirty biker who looked like he knew his ropes but the rush of the crowd swept us along and I wasn't able to score on him ... so I just went with the group and musta met 100 possible great lays ... after checking out the top floor I went along outside and got a hit of air along with lotsa hits of grass, amyl and some good groping ... inside the basement was a terrific rock band that was REALLY GOOD and maybe 1,000 faggots dancing to a hot disco beat ... in back was a dark space that had HUNDREDS of men sucking / fucking / fist-fucking / pissing / man that space was HOT ... I found a real good San Francisco type studette and he eagerly sucked my big tool off ... felt real good to shoot a load down his throat cause the constant rubbing of leather jackets sure was working up the cum in me ... I finally met BIG BILL HARRISON the 12-INCH porn star of BLACK & BLUE and WAKEFIELD POOLE'S beautiful BIJOU ... he was even better looking in the flesh ... over the weekend I musta seen every porno type ever ... Peter Berlin was doing his show at the HOTEL bath-house ... my own JOEY YALE got him there and said it was terrific ... after getting sucked off real good I went back upstairs ... the line up the stairs was unreal. It was so crowded ... as we're all funneling slowly up this corridor some queen yells out "party of four" and everyone cracked up ... I had wisely bought tons of tickets for booze as I first came in and bought beer by the armload ... so I had enough and could spread it around ... BOB LEYTON the editor of NEWSWEST was out of tickets so I gave him a hug and a beer. It was real good to see so many of my buddies ... I missed JIM-ED master of the new mag ACTIONMALE but I did see his slave STEVE KING ... everyone was getting off on his hairy body and tight muscles ... then by great luck I ran into the dirty biker I had seen hours earlier ... now he was really bombed ... said he went down on a leather stud downstairs right in front of the cops ... who ignored the whole scene there ... it was better than a Fellini movie could ever be ... I said let's go to my hotel ... it's a real good one ... called the BUNKHOUSE ... it's as stripped and functional as a bathhouse and only $9 for a double ... he said he wanted to go to his place and I soon found out why ... as we were splitting guys were STILL pouring into the place and I heard the announcer say that STEVE QUINLAN sponsored by the STUD bar in L. A. had won the Mr. CMC title ... and seeing his stripped hot body I knew why ... I take this biker over to my '55 CHEVY TRUCK I drove up to the

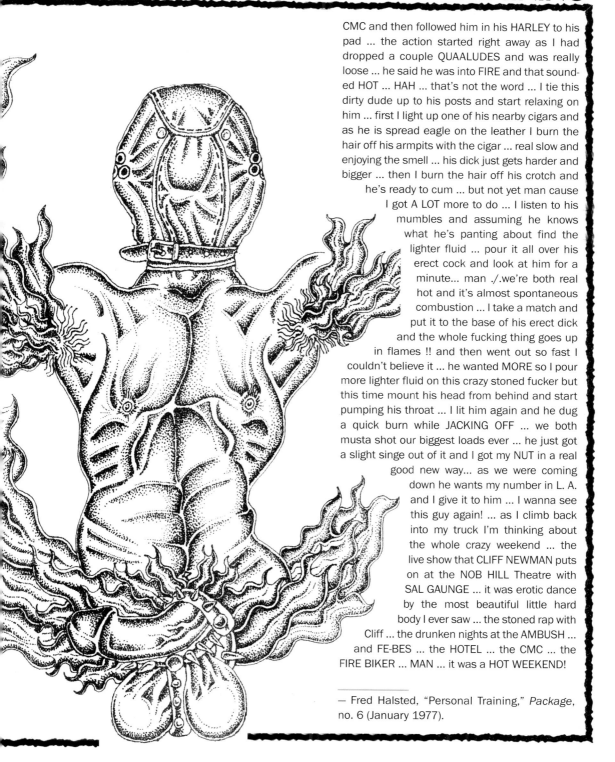

CMC and then followed him in his HARLEY to his pad ... the action started right away as I had dropped a couple QUAALUDES and was really loose ... he said he was into FIRE and that sounded HOT ... HAH ... that's not the word ... I tie this dirty dude up to his posts and start relaxing on him ... first I light up one of his nearby cigars and as he is spread eagle on the leather I burn the hair off his armpits with the cigar ... real slow and enjoying the smell ... his dick just gets harder and bigger ... then I burn the hair off his crotch and he's ready to cum ... but not yet man cause I got A LOT more to do ... I listen to his mumbles and assuming he knows what he's panting about find the lighter fluid ... pour it all over his erect cock and look at him for a minute... man ./.we're both real hot and it's almost spontaneous combustion ... I take a match and put it to the base of his erect dick and the whole fucking thing goes up in flames !! and then went out so fast I couldn't believe it ... he wanted MORE so I pour more lighter fluid on this crazy stoned fucker but this time mount his head from behind and start pumping his throat ... I lit him again and he dug a quick burn while JACKING OFF ... we both musta shot our biggest loads ever ... he just got a slight singe out of it and I got my NUT in a real good new way... as we were coming down he wants my number in L. A. and I give it to him ... I wanna see this guy again! ... as I climb back into my truck I'm thinking about the whole crazy weekend ... the live show that CLIFF NEWMAN puts on at the NOB HILL Theatre with SAL GAUNGE ... it was erotic dance by the most beautiful little hard body I ever saw ... the stoned rap with Cliff ... the drunken nights at the AMBUSH ... and FE-BES ... the HOTEL ... the CMC ... the FIRE BIKER ... MAN ... it was a HOT WEEKEND!

— Fred Halsted, "Personal Training," *Package*, no. 6 (January 1977).

CLASS...ADS

Long Beach. W/male. 25, 6', 150 lbs., br. hair/eyes. Leo. M. Looking for well-built S 21/35 for heavy body and mind trip. Please send photo. Ans. all. #1420

Super Black Leather Stud with Bulging, Throbbing Cod Piece—looking for Leather Guys for wild, way out leather scene. Let's do it in leather. #1450.

LEVI GUY IN WASHINGTON D.C.
Young man, 22, 6'1", 165 lbs. of muscular body and handsome. Seeks older gdlkg, masc, slim, avg-end, versatile man for hot wet levi action. Reply w/ photo. Randy Box 1444.

GET INTO SLAVE/MASTER
NYC. Well defined 40 year old master seeks toilet slave for regular service. Physical and fantasy trip. Limits respected. Looks unimportant. Need slave for regular service. Am well hung and hard to satisfy. Dude, Box #1434.

Attention Bikers/Leather/S&M/Military or Police!!!Bondage/S&M Master with totally obedient slave—both in 20's want to meet Studs 18-35 (tops or bottoms) for HEAVY fun and games! You name the trip! Master is expert in corporal punishment, water sports, elaborate total bondage enemas, dildos, erotic piercing and the complete breaking and training of Slaves. Anything goes—The BIZARRE is our way of life—Couples or novices welcome and tolerances respected! Serious, mature, well-built, fantasy seekers write with photo and phone for immediate reply. If you are a tourist, curiosity seeker or adolescent, GO TO THE LIBRARY!! JIM-ED & STEVE.

SHORT MUNCHKIN STUD
Man to man action in San Francisco. w/m 25, 130, 5'7", j/o expert. Loves to perform. Proud and Horny. Vic #1438.

CHICAGO
Dig beautiful full buns under 35 & slender. Am top or bottom. Good ass is a turn on w/joint & popper. Also w/s or SCAT. Out of towners welcome. Enclose photo. PACKAGE #1398.

grab some california con

every month

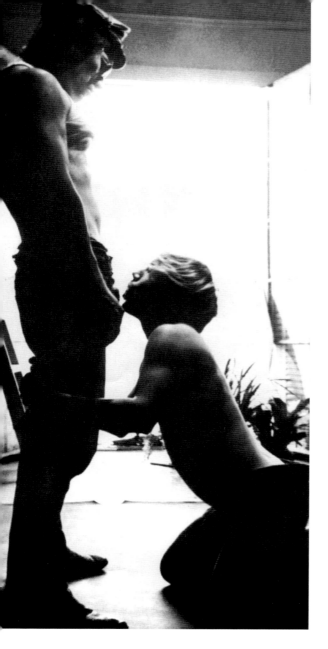

FRED HALSTED

DENNIS IS A COP ../.. 6' 2" .. WHITE .. 33 ..185 LBS .. DARK HAIR / DARK eyes MARRIED .. RESIDES IN MISSION VIEJO PORSCHE TARGA .. WORKS OUT DAILY 10 INCH COCK .. THICK DARK BODY HAIR .. DENNIS IS HOT! I met DENNIS at a Denny's coffee shop off the San Diego freeway. He was not in uniform and we sat close at the counter. I asked him to pass the cream and we started small talk .. he was cruisin'—in that cool cop way and speaking with his deep from the nuts voice .. told him I was restoring my CHEVY PICKUP .. he praised his PORSCHE .. typical CALIFORNIA talk always safely begins with each extolling the virtues of their car .. your car defines who you are in California .. the most FUCKED UP people drive AMC PACERS .. I told him I had been visiting my uncle in Long Beach and had swung down to check out the action at EL TORO MARINE BASE .. picking up right away on my gay reference he asked if I knew any DRILL INSTRUCTORS (D.I.s) .. I said no .. he said he had a good buddy who was a D. I. .. asked where I live .. I told him in a soundproofed house above SUNSET STRIP in L. A., he asked why soundproofed .. I said because it's QUIET .. HE said that's good .. I said do you get into town he said he was thinking of coming up .. I invited him to check out my pad and he said sure .. he said he doesn't know the spots in L. A. but does in ORANGE COUNTY .. he was very interested in finding out where to go in L. A. .. I gave him directions on how to get to my place and we took off .. his PORSCHE hot on the tail of my TRUCK. Without saying anything we had said it all.

It's about an hour drive up the freeway to my pad. DENNIS was really impressed when he walked in and spent some time looking out over the basin .. It was now night and we could see all the way to the Laguna mountains where we had earlier met .. he sat down in my EAMES leather chair and I asked him if he wanted a beer .. SURE .. I'm really turned on as I return with the suds, in fact had an erection ever since we met. As I hand him the beer he takes my other hand and puts it on his crotch ./. FAR OUT .. his meat had swollen up and eagerly I pursued it down his tight LEVIS .. then I started to unbuckle my belt and unbutton mine .. pulling out my erect dick DENNIS grabbed it and took it down his throat .. I slid my hand into his surfer decal T-SHIRT (you KNOW anyone's from ORANGE COUNTY if they have a surfer T-shirt) and got hotter as my hand grabbed his super muscular hairy chest ./. DENNIS has a body like a MR. AMERICA and the attitude of the MACHO STUD .. we go into the bedroom and smoke a joint and play around with each other .. his mind is as crazy as mine and he suggests we go out and kick some ass .. why don't we

pick up a cocksucker and take it from there .. we roar over to the ONE WAY and soon find a panting S/Mer who is turned on a lot to the two of us .. DENNIS comes up with a great idea ./. lets go to EL MONTE and hit some of the real western straight bars there .. our new buddy is really looking forward to WHATEVER we want to do so we all pile into my truck and hit the San Bernardino freeway .. go about 15 minutes from L. A. in ANY direction and you are in a whole different world .. we pull into the ALLEY CAT bar in EL MONTE and notice the pickups and motorcycles in front .. looks right. Neither one of us had ever been there but we go in and order 3 beers. The bartender is a 30ish DOLLY PARTON TYPE BROAD .. and she gives us a friendly welcome. A good country and western jukebox is going and the place ain't too crowded .. we head for a dark rear wall and drink beer .. the bikers and few rednecks look at us but don't pay much attention .. I go into the john and fill up my empty beer bottle with piss .. returning and giving it to the guy we picked up at the ONE WAY he likes his new suds and drinks with GUSTO then DENNIS starts to get hot watching this dude drinking the recycled beer so HE goes to the john instructing the dude to follow .. there he orders the dude to sit on the toilet as he pulls out his thick long cock and empties HIS piss straight into the dudes mouth .. TAMMY WYNETTE is chirping away and the dude evidently likes to get a little sloppy and DENNIS pisses fast and A LOT .. he comes out and orders another beer .. then the dude walks out with a shit-eating smile that erases fast as a straight dude is on HIS way into the john .. and our new water sport slave has his

fucking shirt soaked .. the straight gives him a funny look and continues on into the john as he comes over to where I am standing .. DENNIS comes back with a beer for me too and we just stand around for a while .. I gotta piss again and DENNIS tells him to take it right there .. SHIT .. this is getting good .. we are in a half shadow and I pull out my dick and the dude drops to his knees and I piss straight into his open dripping mouth .. MISS BIG TITS sees the whole thing and a shocked look comes over her face .. I figure she's gonna sound the alarm and a fight is on the way .. well she doesn't .. she looks at the 3 of us and starts to get turned on more .. this crazy broad LIKES the show and that turns DENNIS and ME on even more .. the straight dudes don't really see what's happening .. maybe thinking the one on his knees lost his wallet or something .. after I finish unloading my liquids I drink some more beer with DENNIS .. who's evidently really turned onto exhibitionistic sex in strange places .. the fight doesn't happen probably because the bar ain't too full and we got a panting cunt enjoying the show .. we finish our suds and head back to the truck and L. A. .. dropping our water sport slave off at the ONE WAY and have a good laugh back on the way to my place .. DENNIS has gotta get back to ORANGE COUNTY but says he will be back next week and lets do something REALLY wild .. I mention the infinite possibilities of my truck and start planning for next week's on the road adventure .. but THIS time we really want to do it./././.

— "Fred Halsted," *Drummer*, vol. 3, no. 18 (1977).

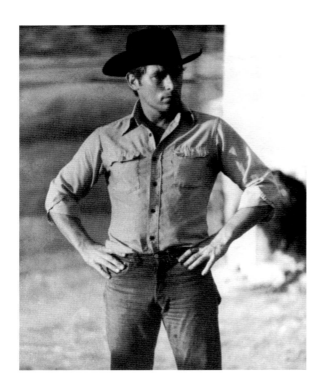

FRED
HALSTED

SARDONIS is the God of Sado-Masochism. I met a witch at a GSF meeting (of all places) and he talked to me after I spoke. He said he saw SARDONIS's aura over mine at the meeting. We had a rap about this and he told me how to chant and open myself to the God's power. I did the next day as I smoked a joint before I worked out. There is one man I wanted to see and couldn't. Well the next day he called.

Dennis (my big cop buddy) called and said he would like to see me again that evening. I said anytime – anywhere! God damn, I got excited real fast ... I've been obsessed with this big stud ever since I first met him.

Several hours later his Porsche roars up my driveway and my saliva starts to drip from the corners of my mouth. Dennis feels that I am real nervous and so he calms me right away by ordering me on my knees as soon as he walks into the house. I get down real fast and start blowing into his crotch through his levis and realize I am in heaven. Dennis has to piss and tells me to open my mouth ... well I sort of start to shake but do what he says ... I've never before drank another man's piss ... but Dennis isn't another man ... he is man! He reaches into his pants and pulls out his big thick meat and I go right down on it. I can feel his piss working up through his groin and then my mouth is filled with the hot liquid. I start to swallow as fast as I can because right away his piss is pouring out of my mouth and over my body. I gulp as fast as I can trying to savor every drop but he is faster than me. I choke on it because there is so much and the taste is new to me but he just keeps pissing ... he stops for a moment and tells me to "drink all your man's piss, cocksucker" and I say "Yes Sir" and eagerly await more ... which comes right away ... it is pouring into me and then he takes his cock out of my open mouth and pisses all over my face, hair and clothes. I just open my mouth wider and swallow quickly so I can get every drop possible. He then tells me I was good and I say "thank you, Sir!" and fall to the floor suddenly exhausted.

Later he is sitting back on the bed and I am licking his naked hairy legs and cleaning his toes with my teeth as Dennis raps about some exhibitionistic trips. I suggest we go do them and not talk about them ... he really gets off in public and I remember our hot scene in a western straight bar in El Monte the first time I saw him. He says he's hungry and let's go get something to eat. Fine with me, but I don't want to go into a restaurant and knowing how his head works I suggest we go to Tiny Naylor's Drive In at Sunset and La Brea. It's a Thursday night about 11 PM now. We pull into the half deserted place in his Porsche. There's about 10 other cars and we park by those palm trees. A big blond waitress starts over to the car. I reach over and unbutton Dennis's levis and lean over and start sucking on his big joint. Dennis likes this as the waitress comes over with menus, he rolls down the window and she hands in the menus.... suddenly stopping in mid-track as she sees me sucking on his cock. Nothing said. I hear him ordering a French dip (which sounded appropriate) and she writes it down and walks away. I raise up and he says "she's gonna call the cops" ... I say "let's watch and see what happens." Well, she goes to her window and seems to order the sandwich ... then back to her station and stares at us. Then she starts back to

El Paso Wrecking Corp.

DRUMMER presents an exclusive peek into what promises to be another hot, new film from director Joe Gage and Producer Sam Gage, who excited us all last year with their "Kansas City Trucking Company." KCTC was made with a professionalism generally lacking in gay male porn. We don't know yet the story line. But we do know the stars include: Fred Halsted, our coverman Steve King, Jeanne Marie Marchand, Stan Braddock, Mike Morris, Jared Benson, Locke and a hot new discovery Guillermo Riccardo. DRUMMER will feature an interview with the Gages and their dedication to the upgrading of male films in our next issue.

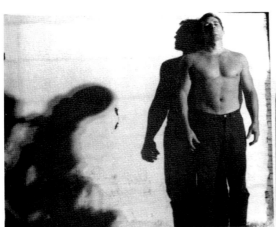

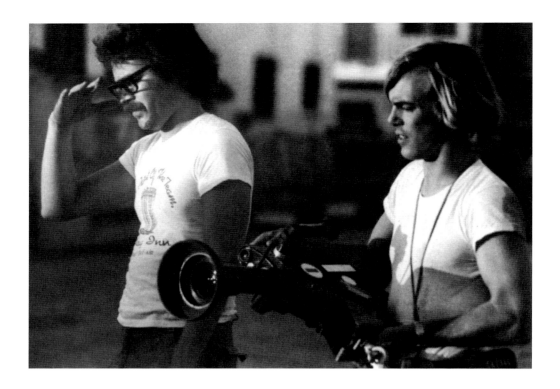

the car and I go back to sucking on his cock. Man, it tastes real good and I'm very glad to have it in my mouth. I hear her come back to his window and hear his deep voice that seems to come from the bowels of the earth. I look up after she leaves and it seems she brought us some glasses of water. Well, we get a lot of personal service from this broad and Dennis gets a lot of good service from me. This play continues while Dennis satisfies his appetite for French Dip and then I hear him start the car. Well I raise up and Dennis says I guess we should go back and the drive in was real good. I suggest that since he hasn't got his nut yet he might want to try another scene. Well it seems he is real turned on and says sure. I say make a right at Nichols Canyon and soon we are winding our way up that hillside canyon that is in the middle of Hollywood. I show him where to park and we soon are out of the car. He says what's the trip now? I take off all my clothes as he leaves his on. He follows me to the double white line in the center of the road ... and there I drop on my knees and he comes over and mounts my eager face again. Cars are driving up the road and soon we are aware of flashing lights as the cars at first don't realize what they are seeing. They do soon enough as they swerve out of the way and blast their horns. None of this bothers me or Dennis. He gets real excited about being blown on the center line of Nichols Canyon and his dick gets even bigger and harder. He likes it a lot. I'm sucking the best I can as some more cars drive by blinking, honking and yelling out a few incredulous remarks. Dennis is so hot he soon comes and shoots his big hot load straight down my throat, grabbing my hair to force his cock down even farther into my oh so willing throat. We quickly make for his sportscar after he has shot his load and peel out of there as now we both feel one of the car drivers surely is calling the cops. I told him it didn't bother me if I get busted. I was arrested last year at Drummer's Slave Auction and spent some time in jail with the hottest men in the city. We're laughing as we speed down from the canyon and I'm feeling in heaven as I can still taste his come mixing with his piss in my body. As we pull up to my place Dennis has to split ... but I again remind him of my truck and the possibilities it allows. I had just acted in a film called *El Paso Wrecking Corp.* (the sequel to *Kansas City Trucking Co.*) and we certainly made good use of it in that hot film!

— "Fred Halsted," *Drummer*, vol. 3, no. 19 (1977) .

FRED HALSTED

UNBUTTONING MY LEVIS I SOON HAVE HIS TONGUE FROM THE TOP OF MY BOOTS TO THE BOTTOM OF MY CROTCH ...

I met him at Larry's. He is from Long Beach (I seem to be a magnet to out of town hunks), really good looking, about 5' 8" tall dressed sort of casual in a dark Pendleton shirt half rolled up to his elbows. I liked him and thought his really hairy forearms were a good sign that he grew lots of hair on his ass. I liked his nervousness, yes, he had been to Larry's before and liked the dungeon look of the bar. I told him I had a space hotter than a dungeon and he got even more nervous. I asked him if that great beach toilet was still hot and he said yes, but the vice busts it a lot so it's pretty dangerous.

There are two hot toilets in Long Beach. One is at the far end of the Pike Amusement center. Real off the wall types go there, a lot of straights and also an occasional guy looking for a blow job or whatever. It's real good 'cause you hear all the great sounds from the rides and the urinals are in an easy sight line to cruise cock. The other is near Belmont Shore area and more gay in the sense that it is on a lonely stretch of beach and down about 50 feet of steps from Ocean Blvd. You go there to cruise and don't have the unexpected drop-ins of the busier Pike john.

I say let's split and go to my place so he follows me out of the bar and drives real close so we don't split in traffic. A good test of how hot someone is is to put a few cars between you (while checking them in the mirror) and watch them frantically try to keep up.

We pull onto my street (a quiet residential area of L. A.) ... so we get out of the cars and he follows me down the sidewalk. We walk down the dark side of the house and I can almost feel the pressure on him ... going around to the rear in the shadows is a detached building. We walk up to it and I stop and pull keys out of my pocket. Unlocking the large padlock I slowly pull open the door, the creaks and scraping along the ground adds to his feeling of anticipation.

Further setting the scene up in his head I walk into the space and he follows me. It is dark and large, ominous shapes appear. I step back and pull some Butyl out of my pocket. Giving him a hit we both experience that great relaxing rush.

He hears an unfamiliar sound and suddenly finds himself trapped by a thick rubber restraint. I grab him tight as I am tying him with his hands to his side standing up. Next I order him down on his knees and he quickly has his tongue licking the black shine of my knee high police boots. Unbuttoning my Levis I soon have his tongue from the top of my boots to the bottom of my crotch ... taking another hit, he soon is giving me great head.

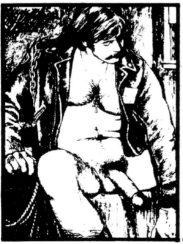
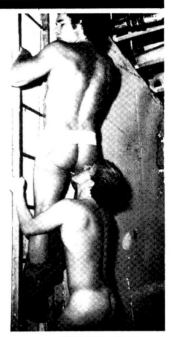

Pushing him all the way down he lays on the cold concrete floor ... feels even better as his pants come down and my fingers work slowly up his beautiful and yes I was right, hairy ass. I get over him and my hot tongue is quickly opening up his butt. That great smell and taste of ass sweat mixed with levis fills my nostrils and mouth and I soon am pumping my cock into his beautiful tight ass. Obeying orders he licks the oily cold floor as his ass is satisfied.

Later as we are walking back to the street he says he liked it a lot and can we do it again.

My mystery space was a garage, the strange dark forms were tires propped against a wall and an old desk, the rubber restraints were an old garden hose.

Making the inconspicuous space a surprise dungeon is a real turn on. Always carry on you your basic equipment – your belt, some aroma in your pocket – what else do you really need? Other areas that work well are old garden sheds with their great musty smells and selection of hand tools a closet with some leather jackets and maybe an electrical cord, a back porch ... you define the space. It is important to keep it dark so the mystery is created ... a garage with the light on is just a garage ... with the lights out it is a fuck space. It isn't what you have – it's how you use it.

— "Fred Halsted," *Drummer*, vol. 3, no. 20 (1977).

FRED HALSTED

I'd been bored by my sex life in L. A. and felt I was being repetitious and too "technical" so I went to MARINE HEAVEN the city of OCEAN-SIDE. Got there early in the afternoon, not much happening, talked to a lot of marines and found they all are wondering why they joined and why isn't there a war for them to fight. The afternoon I spent in the local porno house watching "FANNY HILL." Walked into the dark, large theatre and the vibes knocked me out! 50 hot, young marines jacking off watching the flick. I groped my way to the top row and let my eyes feast on all that fresh meat. They were so turned on and horny, but still marines, sitting with a seat between each other as they pulled out their throbbing cocks and ran their hands over them. Realizing there was no way to get down on some of that I took

out my amyl and jacked off looking at a dark theatre full of panting marines.

Later, I cruised the pier, not much happening, the head under the pier was unusually quiet. Went up to that bar "THE DRIFTWOOD" over-looking the pier and there met the 3 hottest marine bikers I have ever seen. Each in a black leather jacket, I played DOLLY PARTON'S "HERE YOU COME AGAIN" and started a con-versation. BILLY is 18 and looks and acts crazy, MOOSE is huge and looks like he has the DICK OF DEATH, and GARRIT turned me on the most. Sort of the ringleader, his ambi-tion is to be a steel truck driver working in FONTANA (site of the KAISER works) … straight as a board they cruise a lot. A long drunken evening leads us to the live western band bar on Hill St. I am trying to appear straight as I make a pass at GARRIT. Anyway, things work out such that I am later blowing GARRIT on his chopper in the alley. Right near the tattoo par-lor (where that afternoon I watched a marine being tattooed as his buddy said, "you take that fucker, and no sound out of you" … his buddy let out a tear of pain but said nothing as the hot needle dug into his flesh). I got down on GARRIT's throbbing cock while he was reclined on his chopped HARLEY and knew I was in heaven when his load shot down my throat. That was until MOOSE grabbed my shoulder (I don't know where he came from since we had split a while ago) and spun me around on my knees yelling "you're next FRED" … well his fist hit my eye with great energy and I soon was stomped royally in that alley. I broke my leg as I fell, but MOOSE can take credit for various crushed ribs, black eyes, etc.

Afterwards I had to drive home in my stick shift '55 Chevy truck. THAT was frightening, driving for 3 hours on those freeways with a broken leg and almost blacking out. It is funny. I think I liked it. The guys were so hot, and I felt such an almost SATORI-like rush afterwards.

— "Fred Halsted," *Drummer*, vol. 3, no. 21 (1977).

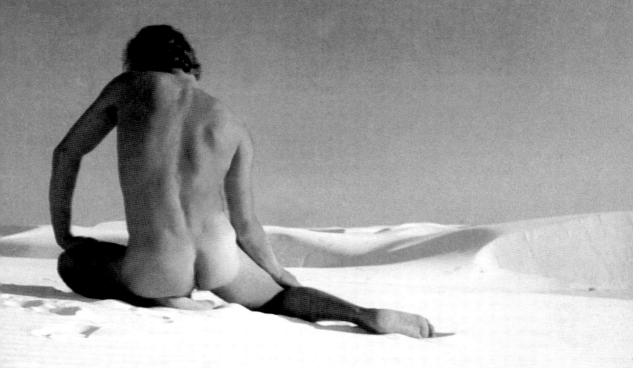

SOME THINGS THAT YOU WILL EXPERIENCE IN THIS LIFE ARE JUST NATURALLY BEAUTIFUL

T.M.

THE CLUB BATH CHAIN

GAYS BLOODIED IN N.Y.

Newspaper of America's Homophile Community

So. Calif.
35¢

The **ADVOCATE** a.p.i.

Issue No. 85

50¢
Elsewhere

Fred Halsted
His S&M Flicks
Stir Up New York

PRISON DOCS LIE

AFTERWORD

On January 30, 2020, restored versions of *L. A. Plays Itself*, *Sex Garage*, and *Sextool* premiered at the Museum of Modern of Art. The event, hosted by Carson Parish with the help of Ron Magliozzi, was the culmination of a process set in motion about ten years before, as the first edition of this book was being prepared. At that time, there was little hope that Fred Halsted's best works would reach a wide audience, but their restorations have made a new career possible for these unjustly neglected orphan films.

The three films from MoMA's collection have been released on DVD and Blu-ray, and new research by producer Elizabeth Purchell has yielded more details about Fred Halsted's body of work. First of all, *Truck It* (1973), long thought to be lost, was rediscovered in two different versions: the VHS for home video release, and the Super-8 reduction print sold by mail order. Fred himself expressed dissatisfaction with this transitional film between *L. A. Plays Itself* and *Sextool*, but now that both versions are available, spectators can make their own judgments. Purchell has examined the box office figures for *Sextool* and found that the film wasn't the financial disaster it appeared to be in retrospect. *Sextool* was in fact the highest grossing gay adult film of the period at a number of the theaters that showed it, and 16 mm reduction prints—evidence for their existence has also recently been discovered—made it possible to present the film at every venue exhibiting porn. Whether Fred actually saw any

fred halsted's

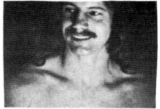

world premiere

"TRUCK IT"

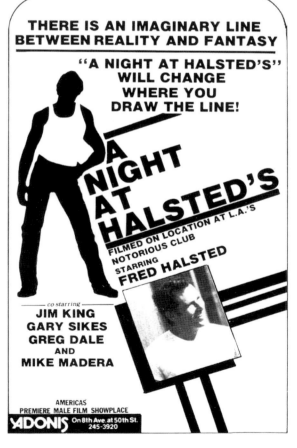
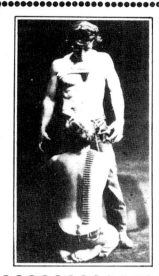
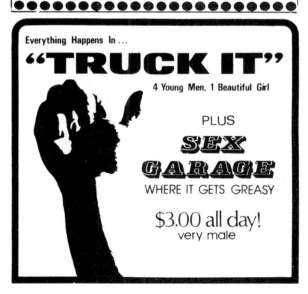

profits from these engagements is another matter; he often complained of theater owners refusing to pay the promised rental fees to independent producers and distributors. In later, more conservative times, *Sextool* proved to be too extreme for a wide release on home video, and this lack of availability since the mid-1980s created an impression that the film was a failure from the beginning.

Before the MoMA screenings, I had only seen inferior copies of *Sextool*: a faded 35 mm print projected once for me at the museum, and a bootleg DVD of such poor quality that it was not only a strain to watch but could barely be heard. A pristine version presented to an audience came as a revelation. Sitting in the front row of the theater, I found the film overwhelming, in no small part because of Donald Geoffreys's soundtrack. The montage of dirty talk and sex sounds creates a menacing and exciting atmosphere. It reaches a frantic pitch with the barracks scene, in which a sailor is brutally fucked by three men, two of whom have red handkerchiefs in their left back pockets, an indication that they are fisting tops. Whereas many scores composed for gay porn films of the era sound like little more than side effects of cocaine—shrill, cluttered, overmodulated—*Sextool*'s electronic music is almost minimal, in a style that Christopher Rage would exploit to great effect several years later for his film *Sleaze* (1982). The sound design suggests the atmosphere of a multitude of gay parties before AIDS destroyed the scene—too many poppers in a claustrophobic room at dawn—while at the same time being entirely listenable. The sight of the sailor coughing up a great wad of semen after relentless fellatio then rising to gobble more cock, accompanied by the sound of whooshing and farting analogue synthesizers, is unforgettable, and the kind of moment few other directors would see fit to include in a porn film. When the scene changes, a civilian worships a man in an LAPD uniform to the sound of sirens and dispatchers on police radio. After the bottom licks the motorcycle officer's Dehner boots, there is a cut to a wider shot that reveals lockers and another cycle cop in full uniform at the threshold of the room. The two officers restrain and rape the man using a handy night stick. The scene is at once so violent, fetishistic, and banal that I consider it some kind of apotheosis of Los Angeles porn films.

As I was preparing this afterword, I discovered that "Donald Geoffreys" was the pseudonym of composer Don Peake, who used his first and middle

names for the *Sextool* credit at the behest of his wife when he was just starting out in the film industry. Peake's other credits include Wes Craven's horror film *The Hills Have Eyes* (1977), produced a couple of years later with music somewhat similar to what he had composed for *Sextool*, minus the sounds of men having sex.

On the subject of pseudonyms, I must admit my misgivings about changing the names of so many people interviewed for the first edition of this book. For the sake of the historical record, I wish to disclose the true identities of several sources: "Tom" is Brian Capon, who deserves credit under his own name for shooting much of *L. A. Plays Itself*; "Frank" is Jay Justice, Fred Halsted's first love, who received a credit in *Sextool* for "chrome assemblage" under his own name; and "Craig," who had the distinction of being the most skittish interview subject I encountered during my research, is John Rose.

Writing about Fred Halsted's work offers an opportunity to research the stories of many people whose names would otherwise be lost to history. One such figure is a long-haired, bearded man appearing in close-up for five seconds during *Sextool*'s party scene. Bathed in vibrantly colored light, he manipulates his hands in front of his face and sticks out his tongue lasciviously in a heart-shaped gap between his fingers. The credits identify him as Buddah Mae. Subsequent to *Sextool*, he appeared in other films. Under the name Buddha Jon, he played a nonsexual role as a landlord in *Falconhead* (1976) directed by Michael Zen. He wears a long, flowing robe to cover a great expanse of belly, and his voice is dubbed to sound more butch; later in the film he makes stylized hand gestures to perform a magic spell. As Buddha Jon Parker, he played the bearded mother of the protagonist in *Carmen* (1985), the silent directorial debut of Alexander Payne. Once again, he wears a long robe and gestures wildly as he acts. Under his own name, John Parker, he played his most substantial role in *Madame Wang's* (1981) directed by Paul Morrissey. Parker's long robe nearly comes undone and exposes his naked body as he dances around a stage with other eccentric characters to the sound of frenetic disco music. Fat as a Buddha, with religious beliefs to match, he later meditates shirtless and discusses his spiritual exercises. Synchronous sound reveals

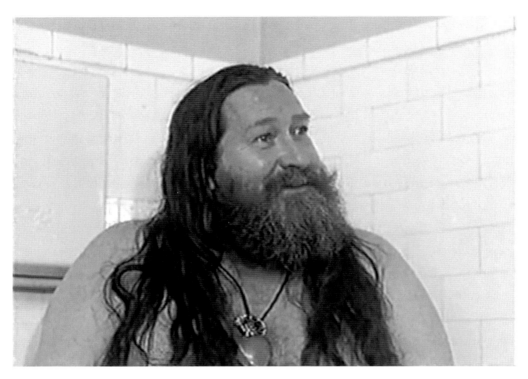

John Parker in *Madame Wang*'s (1981) directed by Paul Morrissey

the quality of his real voice, genial and campy. Still later, he goes to a party attended by Samson De Brier, one of Hollywood's great bohemian hosts, occultist and star of Kenneth Anger's *Inauguration of the Pleasure Dome* (1954). De Brier was likely a friend of Fred Halsted's, though Fred never cast him in a film.

John Bowman Parker came from the Eastern Shore of Virginia and moved to New York City, where he met the woman he would marry, Brigid Berlin. The daughter of the chairman of the Hearst Corporation, she occasionally acknowledged her gay husband. In an interview with Simon Doonan, she explained:

> When I was 21, I married a window trimmer, John Parker. He worked at a store on 57th and Fifth called the Tailored Woman. He had the deepest windows in town. I knew all the window-dressers up and down the avenue—Joel Schumacher, Gene Moore. [John and I] stole daddy's Cadillac and ran off. I rented a house in Cherry Grove [on Fire Island].... I used to come into the city on the seaplane just to get checks. I hung out with all these piss-elegant

queens…. I was insane, but also very grand. I went through $100,000, and my mother went berserk.

The couple's marriage certificate attests to the veracity of part of this account, showing that the ceremony took place in Onacock, Virginia, John's hometown, on June 26, 1962, the day before his thirtieth birthday. Brigid undoubtedly met her fiancé's parents. Their reaction to the match went unrecorded; not so the reaction of Honey Berlin, her socialite mother, who snubbed a man she clearly held in contempt. Andy Warhol described the scene in his book *POPism*:

> When Brigid brought her window dresser fiancé home to meet the family, her mother told the doorman to tell him to wait on a bench across the street in Central Park. Then she handed Brigid her wedding present—a hundred dollar bill—and told her to go to Bergdorf's and buy herself some new underwear with it. Then she added, "Good luck with that fairy."

Although money would seem to have been the main reason for the marriage, Gary Comenas mentioned another motivation on his website *warholstars.org*: "The marriage to John Parker dissolved when the money was gone, Brigid having failed to turn her husband into a straight man, although they did have sex." Perhaps the trip to meet the in-laws in daddy's Cadillac, as well as the marriage itself, were attempts to conform to conventional parental expectations.

At some point after John Parker disappeared from the margins of Warhol's Factory, he moved to Los Angeles, gained a substantial amount of weight, and began acting in independent films. His appearance changed so greatly that if he hadn't used variations on his name in his credits—including his real name for Paul Morrissey, who probably knew him from New York—identifying this man would have been almost impossible. The transitional material of Parker's biography is missing. One among multitudes of similar stories in California, the thin, dapper, (and possibly avaricious) art director of the Tailored Woman in 1960s New York reinvented himself in the 1970s as a bear in a muumuu, the colorful and flamboyant character actor called Buddah Mae in *Sextool*. John Parker died in Los Angeles on his sixty-eighth birthday, June 27, 2000.

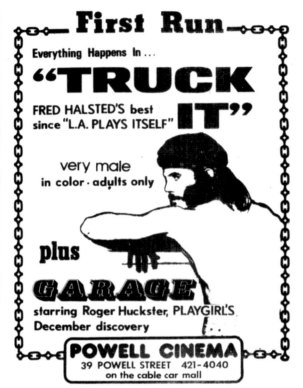
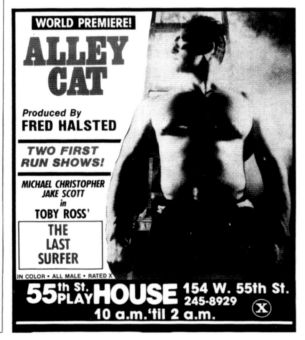

Within months of *Halsted Plays Himself*'s publication, the artist Bobbi Woods told me that she recognized the voice of the person I called a "tongue-tied young hick" performing with Fred Halsted on the soundtrack of *L. A. Plays Itself*. He is Wesley Hayes, whose only other role was Butch in *Ciao! Manhattan* (1972), a film that can justifiably be called an exploitative mess. After decades of attempting to put his brief time as an actor behind him, Hayes has publicly acknowledged his work once again, albeit selectively. He contributed to the commentary track of the *Ciao! Manhattan* DVD released in 2002, was interviewed about the chaotic production of the film for the second Edie Sedgwick oral history, *Girl on Fire* by David Weisman and Melissa Painter, and attended the book's launch party at UCLA's Hammer Museum in 2006. A capsule biography in *Girl on Fire* pointedly omits *L. A. Plays Itself*: "Clinton Wesley Hayes, a principal actor in *Ciao! Manhattan*, never made another film. He later opened the first skateboard and roller skate shop in Manhattan, and is now a bodybuilder and welding inspector." In the minds of some people, even the most despicable, incoherent feature film is preferable to the greatest gay porn film.

Ciao! Manhattan's coproducer Robert Margouleff must have had a say in casting the inexperienced Hayes, a hitchhiker recently arrived in Los Angeles from Texas, as the male lead of the film. Initially funded by Margouleff's parents, *Ciao! Manhattan* was his first and (until 2011) last producer's credit. He is known chiefly for his work in music. In collaboration with engineer Malcolm Cecil, he designed and constructed TONTO (The Original New Timbral Orchestra), a massive analogue synthesizer. Under the name Tonto's Expanding Headband, Margouleff and Cecil released *Zero Time* (1971). After hearing this instrumental album, Stevie Wonder hired the pair to coproduce *Music of My Mind* (1972), *Talking Book* (1972), *Innervisions* (1973), and *Fulfillingness' First Finale* (1974), all of which prominently feature the sound of TONTO. (Their work on *Innervisions* received a Grammy Award for Best Engineered Non-Classical Recording in 1974.) Halsted and Margouleff knew each other—Fred used tracks from *Zero Time* for the soundtrack of *L. A. Plays Itself*—but how well is uncertain, as is who discovered Wesley Hayes. Joey Yale may not have been the only *ingénu* waiting to be picked up outside a Los Angeles leather bar in those days.

The apartment where Halsted roughs up Yale at the climax of *L. A. Plays Itself* is an art-directed pigsty, its floor strewn with newspapers. In addition to the headline describing the Manson family ("New Weird Cult"), there are other headlines that relate to events less recognizable to present-day audiences of the film, including "American Kidnap [Victim] Tied, Gagged, Dead in…"—other newspapers in the pile obscure specific details. Nick Fitch, who attended the 2020 MoMA screenings, explained to me via email that this refers to the killing of Dan Mitrione in Montevideo in 1970: "His involvement in Uruguay inspired the Costa-Gavras film *State of Siege*, where Yves Montand played the Mitrione character…. Mitrione was an American police officer, whom the American government sent first to Brazil and later to Uruguay to instruct security forces in the practice of torture, particularly the application of electric charges to genital areas and the insertion of needles under fingernails. He operated through the Office of Public Safety (OPS), a police training program, under the umbrella of the Agency for International Development (AID), both of which had CIA operatives in their employ." There's no way of knowing exactly what Fred Halsted thought of the United States' Cold War foreign policy, which in the Western Hemisphere entailed unstinting support for any dictatorship, no matter how base and illegitimate, as long as it declared itself "anticommunist." Fred may simply have chosen the newspapers to suggest a BDSM scene gone too far. At the same time, it's clear that he had a strong intuitive grasp of the psychosexual makeup of the sort of policeman who runs a school for torturers.

A few years ago, I received an email from a woman I had previously been unable to find, Fred's niece Lauren Halsted Burroughs. She wrote, "It's funny, the more I learn about Fred, the more connected to him I feel—even little details, like how he was a vegetarian (I've been a vegetarian since I was sixteen) and his love of gardening (I used to say all the time that if I were to start my career over again I would study botany and start a landscaping business), or even how I lived in the Castro in San Francisco for a number of years while in grad school and have a few good friends in the leather scene." I have met with Lauren a number of times to discuss the uncle she barely knew. She told me

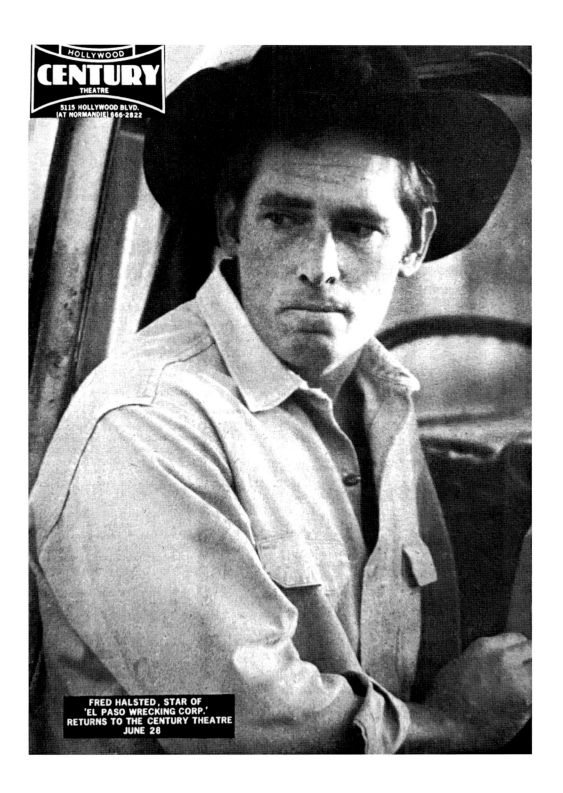

that the owner of Halsted Construction in Orange County is no relation to her or Fred; this was just a coincidence. She also confirmed that most of Fred's effects were consigned to a landfill by her father Milton after his brother's death. Milton has declined to say much about the early life of the Halsted brothers or Fred's career, but Lauren holds out hope that he will eventually open up about these subjects at the end of his life. In further correspondence, she shared what she has learned about her grandparents:

My grandfather, Milton Halsted Sr., left the family when my dad was seven and Fred was three. They were living in Long Beach at the time. He just didn't come home from work one day. Before that, he worked as a construction worker, mostly in the oil fields around Bakersfield. He also did some work up in Alaska, and he would bring home rationed items they couldn't buy in California, like sugar. He ended up being married six times to five different women (one woman twice). He was a very heavy drinker—my dad said he always had a beer or whiskey in his hand, and the few pictures I've seen of him confirm this. His fingers were stained yellow from smoking. My dad told me that in Bakersfield, he was a volunteer sheriff. They gave him a gun. He liked to hang out in bars, and apparently one day he shot up the inside of one (I don't know if he hurt anyone). They brought him to the jail, but since he knew all of the law-enforcement guys, they just let him go.

My grandmother Lillian Knight didn't work in agriculture, but she was definitely a hustler. She had lots of friends who were willing to help her with places to live. She immigrated to California, through Oregon, from Saskatchewan. According to my dad, she was very beautiful and at one point was Miss Kern County. I get the impression that she was charismatic like Fred. They did move a lot—my dad was born in Bakersfield, then they moved to Long Beach, where Fred was born. After their dad left, they moved to Los Angeles, then Toronto, Pasadena, Whittier, Bakersfield, Oildale, San Jose, and I'm sure other places as well. She loved the desert because she developed a bad case of rheumatoid arthritis. She picked up odd jobs: she glazed ceramic flowers for a time, and she set up a little café in the front room of a dingy house they lived in in Pasadena. When my dad was eleven or so, she encouraged him

and Fred (whom she called Miltie and Freddie) to go around the neighbor-hood collecting old newspapers they could recycle for spending money. My dad described living in spare rooms of her friends often. My grandmother was very spiritually experimental—she was always looking for something. After she left the Doukhobors, for a time she was a Rosicrucianist. She would take my sister Debbie to a different church every time she saw her. According to my dad, she did the best she could, and they never went hungry.

Director Joe Gage once described his friend Fred Halsted to me as "white trash with an attitude." Such a figure rarely thrives in America's official cul-ture, which has constructed many barriers to upward mobility; when one does, the moment of glory is generally brief. All sorts of people profess wanting to know an uncouth working-class hero, yet when the genuine article appears, they shrink from inviting him to dinner. Society's true rejects, no matter how fabulously damaged, can't really succeed in the United States, unless it is a success well beyond the pale of polite society. The game has been rigged from the beginning, and there is no transcending the domination of one social class over another.

Halsted directed his own tales of domination from the point of view of the person doing the dominating. He knew whom he addressed: the respectable gay men in real or ersatz marriages, the ones who enjoy their secret stashes of porn featuring disposable people whose fates can't really touch them. He knew that in America, the intersection of sex and fascism meant much more than role playing in Nazi drag, and he knew it when many people were still trying to be egalitarian hippies. Fred Halsted, who was born without money or power, therefore likely to be only the subject of pornography, had a rare oppor-tunity to be the director and producer of pornography. He was an exception the likes of which we will probably not see again, and his work anticipated the kind of sex films that are now omnipresent in the vast, disreputable margins of the media landscape.

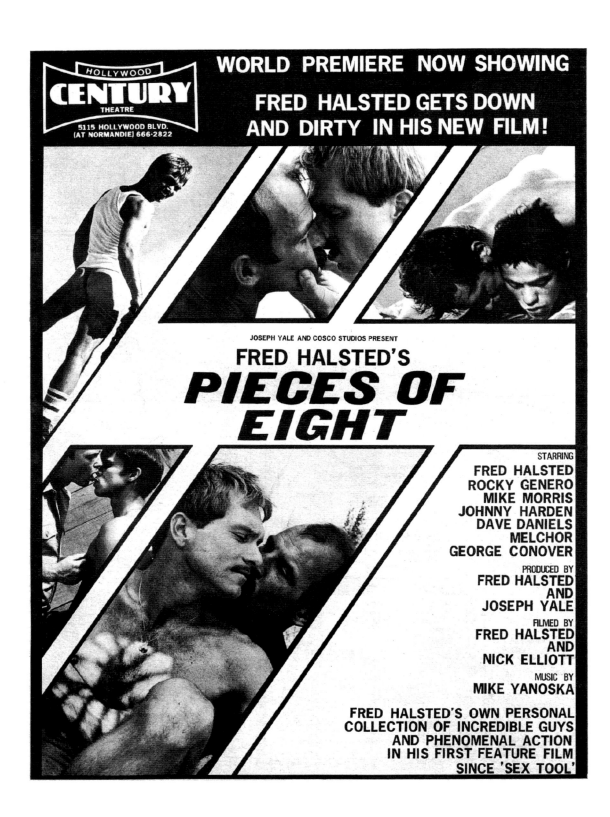

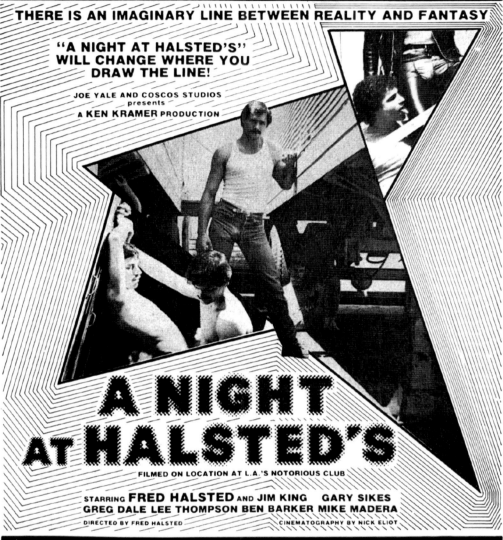

gay money.

West American Advertising Can Open the Vault.

$25,000.

That's how much your average gay worker earns in a year. Multiply that by 20 million gay consumers, and you've got an affluent and very powerful market. And if you have a product to sell, it doesn't take a course in economics to know that it has more buying power than you can afford to discount.

But that $25,000 isn't worth one red cent if you can't reach the right audience. And the gay market is one of the most difficult to find without help. That's where we come in — West American Advertising.

We know the gay market. We know the kind of advertising that sells. And we're the only advertising agency around with the kind of experience and expertise that will put your advertising into media guaranteed to reach the gay marketplace.

Gay dollars are just as green as anyone else's. And West American Advertising will help you make sure they stack up in the right place.

Bank on it.

WEST AMERICAN ADVERTISING
7529 FRANKLIN AVE / LOS ANGELES
CA 90046 213·874·4100

BIBLIOGRAPHY

This bibliography includes only texts published during Fred Halsted's lifetime or soon after his death.

Action Male! "Fred Halsted," vol. 1, no. 5 (1978), pp. 20–21, 29.

Anonymous. "What You Should Know About *L. A. Plays Itself*." Protest flyer distributed on the occasion of Fred Halsted's Cineprobe screening, April 23, 1974, in the collection of the Film Study Center, Museum of Modern Art, New York.

Arseneaux, Bill. "Fred Halsted: An Interview, Part One," *Entertainment West*, no. 125 (February 28, 1975), pp. 12–14, 19.

_____ "Fred Halsted: An Interview, Part Two," *Entertainment West*, no. 126 (March 28, 1975), pp. 13–14, 28–29.

B. B. "Fred Halsted (1941–1989)" *Guys* (July 1989), pp. 34–35.

Berlandt, Konstantin. "An S&M Film the Whole Family Can Enjoy," *Village Voice* (June 2, 1975), pp. 69–70.

Byron, Stuart. "Brothers Under the Skinflick," *Village Voice* (July 20, 1972), p. 57. A shorter version was published as "Grand Illusions," *The Real Paper* (June 13, 1973), p. 17.

_____ "Fred Halsted," *Village Voice* (November 12, 1979), p. 53.

Drummer. "Halsted Undesigned," vol. 8, no. 67 (August 1983), p. 85.

Entertainment West. "Halsted and Yale" (May 9, 1975).

Faber, Charles. "Fred Halsted Looks to the Boards," *The Advocate*, no. 263 (March 22, 1979), pp. 31–32, 43.

Fairbanks, Harold. "Fred Halsted" (Obituary) *The News* (Los Angeles) (June 9, 1989), part V, p. 19.

_____ "Fred Halsted" (Obituary) *Leather Journal* (October 1989), p. 11.

Fredericks, James. "Gayflicks: *Sextool*," *Gaytimes* (Los Angeles) no. 29 (April 1975), pp. 12–13.

Gold. "*L. A. Plays Itself*," *Variety* (April 12, 1972).

Gonzales, Don. "We Can't Talk about S&M in the Kitchen," *Mandate*, vol. 1, no. 5 (August 1975), pp. 32–33, 50–51.

Halsted, Fred. Untitled account of meeting Joseph Yale. *Drummer*, vol. 1, no. 4 (1976), p. 48.

_____ "Editorial" (Gay Superiority) *Package*, no. 1 (July 1976), p. 4.

_____ "Slaves," *Package*, no. 1 (July 1976), pp. 28–29.

_____ "Personal Training," *Package*, no. 1 (July 1976), pp. 36–38.

_____ "Editorial: The *Advocate* Connection," *Package*, no. 2 (September 1976), p. 3.

_____ "Personal Training," *Package*, no. 2 (September 1976), pp. 43–45.

_____ "An Alienated Rough Lay," *Package*, no. 3 (October 1976), p. 3.

_____ "Personal Training," *Package*, no. 3 (October 1976), pp. 19–21.

_____ "Editorial" (Libertarian Party Endorsement) *Package*, no. 4 (November 1976), p. 3.

_____ "Personal Training," *Package*, no. 4 (November 1976), p. 16–18.

_____ "Editorial" (Piss, Leather and Western Civilization) *Package*, no. 5 (December 1976), p. 3.

_____ "Personal Training," *Package*, no. 5 (December 1976), pp. 16–19.

_____ "Personal Training," *Package*, no. 6 (January 1977), p. 40–41.

_____ "Fred Halsted" (Dennis, part 1) *Drummer*, vol. 3, no. 18 (1977), pp. 24–25.

_____ "Fred Halsted" (Dennis, part 2) *Drummer*, vol. 3, no. 19 (1977), p. 24.

_____ "Fred Halsted" (Garage Dungeon) *Drummer*, vol. 3, no. 20 (1977), p. 26.

_____ "Fred Halsted" (Broken Leg) *Drummer*, vol. 3, no. 21 (1977), p. 79.

_____ "Domination by Submissive Men," *Drummer*, vol. 3, no. 22 (1978), p. 79.

_____ "Fred Halsted by Fred Halsted," *In Touch for Men*, no. 56 (June 1981), pp. 52–53.

Halsted, Fred, and Joseph Yale. Marriage contract, dated May 2, 1975, in the collection of the Film Study Center, Museum of Modern Art, New York.

Hampten, Thane. "A Film by Fred Halsted: *L. A. Plays Itself*," *Gay* (May 15, 1972), pp. 7, 18.

Honcho. "Halsted Plays L. A.")April 1979), pp. 12–13.

Hughes, Jeremy. "Halsted and Yale—Who's on Top?" *Skin*, vol. 3, no. 1 (1981), pp. 8–9, 52, 54.

Itkin, Mikhail. "America's First Gay Family of S/M: Fred Halsted and Joey Yale," *Coast to Coast Times*, August 22, 1978, pp. 20–21, 44. Another version was published as "*Maverick* Interviews America's First Family of Gay Male S/M, The Halsteads" (sic) *Maverick* (November 1975), pp. 10–11.

_____ "America's First Gay Family of S/M: Black and Blue Love, Part II," *Coast to Coast Times* (September 12, 1978), pp. 14, 40–41.

Just Men. "The Gay World's Best-Known Couple Split and Begin Life Apart," vol. 2, no. 4 (1984), pp. 18–20.

Karr, John F. "Porn Corner: I Lost It at the Movies," *Bob's Bazaar* (X-Rated *Bay Area Reporter* Supplement) (August 16, 1979), pp. 29–30.

Leighton, Robert. "*Gaytimes* Profile: Fred Halsted," *Gaytimes* (Los Angeles) no. 31 (June 1975), pp. 14–15.

Liebowitz, Fran. "Film Review," *Interview* (June 1972), p. 22.

Lowndes, Leil. "Short Takes: Fred Halsted," *Oui* (June 1977), p. 111.

Manshots. "Fade Out: Fred Halsted (1941–1989)" (October 1989), p. 74.

Martin, Roger. "Gay Products Probe," *Gaytimes* (Los Angeles) no. 29 (April 1975), p. 14.

Mekas, Jonas. "Movie Journal," *Village Voice*, (April 20, 1972), p. 75.

Merrill, Addison. "N. Y. Hits Abuse-Abasement Pic," *Variety* (April 19, 1972), pp. 3, 22.

Minton, David. "Community Leader: Fred Halsted," *In Touch*, vol. 1, no. 2 (November 1973), pp. 18–23.

Moritz, William. "*Sextool*: Fist Fucking the Mind?" *Entertainment West*, no. 126 (March 28, 1975), p. 19.

Murphy, A. M. "*Truck It*," *Variety* (February 21, 1973).

_____ "*Sextool*," *Variety* (March 12, 1975).

Von Praunheim, Rosa. *Army of Lovers*. (London: Gay Men's Press, 1980), pp. 17, 91–96.

Rinker, Davidlee. "Interview: Fred Halsted," *Kalendar*, vol. 3, no. 9 (May 24, 1974), pp. 1, 14–15, 18, 21, 23.

Rowberry, John W. "SMTV: A Personal View of the History of Sadomasochism in Film and Video," *Drummer*, no. 102 (January 1987), pp. 29–32.

Screw. "Deep Fist at the Modern" (April 29, 1974), p. 11.

Siebenand, Paul Alcuin. *The Beginnings of Gay Cinema in Los Angeles: The Industry and the Audience*. (University of Southern California Ph. D. dissertation, 1975), pp. 191–231.

Teal, Donn. "New High? New Low? Halsted's Porn: Can Sado-Masochism Be Poetic and Beautiful?" *The Advocate*, no. 85 (May 10, 1972), pp. 22–23.

_____ "S&M Flicks Cause Furor," *The Advocate*, no. 85 (May 10, 1972), p. 22.

Variety, "Sado-Maso Sex Makes Art Museum" (April 24, 1974).

_____ "Fred Halsted" (Obituary) (June 7, 1989), p. 85.

ACKNOWLEDGMENTS

The following people helped me in various ways during the research, writing and compiling of this book: Chantal Akerman, Thom Andersen, Albert Barba, Jeanne Barney, Thomas Beard, Angelica Biddle, Jordan Biren, Jeff Burton, Chris Chang, Christine Chang, Daryl Chin, Hedi El Kholti, Andrew Epstein, Paul Evans, Harold Fairbanks, Mark Flores, Sasha Freedman, Joe Gage, Allen Glass, Bobb Goldsteinn, James Grauerholz, Matthew Grover, Bruce Hainley, Ed Halter, Rick Herold, William Higgins, Paul Hill, Bill Horrigan, Alexander Horwath, Rich Hyatt, Larry Johnson, Dave Jones, Laurence Kardish, Michael Kearns, David Kordansky, Karl Lee, Sylvère Lotringer, Doug McClemont, Adrienne Mancia, Brian Mann, Dale Matlock, Chuck Mobley, Olaf Möller, Michael Oliveira, Bill Patterson, Deborah Pefley, Rosa von Praunheim, Larry Qualls, Frank Rodriguez, Joe Rubin, Jason Sato, Regina Schlagnitweit, Margie Schnibbe, Joel Shepard, Paul Siebenand, Josh Siegel, Charles Silver, Rob Smith, Zack Stadel, George Stoll, Bruce Whitney, Michael Yanoska, and many others who requested anonymity. William Moritz (1941–2004) also provided help and encouragement long before the idea of doing a book on Fred Halsted occurred to me.

Parts of this book have previously appeared in *Animal Shelter*, artforum.com, *Bidoun*, *Butt*, *Little Joe* and in *Los Angeles: A City on Film*, a Viennale catalog published in collaboration with the Austrian Film Museum.

An Art Center College of Design Faculty Enrichment Grant supported the research for this book.